SILVIA VON BENNIGSEN IRENE GLUDOWACZ SUSANNE VAN HAGEN

Global Art

HATJE
CANTZ

GALLERIES

AUCTION HOUSES & ART FAIRS

CORPORATIONS

FOREWORD

How is the art world reacting to globalization? What does global integration mean for the production and distribution of art? What is the role of museums, biennials, and international exhibitions of contemporary art in a period of globalization? What is the role of art schools and academies? How are the interests and buying habits of collectors changing? Has an artist's status come to matter more in the art world than the quality of their work? Is it still possible for something new and unique to emerge in a globalized world? How does the art scene operate in the emerging markets—in China, India, Russia, the Emirates? Does the church still have a role to play, and if so, what kind? And not least of all, what influence does the market have on art, and what is the significance of the recent financial crisis for art? How, in short, do art and globalization relate to each other? This question formed the starting point for this book, which has been over two years in the making.

The interviews gathered together here were personally conducted with internationally renowned artists, gallery owners, collectors, curators, and business people from Europe, North and South America, the Middle East, Asia, and Australia. They offer personal viewpoints on the new phenomenon of globalized art in ways that are both illuminating and informative. It is the spoken word, and the tone of these conversations, that shape the character of this book. The questions contain key words that aim at guiding, rather than interrupting, the interviewee's flow of conversation. The spoken conversation allows an image of the interviewee to emerge that is authentic and undistorted. Thus the collector Harald Falckenberg characterizes the present changes this way: "The faster the world moves, the faster the 'new' becomes old again." Lisa Dennison of Sotheby's finds that the boundaries between institutions—museums, auction houses, and galleries—are becoming "increasingly porous"; Yves Carcelle from Louis Vuitton thinks that "artists need loudspeakers"; and Francesco Buranelli from the Holy See in Rome is convinced that art can become a universal language "that everyone can understand." The art historian Robert Storr tells us that "money talks, but it does not have a lot

to say." By contrast, the Russian gallery owner Marat Guelman thinks that "money is blood for art, art needs money," and Marc Spiegler, the head of Art Basel, is firmly convinced that the art market "will never be as small as it was," even if it contracts in the wake of the global financial crisis. The artist Maurizio Cattelan uses the following image to describe how hopeless it is to stop this "revolution": "globalization has made all of us more aware of dimensions and scale: we suddenly felt like a tiny rat trying to climb on top of an elephant. To convince the elephant to stop marching would be out of the question."

The insights and points of view revealed in conversations with more than forty participants offer the reader an overview of the art industry at a time when the world is becoming ever more integrated. They give an intimate, insider's view of artists' working practices, the activities of collectors, the attitude of companies and the church to contemporary art, the work of museum curators, exhibition organizers, and gallery owners. Often the people interviewed are commenting on this subject for the first time.

The financial crisis that broke out in September 2008 has not spared the art market. We therefore added questions on this subject for everyone we'd yet to interview, and offered people we'd already talked to the opportunity to come back and comment on it. Some of them used this opportunity, others saw no reason to change their view of things. Taken together, the interviews constitute a many-layered document, which offers a contemporary snapshot of the long-term historical process that is the globalization of art. It is not our intention to judge this process or even draw conclusions on it—given the possibly long-term effects of the present economic crisis, that would be premature. The purpose of the book is rather to stimulate further discussion on the question of how far globalization has affected the art world and what changes have been the result. Our aim has been to present the

different sides of the subject, and the various opinions, activities, motivations, and personalities of the central protagonists of the international art world.

We could not conclude this foreword without offering our interviewees our deepest thanks for their time and patience, and for being ready to share so much of their knowledge, views, and opinions with us.

Silvia von Benningsen Irene Gludowacz Susanne van Hagen

ARTISTS

JOHN BALDESSARI Santa Monica

JEAN-MARC BUSTAMANTE & THADDAEUS ROPAC Paris/Salzburg

MAURIZIO CATTELAN Milan/New York

JITISH KALLAT Mumbai

OLEG KULIK & JACQUELINE RABOUAN Moscow/Paris

VIK MUNIZ New York

NEO RAUCH Leipzig

KIKI SMITH New York

JANAINA TSCHÄPE New York

AI WEIWEI Beijing

JOHN BALDESSARI Santa Monica

John Baldessari

John Baldessari is one of the most influential artists since the late sixties,
especially to younger artists. He was born in National City, California, where
he studied art at the San Diego State University, the Otis Art Institute in
Los Angeles, the Chouinard Art Institute, the University of California at Los
Angeles, and the University of California at Berkeley. He taught at the Cali-
fornia Institute of the Arts from 1970–88 and at the University of California in
Los Angeles from 1996–2007. In his lengthy career, he has been featured in
more than two hundred solo exhibitions throughout the United States and
Europe and over seven hundred and fifty group exhibitions. He started as a
painter, and after burning his own paintings in the sixties, he was one of the
first artists who started to work with the subject of mass-media, which

includes videos, films, artist's books, photo-collages, billboards, and public
works. In 2004, he was made a member of the Academy of Arts and
Sciences, and in 2008 he was honored to become a member of the American
Academy of Arts and Letters. In the same year, he received the Biennial
Award for Contemporary Art at the Bonnefanten Museum in Maastricht. In
2009, the retrospective *John Baldessari: Pure Beauty* is opening at the
Tate Modern, London, and will be traveling during 2010–11 to the Museu d'Art
Contemporani de Barcelona, the Los Angeles County Museum of Art, and
the Metropolitan Museum of Art, New York.

"The United States used to be called a melting pot and now the whole world is the melting pot."

How did you get into art?

I came into art very late. Having a religious background, in the beginning I wanted to become a social
worker, and I just did not think art helped anybody. In school I studied art, but I quickly realized that
I could not support myself and figured I would have to get a job. My sister suggested I might teach
in the public school system, which I did for years—but not only did I teach art, I had also a general
credential. At one point I was teaching juvenile delinquents—they were young criminals—so I had
no shared values, but what I noticed was that they had more need for art than I did, therefore I
thought it must do some good. Art is some sort of spiritual nourishment, and I guess because we
have museums and we come up with money for them, there must be a need. I think deep down
it is both: it is necessary not only to witness art or to consume it, but also to make it. The arts—to
write, to make music, to build, et cetera—there seems to be a need that is beyond pure function. I
don't consider myself to have a social role, nor do I have this mission, but art does fill that need. I am
always surprised how my work is received in public. Some works that I think are masterpieces fail
and others all of a sudden catch the public consciousness. What is it that is being communicated?
It is a mystery. It is probably good that we do not know, because if we really knew, all artists would
be billionaires and would know what people wanted. I love what Damien Hirst said: "People will buy
what I tell them to buy."

How do you feel about his auction at Sotheby's in September 2008?

That is as inexplicable as the economy. Who understands why on the same day Lehman Brothers fails, Hirst can make $200 million? The best thing I heard was from a collector going into auction, who said it was an escape from reality—and I guess we need that! You always hear that, during a bad slump, movies and entertainment have success because people want to escape. I think Damien considers his subject-matter the art market—I know him and I do not think he would disagree. I think his model is Andy Warhol, and if you look at it that way it makes complete sense.

You were one of the first artists who started to work with the phenomenon of mass-media. How did you become interested in it?

When I first emerged (i.e., when people began to take interest in me through reviews and newspaper articles) in the late sixties and early seventies, some of my first shows were in Dusseldorf and Amsterdam. I had seven shows my first year in Europe. What was interesting when I was first a painter and I suppose my style was Abstract Expressionism, the complaint one always heard from the public was "my kid can do that" or "you don't even know how to draw," and so on. These comments made me think: What would happen if I stopped painting and would give people what I think they could understand? The most obvious medium was the photographic image and text, and I decided to work with it. This way of thinking made me use other materials than paint and canvas—photography books, billboards, magazines. Most of my motivation for pursuing this direction was trying to get outside of the museum or the gallery and to communicate with a larger public.

I am a first-generation American and when I started to get galleries in Los Angeles interested in me, somebody said that I was a "European artist." I still do not know what it means, but possibly my up-bringing has affected my thinking in a certain way. After a while galleries in the United States became interested in my work. At that time information was traded mostly amongst artists through certain magazines. Also what helped me a lot were major exhibitions like Documenta or the Venice Biennale where I could communicate with other artists. Then the Internet began to change everything—an artist in the most obscure country in the world can immediately know what some artists are doing in Berlin, New York, et cetera. This is certainly advancing a homogenization of style, wherever you go in one country or another, there is going to be a similarity—things look alike. Recently I came across an article, it was called the "Fourth screen," which is the iPhone. You have cinema, video, TV, computer, and now you have the iPhone and YouTube. Everybody is in touch, which immediately accounts for our world, at least in the arts and I assume in all other fields as well.

How important is the environment for you when you work on your art?

A lot of artists are nomadic, but not me. I do my artwork and then it is shipped. Although, I remember, in the late sixties I was showing in Dusseldorf with Konrad Fischer, who was very smart. Instead of shipping the artwork he would ship the artist, which was much cheaper, and the artists made the

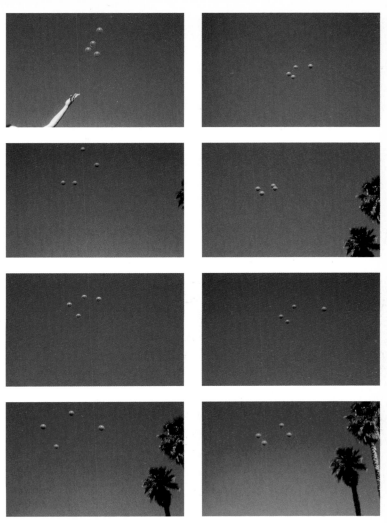

John Baldessari, *Throwing Four Balls in the Air to Get a Square*, 1972–73

work in that city. I stayed there for more than a week and that enabled me to meet the art community in Germany and other countries in Europe. Today I have an amazing network of friends in Europe just by going back and forth. What always bothered me was that when you spoke about "world art" at that time, you were speaking about art in the Western world; the rest of the world was just ignored. Then in 1989, there was this landmark show in the Centre Pompidou by Jean-Hubert Martin called *Magicians of the Earth*. He was very much criticized for going around the world and getting artists from everywhere, but at least he was ahead of his time and I think that counted the most. What I noticed at this exhibition was that art is an amazing universal language, even though you do not speak the same language. In the sixties and seventies, not many people in the art community traveled beyond Europe—they might have been to Egypt for exotic reasons. In the global world today, it is very common to go to China, Korea, Japan, and so on, and one could be traveling constantly. It made me think that the United States used to be called a melting pot and now the whole world is the melting pot.

Do you think that the role of the artist has changed due to this phenomenon of artists constantly traveling around the world?

I do not think the role of art has changed. The economics have changed—more money is earned, for better or for worse. From my point of view I want as many people as possible to see my art, but at a certain point you depend on others, usually a museum or a gallery, to get you out in the world—there has to be some reason to travel.

Konrad Fischer used to say, and I quote, "Art should not have a message." I do not know if I totally believe in that, but I can see what he meant—art should not be about propaganda or a message. Some famous movie director said once, "If you want to send a message, send a telegram."

Are biennials still important for the artist today?

I think they are going to continue, but I think that we are using an exhausted model. For instance, I do not know how valuable it is for the Venice Biennale to have country pavilions. The art is chosen by committees, and it is usually about trying to send a message about that country—so it is propaganda. Are we seeing the best art? I do not think so. I do not need to see art about saying, "Do not kill people." I know it is not good to kill people: tell me something I do not know.

You have a long-standing experience in being an artist and in teaching art. Do you sense the importance for young artists to become quickly integrated into the art market?

Yes—and I think it is a real problem. If young artists use their eyes and ears, what do they see? What do they hear? Today young artists are calculating and they think: "First you have to have a show at some place, then the next step is to get it reviewed in a magazine or newspaper, but better to have the review with pictures, and not just in black or white, you should have the pictures in color—and

then of course you should sell something." All of these hurdles beyond just creating art—that creates anxiety! Or the age of the artist—they have an article with color about their show in a magazine and how old are they? All this matters today, and you are calculating in your mind what sells! I think right now we have a lot of figurative art because it sells. In most galleries you have painting, because people know painting is art. If you see something else and it is inside the gallery then it is art—if it is outside the gallery people might not realize that it is art. But if you see a painting on the street, it is still a painting—it is still art.

Then, artists are thinking they have to get a graduate degree—an MFA or a PhD—and it is very important for young artists today to have this from a reputable school. They think that this is a license and that will help them. I only hire young artists, and I hear them talk about all this anxiety. I think if you would ask them they would say art is first, but they know that there are all these other issues and how to deal with it. When I was teaching at UCLA, I had one really very good student, and collectors were knocking on his door—I thought that he was amazing. He decided to wait a while, which was very daring. Larry Gagosian wanted to buy his paintings and he said no to him. He became a very good painter and he is showing in galleries today. I am an admirer of that resistance, because the other anxiety is this: young artists who are just out of graduate school get offered a show in a gallery, which might not be the gallery of their dreams, but it is an offer. It is a tough decision to say yes or no: should they wait for a better offer? Or they think: "This may be the only chance I have." Then other graduate students—and this is painful for me—will be incredibly good and then will stop because they want a good life. They want to go out, to have dinner, buy a house, et cetera. They do not want to suffer. To have a job, to make money, and then also to find time to do art—you have to save money for art materials and to rent a studio—who wants to do that? Talent is cheap—you have to be obsessed, otherwise you are going to give up. When I became an artist, it was normal that you had a job and did art when you could—there was not as much anxiety.

Does art need to become bigger in size to be recognized?

Young artists are seeing what museums are showing and what galleries are showing—and the message is: I should do that. A couple of years ago, a few galleries started to enlarge their spaces and opened up a second space. The message you send to younger artists is, instead of painting a certain way, paint something bigger. I remember having an ex-student working for me who moved later to New York, who said then he could not do a show for less than $20,000. The message is: to produce a work of art should cost a lot of money. My question is: Have you ever heard of Kurt Schwitters?

Is the passionate collector disappearing in the global art world?

The last crash in the art market was in the early nineties. Many people had predictions in the sense of, "Now art is going to be real . . . and all the huge prices are gone . . . and art will become pure," et cetera. It did not happen! "Once the horse is out of the stables, you are not going to get it back!"

The lowest reasons to buy art are for investment and status—those are the worst reasons. In that context it could be possible that art becomes just a luxury good. But there are many art collectors who are really passionate about art. Such people are not about making money on art: there will always be purist artists and purist collectors, purist museums and purist museum directors, even purist gallery owners.

Will the financial situation affect the art world?

I know that I will not stop what I am doing. I was a first-generation American and was born during the American Depression—there was no money, there was very little to eat, and we had to grow all our own food. If I have to do this again, I will do it and my mode of living might change. It would be more scary for younger people because they think times have always been good. I know a lot of younger artists who, if there is no money, will do something else. I think you have to be into art for the right reasons.

Will art become globally more widespread and available to everyone?

If you look at the movie industry, early Hollywood was just a business then—but many movies were spoken about as art. Even though it is not meant to be art, it might be art; that kind of phenomenon will continue. Back to the art world—we have design now again—was Rietveld furniture meant to be sculpture? No, but it is certainly thought about that way now. Time is the judge and this is what we are talking about: Which art will last? Art is fickle as fashion, and we can only make short-term predictions. You can go back into art history and there are thousands of names you have never heard of today, but at one time they were very active. Then if you look at some Old Masters like Goya or Giotto, they are so modern. Or if you go back to the cave-paintings: they are still important as mankind's first artistic expressions. All art comes out of art.

Luckily, I have been successful in communicating, and I have good connections with young artists, which I did not plan. The reason for this might be the fact that I have always worked with young artists and therefore I might understand the thinking of young artists and what kind of message they need to hear. I am not purposely trying to do that, I am just trying to do work I enjoy. I always tried to make my teaching as much like art as I could.

JEAN-MARC BUSTAMANTE &
THADDAEUS ROPAC Paris/Salzburg

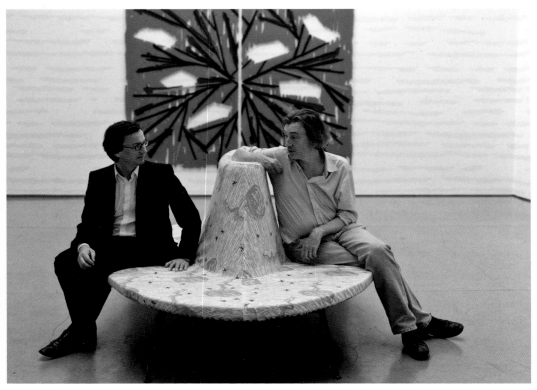

Thaddaeus Ropac and Jean-Marc Bustamante in the Galerie Thaddaeus Ropac, Paris

Jean-Marc Bustamante began his career in 1975 as assistant to the American artist William Klein. In 1983, he met sculptor Bernard Bazile and the two decided to work together as BAZILEBUSTAMANTE. Since then Bustamante has been using photography as the basis for an oeuvre ranging from sculpture to his own unconventional forms of painting. A member of that microcosm of French artists whose reputation is international in scope, he represented France at the Venice Biennale in 2003, the year when he joined the Thaddaeus Ropac gallery. Thaddaeus Ropac opened his first gallery in Salzburg in 1983 and followed up with a second space in Paris in 1990. Initially specialized in contemporary art from Europe and North America, the gallery has collaborated in recent years with artists from Asia and the Middle East. Galerie Thaddaeus Ropac is present at all the biggest

world art fairs and represents internationally known artists, among them Jean-Marc Bustamante, and young emerging artists.

"The geographic and cultural context is decisive for an artist. And even more so for the market."

To what extent can the geographic and cultural context contribute to determining an artist's creative process?

Jean-Marc Bustamante: My artistic path is linked to my biography. My father is South American—from Ecuador—and my mother is English; in terms of my family there's nothing French about me except my very French self. I grew up in Toulouse. I'm the product of an international mix—I'm more global, you might say now. In addition I'm part of an interesting generation, one open to the transversal and unconcerned with the specificities of national cultures. I began learning about art, life, and work in three countries: Germany, Belgium, and the United States—to which, obviously, I add my country of origin, France, where I still live. But if I exist as an artist today it is above all thanks to the Belgians, who were my first collectors. At one point I was living on an art circuit between Eindhoven, Krefeld, Bern, and Belgium. So my training happened in just a few countries: on the one hand there was Europe, with a predominance of English artists, and on the other there was America.

Yet it was France that you represented at the Venice Biennale in 2003. What influence did this have on your work and your reputation?

JMB: I represented France at the Biennale the year when France and Germany thought they might exchange pavilions. Six months before the official opening, I had a phone call from the French Minister of Culture, Jean-Jacques Aillagon: he and his German counterpart wanted to exchange pavilions to mark the anniversary of the *entente* between the two countries. My project for the French pavilion was already well underway and for a number of reasons I was not keen on the idea. Firstly, I would have preferred that the request had come from the Germans; and secondly the German pavilion was very different and had been home to brilliant exhibitions that had a very close rapport with that country's history. So I decided to refuse. Looking back, maybe I was wrong. Things should have been prepared farther in advance, though. But I am ready to do it again!

Thaddaeus Ropac, you have two galleries, one in Salzburg and one in Paris. You specialize in contemporary art from Europe and North America. What are your other selection criteria? What is your gallery concept?

Thaddaeus Ropac: When I opened my first gallery in Salzburg twenty-five years ago, I wanted its emphasis to be international. Apart from my native Austria, Germany was the first country I looked into, and just afterwards I became really interested in the United States: that's where I learnt about art and the market.

In the eighties, the art world was totally different and the globalization process was not yet complete. This was when, in Salzburg, I began showing artists of my own generation like Jean-Michel Basquiat, Keith Haring, and Robert Mapplethorpe. Within a few years, some of these artists saw their careers really take off; this is what helped the gallery establish the international profile it has today and led me to open a second space in Paris in 1990. The program included a wide range of international artists. I have never really believed in regional movements—more in artistic individuality. Artists from different cultures and with different perspectives have always fascinated me, and this is why I began working with Jean-Marc.

My selection criteria for artists is very subjective and personal. This subjectivity is something crucial for me and in my opinion it is what has made the gallery a success.

To come back to the question of movements, we could see twenty years ago that some galleries were really specializing in a single tendency. Galleries would ride the wave of artists belonging to their particular school and an extraordinary number of artists came along one after another; a lot of them were forgotten, and very few had lasting careers. At that time the strictly German concept of following only one line of artists (the "program gallery") was more or less universal. For example, Konrad Fischer was highly respected for showing initially only Minimal and Conceptual Art. In the eighties the gallery system started to diversify. I see my own gallery as being more in the style of the eighties: that was the period when things opened up and art from artists of different currents and with different ideas could be looked at together.

In recent years this phenomenon of galleries that are limited to one specific current has reappeared. I'm not really interested by this school approach (for example, the Leipzig School), as I feel that an artist can only have a personal stance. Sometimes artists can meet and exchange and share and so end up having related ideas, but these are rarely the same. One of the best twentieth-century examples is the Surrealists. They used interactions between theater, literature, and art. But even many of the Surrealists have faded into oblivion, and only the most important gained historical relevance.

Do you think it is still possible to create something unique in a globalized world? We see art boundaries fluctuating more and more, not only between countries, but also within different genres.

TR: I think no age can exist without the making of art. Artists are few and far between, but they have always been a part of history. Today globalization is bringing artists more and faster recognition from

a greater number of people. And even though we're witnessing an unparalleled expansion of artistic output around the world—sometimes you can't even keep track of it—I don't think this spells doom for individual genius. The fact that communication between artists, institutions, and critics is faster today doesn't change the fact that a European artist remains a European artist. And the cultural differences in Europe are always visible and worth looking into: you don't have to go to China or Korea to see how different the artists' approaches can be. We are a huge community of millions of people, but we have our own concept of regions—I won't say of nations, because that immediately takes on a nationalistic tinge—and there's a creativity specific to each region. The geographic and cultural context is decisive for an artist, and even globalization will not have an impact on this.

JMB: And even more so for the market. Being a French rather than a German artist is still something of a handicap, and you find yourself wondering why. I think responsibility here lies with the artists and not, as many people say, with the galleries. For example, I'm with a non-French Paris gallery. I chose to work with Thaddaeus not because he is Austrian, but because I feel that I'm with a gallery that understands my work, defends it, can export it, and can show it under optimal conditions and in a serious, professional way. I need that, and it's true that at some point in France something broke down and an inexorable decline set in. I recall that when I came to Paris in the mid-seventies, you couldn't be a painter if you hadn't read current criticism and philosophy. Whereas in Germany people just painted. France has never recovered from this intellectual tyranny. Today, it seems to me, my work is much more appreciated abroad than in France. Here I'm a kind of misfit, I've built up an oeuvre that doesn't put theory first; on the contrary, what is dominant is the visual experience—physical presence prevails over all the rest. Form and decorativeness don't scare me, but they don't suit the critical establishment, which includes museum people for the most part. Some people are ill at ease and feel out of place faced with the crazy simplicity of a picture. It took Daniel Buren thirty years to begin to let go, and this has really worked for him. He was locked into a reductive ideology—one that was still exciting, in spite of everything—and couldn't allow himself the apparent superficiality of a Sol LeWitt or the poetic lightness of a Ryman—two artists who have an appearance of freedom within a tight structure.

Looking beyond the issue of intellectual engagement—all good artists are engaged—I have always been interested in the exquisite precision underlying the greatness of some artists who take art to a higher level—from Pieter Saenraedam (1597–1665) to Andy Warhol. The question of looking and illusion remains central to my concerns and explorations, in which "the photographic" has enabled me to hone strategies in terms of color, light, and transparency in space while at the same time putting a crucial emphasis on man's place in the world. This oeuvre is both intellectual and highly psychological—and uncompromisingly formal because in a polished, precise way it raises the issue of the viewer, the individual looking at the work. The artist has to imagine himself inside the mind of the viewer.

Jean-Marc Bustamante's *Lumière 01.03* for the 2003 Venice Biennale

Globalization hasn't driven you to produce more and more?

JMB: No, my galleries leave me real independence, and my output is very reasonable. Good artists today are like islands drifting through a landscape that allows them less and less visibility. People's eyes are turned more toward the newcomers—but why not? After all, being a good artist is something you have to work at. Art's in fashion, and the economic crisis is going to give new collectors the time to appreciate works better; and the works take time, too, as they settle slowly into indestructible blocks. Good artists are indestructible.

What changes have there been in the art market since you opened your first gallery in 1983? What are the most important art centers now?

TR: The last twenty years have been shaped by the Americans and the Europeans: the only art markets that existed were based on those two continents, with each taking a real interest in the work of the other. This has always generated reactions from the public as well. If you take Pop Art as an example, which started in the United States but increased its success in Germany, if collectors in Belgium and Switzerland, and Peter Ludwig in Germany, had not started buying artists like Jasper Johns, Rauschenberg, Lichtenstein, and Warhol, Pop Art would probably never have had the impact it did on the American market. At that time the rest of the world—Latin America, Asia, Africa, Russia—was less important. Only a few artists from these regions managed to surface and get looked at, like Lee Ufan, who lived in Paris. But as non-Westerners they mainly owed their presence on the art scene to the fact of being expatriates. That's what enabled them to get in touch with different actors on the art market. But if they had not been obliged to move to the West, they would certainly have stayed in their home countries. It has to be said that before the opening came along, it was virtually impossible to visit China, and our knowledge of the art of those countries was restricted to information from third parties or from this small group of artists.

In recent years the geographic barriers have become more porous, and we can be acquainted with an artist from Reykjavik without his being forced to move here. So where an artist lives is no longer so important. Only certain cities, however, are recognized international art centers, because to achieve this status a city has to have a "critical mass," a substantial concentration of artists and art-related institutions. This will always be the case for a few places like Los Angeles, New York, London, Berlin, and Paris, and a few smaller centers such as Vienna and Zurich. Today new points of focus have emerged—Moscow, St. Petersburg, Beijing, Istanbul, Shanghai—all these places have attracted worldwide attention, but it is unclear which ones will continue to have long-term recognition.

To what extent is an artist dependent on the market and the art fairs? We are seeing more and more artists doing their own marketing.

JMB: Today you either adapt to the tempo of the market or you go under. So if you want to remain visible you have to produce. For fairs like Basel, for instance, all the galleries ask their artists for a

work. Sometimes there is nothing ready and they get ridiculously worried. I think resistance is called for here, because a work is the outcome of a long, complicated process. I'm not sure all artists can keep up, and this can lead to their being out of phase. An artist doesn't have to produce three thousand works; he can produce five and be just great. But the way things are structured today, works have to be constantly put into circulation, because of the pressure from the market.

Personally I see that as neither vital nor desirable. At the same time, there are no rules. Some artists have to produce prolifically in order to be understood. No problem. What counts first and foremost for an artist is being understood. All the tricks and all the strategies are acceptable. I like talented artists who are capable of turning out masses of bad work. To be able to tell a really funny story you often have to tell a stack of really unfunny ones.

What do you think of the phenomenon of collectors who travel more and more and are at fairs from January 1 to December 31?

TR: I think the importance of contemporary art fairs is somehow overrated. Taking part in fairs because it is important or necessary is fine, but I really feel that we're headed toward a return to the traditional gallery and that this is happening because in art it's not always possible to work fast the way people are doing today. When an artist has an exhibition in a gallery he prepares a long time— months—in advance, choosing the works carefully and matching them to the space and getting the lighting right. There's a whole conversation going on between the artist, the works, and the space. But this is impossible at art fairs, where everything is pure compromise. At the fairs, you're faced with a difficult situation where everything is temporary, from the walls to the carpet; the lighting is insufficient, and you have a day and a half for the hanging. Some works will never be shown at a fair, which is why we keep telling collectors and the public to make the effort to go see the works in the gallery: because no artist looks their best during a fair.

JMB: True, the situation is rather paradoxical in this respect. I remember that twenty years ago, even in France, you used to travel a lot more to see exhibitions: you'd go to St. Etienne, Grenoble, Bordeaux, but now you travel much less because there's a lot more to see where you live. In those days the art scene was much smaller. When Kiefer had his first exhibition at the CAPC in Bordeaux we all went. People made the effort and traveled long distances. Today if he had an exhibition there, few people would go. There's this contradiction now between globalization—art being spread around— and the sedentary behavior of people who are involved with art but travel less. I did an exhibition with Ed Ruscha in Strasbourg, a great project that took us two or three years, but nobody saw the exhibition except people from Strasbourg, because people don't travel very much in their own countries. Yet Ed had come from Los Angeles and we did a *mano a mano*, which was very generous of him. That's globalization. You can't see everything. It's like with TV: when there were only three channels you saw everything; now there are a hundred and fifty and you just channel-hop.

What do you see as the relation between art and money? Does this influence your own work?

JMB: That's not the real problem. The most important thing for artists is to be bought for good collections. Placing your work is crucial—it is not just a matter of selling for selling's sake. True, we don't turn up our noses at the money, which is the incentive to keep producing, especially when your works are expensive to make. But you so much want your work to be good that money is just a means to an end.

What are the advantages and disadvantages of the new kinds of collectors/investors and the art funds? Is art becoming a brand image?

TR: There are different kinds of collectors; however, we want to develop long-term relationships. Our aim is not only to sell but also to place artworks with collectors who love them and plan to live with them over time. That is one principle we absolutely stick to. But today for some collectors, pure passion is accompanied by investment strategies: only the proportions change. It's up to us to try and see if the passion is more powerful than the urge to invest.

What do you think of the artist being turned into a celebrity?

JMB: I don't think the celebrity cult is anything very new. Salvador Dalí was more of a star than Damien Hirst. And Picasso—what a star! What is new is the access for the general public. Art has become more popular. Take the Jeff Koons exhibition at the Palace of Versailles: it's being talked about a lot, but people don't really know what it's all about. The people who rush to see Koons at Versailles are not really taking him seriously. They're going there to be entertained.

The celebrity cult gives the artist real power over the public. Does this mean art can affect social policy?

JMB: Yes, but only indirectly. I've always found artists who "do" social stuff extremely boring, but at the same time I think that any great work always includes this parameter because it talks about humanity, about reality; it may not necessarily be direct, but you do have this social side in Jeff Koons's work. There's a rapport with the consumer society in the way he treats objects, using references to childhood dreams, and in the way he makes those objects shine out into the world. He has a social impact and he makes lots of money with it, but that is not the problem. The artist has a vision of the world and tries to tell us something via his personal sensibility. He is a militant, that goes without saying, but as a simple citizen he is somewhere else. I'm a militant for life, for the dazzlingly beautiful, for emotion, and for a vision of the world that is not the everyday one. It isn't up to artists to solve social problems; all they can do is offer a new, original way of seeing the world. That's the most important thing. By getting people to think differently, Warhol gave them a different way of seeing the world every day.

TR: I don't think artists can have any social impact. If art has an enormous impact, it can only be historical and not visible in the present moment. Take Picasso's *Guernica* as an example. It's only of historical interest and has had an impact well after Picasso painted it; over decades it has become a touchstone. Let's not forget that Picasso was a fervent communist until he realized the party was just using him. It's very interesting to see how he dealt with politics, but that interest only came with the passing of time. As I see it, artists today can only have an immediate social impact on a tiny part of the population.

JMB: One thing we can be sure of is that artists are visionaries. We can see this in the way their ideas get taken up in advertising, and the applied arts, and the environment. An artist like Miró, for example, had an enormous influence on Spain, and especially on Barcelona . . . Lightness, humor, color, organic form, imagination—you find all those things in Catalonia. I believe that great artists reflect their background. Beuys—like Kiefer—has left a powerful trace in Germany, for better and for worse. Today we look at Germany through those artists. Just as we look at England through, among others, Damien Hirst and Gilbert & George. There's a kind of imprinting that works in both directions.

What do you think about the commercialization of art, as in the LMVH model?
JMB: That's a complicated question and not an easy one to answer directly. A priori, if the artist finds a niche in that system, that's fine. Look at Murakami, for example. There you have a great exchange between artist and patron. I don't think there is an LVMH model. I find it very interesting that amid all this diversity of interests, art finally succeeds in getting its message across.
The great artist is always more powerful than his patron, just as he is more important than his subject, and just as he is always more important than what he says.

TR: I think that working with any major company often can necessitate major compromises on the artist's part. This we must keep in mind and carefully weigh when making any decision for the artist to participate in corporate sponsorships. It can have great or less-than-great results, like any other partnership.

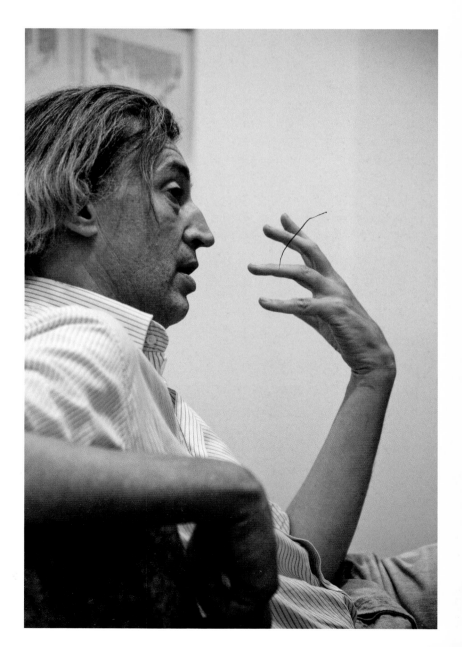

Jean-Marc Bustamante

MAURIZIO CATTELAN Milan/New York

Maurizio Cattelan

Maurizio Cattelan was born in Padua, Italy. He is self taught and did not attend an art school. Before turning to art, he worked in various professions such as that of cook, gardener, electrician, and mortuary attendant. He started his artistic career as a designer, making his own furniture, which brought him into art. With his satirical and controversial sculptures and installations, he became one of the most internationally well-known artists of his generation. Cattelan had several solo exhibitions in museums such as the Museum of Modern Art, New York (1998), the Museum of Contemporary Art, Los Angeles (2003), Fondazione Nicola Trussardi, Milan (2004), or the Kunsthaus Bregenz (2008), and participated in several biennials, including Venice, Melbourne, and the Whitney Biennial, New York. In 2006, he co-curated the 4th Berlin Biennale, together with Ali Subotnick and Massimiliano Gioni, with whom he was also founder of The Wrong Gallery, and co-editor of the magazines *The Wrong Times* and *Charley*.

"In art, however, globalization has made all of us more aware of dimensions and scale: we suddenly felt like a tiny rat trying to climb on top of an elephant. To convince the elephant to stop marching would be out of the question."

What is the role and function of art today? How much has the role of art changed in recent years?

The role of art did not change, not even its function. Everything that is around it, though, is very unclear: we are buried beneath the weight of information, which is being confused with knowledge; quantity is being confused with abundance and wealth with happiness. In the end, we are only monkeys with money and guns.

How important is a classical art education to you personally?

I was trained as an electrician, and this really helped me a lot. Art is about systems and transformers and I was specialized in antennas: I am just a repeater—I magnify and diffuse what is already out there.

How did you get into art?

The first encounter with art was through design: I moved into an empty house and started building furniture for myself. They were strange objects that some people could also experience as sculptures. Art seemed a way to escape work and authority: so I got to art for exclusion and, I would say, almost by accident. I thought it was a place of freedom, but in the end if you have no office and no boss you work all the time. Art is in your head: you can't take a break from yourself. Even though a couple of times I did try to fire myself.

What does networking in the art world mean to you?

A team is always stronger than the sum of its parts. But I don't believe in networks, I'd rather go for more informal words like "friends" or "family," with their connivance, participation, and violence.

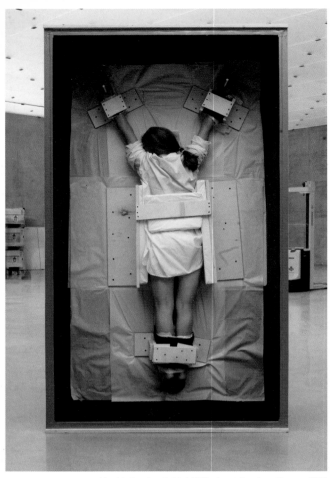

Maurizio Cattelan, *Untitled*, 2008, view at Kunsthaus Bregenz, 2008

What is the importance of biennials for artists today, and for you personally?

In this new situation of the market, with the art fairs that seem to be losing their leading positions in the rank of entertainment art events, maybe biennials will take the chance to regain a predominant position in the art world. I've never fully believed in this debate on who's first and who's second or third: art is never about rankings and records but always about visions and questions. What seems interesting to me is the established role these events have in concentrating a lot of people in one single place: in the mass even the smallest idea can sound loud.

Does art need to become ever more spectacular or bigger in size to be recognized?

Art isn't necessarily getting bigger or more spectacular than in the past. In any times of history you could find art that could be collected in private houses and art that could only exist within the public arena. What contemporary art is trying to achieve today is a new way to address audiences and find a new public response. Art is not about entertainment, art is about engagement. And maybe not about dimensions but rather about diversions.

The borders of art are becoming ever more fluid, not only between countries but also within art forms themselves. Is it still possible to produce something new and entirely unique in a globalized world?

I've never understood why it should be a resource to be able to find the same things everywhere and at the same time. In art, however, globalization has made all of us more aware of dimensions and scale: we suddenly felt like a tiny rat trying to climb on top of an elephant. To convince the elephant to stop marching would be out of the question.

There is immense pressure for artists to produce new art work. In such conditions, is there any chance of developing something new?

You can't chop your ear off every day. The best art comes along when you're brave and visionary enough to trust the artists even when they lie. In the end, we're all untruthful: we promise a bridge where there's no river.

What do you consider the relationship between art and money today? Does this relationship also have an influence on your personal work?

What was true yesterday is false today and a question mark for tomorrow. I am just as anxious as always: in my daily life, money never really changed anything. It increased my obsessions and probably even made me more compulsive. I am extremely repetitive, I can only do something if I've tried it out before. I've always been concentrated on not owning anything: I do not know how I thought about it and how the idea arrived, but to liberate myself from everything looked certainly useful. Life is like images, to make it work there's always so much to do.

Has collecting become a status symbol, both for individuals and enterprises? Is art becoming a kind of "branding"?

The contemporary art market in the last few years has grown so big that even the way of working was changed. Among collectors you could also find buyers, which is a completely different thing. Collectors have dreams every night. Even better, they have nightmares.

Can art have any kind of social or political role?

I never trust politics too much, and I am probably the wrong person to address any social role through my work. I am not reflexive enough, I react and respond rather than take the initiative, and also I am never coherent: I can answer to the most difficult question in a few seconds, but I need five years to reply to the simplest. I guess this doesn't make me a good politician. But art has always had the role of questioning and doubting: images demand to take a position. Most of the politics today are done through moving images anyways.

Could there be an end of art? Could art become mere entertainment, like watching television? Could art just "fizzle out"?

Death is always the most interesting thing to look at: without an end there's no beginning. One of the biggest problems of TV, and largely of entertainment, is that it usually forgets to face death. TV often relies on its fastness in strolling images and ideas and so its visions are not sharp enough to stay. They are forgotten as they appear in the black box. I am sure you can think of a few occasions in which, instead, television did remember the End: if TV starts learning from death, it will be the best form of art.

What do you feel about the cult of the "art star"?

Art will never have its Hollywood, and hardly any red carpets: unlike cinema, there's no happy end.

Is making art for "eternity" important to you? Does it matter to you whether your art will still be looked at, and looked after, in fifty years' time? How "durable" do you think art should be?

The idea itself of immortality makes me very nervous: any single mistake or terrible thing you make would be remembered forever. We always need a second chance: we all want to go back, change, make different choices, say different words, make other works, and answer your questions in a different way.

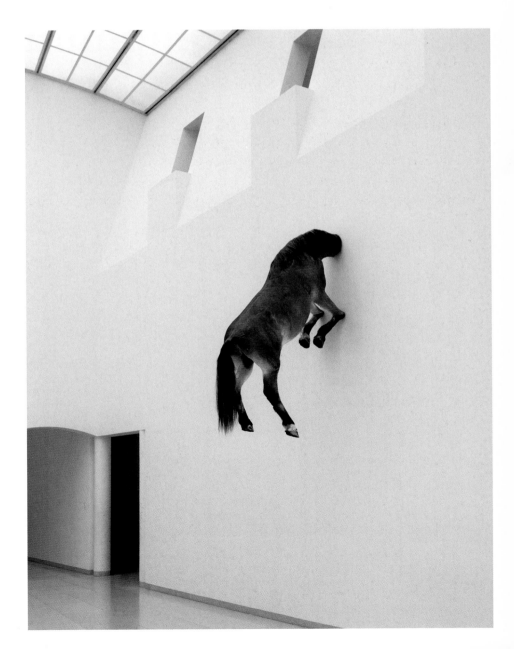

JITISH KALLAT Mumbai

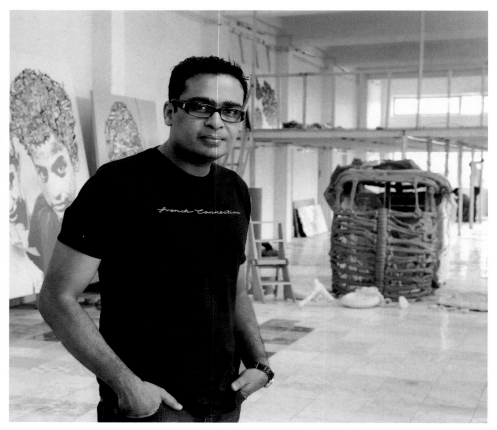

Jitish Kallat in his studio in Mumbai

Born in Mumbai in 1974, Jitish Kallat is one of the youngest Indian artists to
have received international recognition in the last few years. In 1997, in his
early twenties, he was offered his first solo show by the Gallery Chemould,
one of India's leading and oldest galleries. Now, a decade later, five of the
most influential galleries in the world represent his work. His often large-
format works use both painting and photography in an elaboration on concep-
tual forms. He also writes frequently on the subject of contemporary art
and is working internationally on curatorial projects.

"People can come to art for the wrong reasons, but they might grow to end up staying for the right reasons."

When did Indian contemporary art really start?

While there are six decades of art-historical developments in post-independence India, it was in the mid-nineties that the scene slowly began to transform, with the last five years seeing accelerated changes in the scale of activity and the audiences that engage with it. In the last five years, the growing global interest in the Indian art scene has made it a transit lounge for visiting curators, museum groups, artists, et cetera. Just ten years ago, the only interface that India had with the global art world was the participation of a few Indian artists in the primarily non-Western biennials, with no Indian gallery having access to any of the art fairs. But the strength of this homespun art scene is that its early incubation has happened entirely within India and was nurtured solely by Indians.

In many ways the liberalization of the country in 1991 was a key catalyst for all of the global interest in India. At the same time there was this bubbling change reflected in the general culture, and truly exciting work was being made there. The year I joined art school was 1991, and India moved from having one slow-mo, state-run television channel airing sedated entertainment to ninety channels in the space of a year. The whole sound and visual detonation of media—and the brisk infusion of changing cultural tastes that came with it—was impacting the way I thought about art and the visual language. From a macro perspective, looking outside-in, the flow of foreign direct investment created a level of magnetism and diplomatic justification for the institutional and museum interest in the arts of India.

When you started your career as an artist, who were the patrons of the arts in India? Were they private or were they institutional?

There was a fairly significant group of private collectors but nothing compared to the large numbers we have now in our overgrown market. I remember when I was showing my work at a student exhibition in my art school days, the Deutsche Bank acquired one of my large works. I had an unusually early start. I was just out of art school and at my debut solo titled *P.T.O.*, Gallery Chemould managed to sell all my works before the opening to important collectors, which was not so normal at that time and especially for an artist who was all of twenty-two years. With the total absence of state support for the arts, the private galleries were not just spaces of visibility but spaces of experimentation as well.

What do you think is the role and function of art today?

It is hard to mark a definite role for art in society and assign a specific use-value to it. I don't think there is a very static idea of what role art can play. As an artist, I think my effort would be to try and make sense of the world through my work. Today my "immediate" is not just what is here now; my "immediate" is the globe at large as the world travels into all our living rooms every day. You can actually be an armchair world traveler in this globalized world. For instance, a few months ago while riding a cab in New York I had the absurd experience of watching a news channel on Taxi TV; I was looking at the same flickering data in my bedroom in Mumbai the previous day, the airport lounge, the hotel room, and then finally even in the cab in New York, creating a strange seamlessness of visual experience.

The art that's made today absorbs all these cultural signs and symbols. As the artworks travel incessantly and gather "art miles," they simultaneously gain and shed meaning through the differing contexts in which they are received.

What do you want to express in your work?

Much of my work addresses the classic themes of life: birth, death, survival as it gets played out on the populous streets of Mumbai. But then, these are the same themes that are core themes of life anywhere on this planet.

People and the image of the city have always been consistent themes in my work. Painted like a billboard, hundreds of people leaving a train station is one of the resounding images in my works painted almost a decade ago. The *Rickshawpolis* paintings are vast collision-portraits of the thumping, claustrophobic city-street. Cars, buses, scooters, cycles, cats, cows, and humans collide and coalesce to form mega-explosions. These optical jerks, caused by the high decibel of daily action, can also be read as distorted reflections of a city seen on the dented body of an automobile. The painting itself is mounted on bronze sculptures, re-creations of gargoyles that are found atop the hundred-and-twenty-year-old Victoria Terminus Building in the center of Mumbai. The gargoyle, herein symbolizing the figure of the bystander/artist/self, has been a daily witness to this constant calamity of the street running into itself.

Dawn Chorus and the *Universal Recipient* paintings become double portraits; the portrait of the city forming the mane of another portrait, of a person who lives in the city.

Is it still possible for you to create something new and entirely unique in a globalized world, where every artist knows what everyone is doing?

In this world I think that the notion of the "entirely unique" is not just an impossible position but also an uninteresting one. At a time when all knowledge and experience gets pulled through a process of intense interbreeding, culture will reproduce in exciting hybrid ways. It is hard to separate our virtual experiences from the real ones; our virtual interactions are satisfactory surrogates for real one-to-

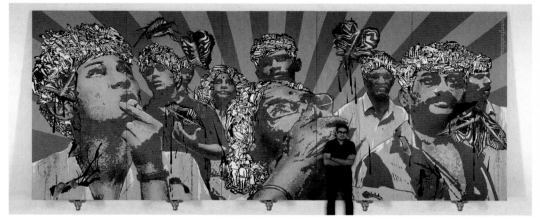

Jitish Kallat in front of his work *Horrorificabilitudinitatibus*, 2008–09

one meetings. How can my brain, which receives a few million signals every day, not be a result of those few million signals? My work would probably be unique only by virtue of the fact that it doesn't remain rigid in pursuit of uniqueness and instead becomes a flexible processing field to engage and disentangle the million signals that enter my system every day.

Don't you rely on any of the Old Masters, or any other artist?

Without doubt. I love all of them and a vast number of artists will be part of the subterranean citation index of my work. But it is also the stuff on TV, the billboards, and the way data invades my cellphone, and the mess and grime of one's neighborhood; everything has an impact on one's whole visual and cultural framework.

Did India as your geographical location determine and influence your creation?

The location of India is indeed key to the way my practice and perspective have shaped. Where else could you hear a *bhajan* (devotional song) being played on the street within walking distance from the funkiest nightclub in the city; or the existence of upmarket high-rises in the middle of slums. These juxtapositions and resulting cacophony can be startling and sometimes painful, which in turn becomes the breeding ground for culture, contaminated and enriched through endless cross-pollination.

I often say that the street is my university. The key themes of life get enacted on a Mumbai street; pain, happiness, anger, violence, and compassion are all played out in full volume. In some ways I feel an artistic inadequacy while dealing with the way stimuli percolates one's system if one lives in a place like Mumbai. An analogy I often make is of holding a pen to paper in a fast-moving locomotive,

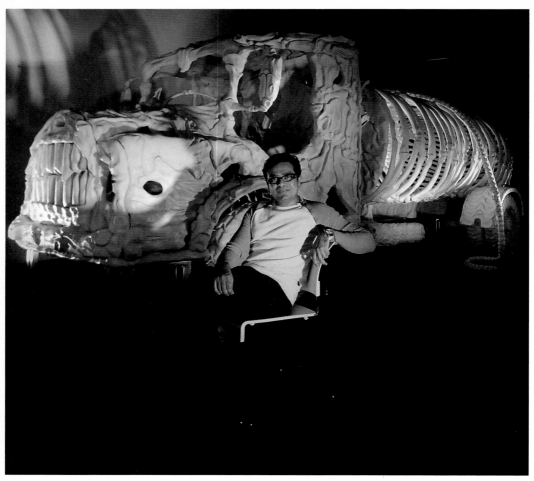

Jitish Kallat with his *Aquasaurus* shot at Warehouse on 3rd Pasta, Mumbai

the drawing becomes a seismographic record of the many tremors of the journey. Making art against the backdrop of a fast-changing India is somewhat a similar experience.

You are one of the three or four internationally well-known Indian artists. What do you think about the phenomenon of Indian art gaining in value on the art market?

At one level, given the quality of art that was being made in India, it was hugely undervalued until recently. So part of the price rally we saw in the last few years was the rapid catching up that happened. There has been tremendous wealth creation within India in the last decade, and as basic needs get quenched, people are able to focus on art, design, et cetera. This is as far as the local scenario goes.

Globally speaking, one has to see it in the context of the general realignment of the world and India's sphere of influence on the planet as an emerging power. That has created a deep interest in everything Indian and we see that interest extend to the art market as well. But the art world and its markets go through cycles of infatuation so one should not take attention or neglect too seriously.

Does art influence the masses socially and politically? Is art powerful?

If your core intention is to deploy art in order to mobilize people and transform society, then you've got to make art in the format of the slogan. And for this we have the history of propagandist art to refer to. But we cannot disregard the power of the nuanced art object and how it can have an influence on the individual who confronts the piece in isolation. So it is your intention which will result in what you do. If you ask me about the power of the arts to affect mass change, I guess cinema and music have tremendous transformative possibility at a larger scale. But again, the power of the art is in its possible influence and changing meanings across a breadth of historical time.

Did Mahatma Gandhi inspire you as an artist?

Gandhi was a hugely influential figure, but with regard to my works such as *Public Notice-2*, it is primarily my interest in the historical speech or text. The historical speech is a series of wise words that can become a template upon which to position today's world to see how the world has become misaligned. To me, it is less relevant whether Gandhi spoke these words or if somebody else did; after all, the words emerge not necessarily from the throat of an individual but from the urgency of the historical moment.

Gandhi was an artist who used symbols, words, actions at precise moments to reawaken an entire subcontinent to stand up against an oppressive invader, using the most imaginative tool of non-violent disobedience. In today's terror-infected world, where wars against terror are fought at prime television time, voices such as Gandhi's stare back at us like discarded relics.

Who do you think plays the most important role in the art world today . . . gallery owners, museums, collectors, or auction houses?

Maybe the philosophical reply to your question has to be: the artist. The reason I say that is because artists have existed way before we had an organized art world. If everyone leaves, will all the solitary figures of the artist stop making the scribble? I don't think so. So that apart, in our current art-world circus, all the different constituencies are at once stakeholders and inject layers of value addition to nourish the art ecosystem.

How do you work with your different galleries?

Galleries work with a certain number of artists. Similarly, I work with a certain number of galleries based on the geographic locations within which they have developed their programs. I work at a pace and in a rhythm that is comfortable to me. My pace and rhythm has always been on the brisker side; I speak fast, I move my hands a lot, and I also make art that way! And then I juggle several caps. I write on the arts and am currently working on two curatorial projects.

What are the advantages and disadvantages of the new model of a collector?

I mean, undoubtedly there is what one might call "label culture" that has infected every sphere of life, and the art world is equally a victim of indiscriminate herd mentality or the bandwagon effect. This is particularly visible in the three-minute purchases made at art fairs or the glamour-clad paddle-raising sport called "auctions."

I think it is the result of art being treated as an asset class, such that even an "art appreciation course" would mean how to buy art that will appreciate in value; the intention is mostly speculative rather than evaluative. But I'm not all pessimistic about the situation; it is wonderful that greater numbers of people across the world are drawn to the discipline of contemporary art. Even if art is seen in the territory of trade, diplomacy, or even cultural tourism, if greater numbers of people experience it that is wonderful.

In India I have seen some people who entered the art world as speculators and have evolved to become passionate collectors. I've also seen that a lot of people got drawn to contemporary Indian art when it began jumping price points. People can come to art for the wrong reasons, but they might grow to end up staying for the right reasons.

How do you consider the relationship between art and money? Does it influence your work?

The production of some pieces would just not be possible without capital, and therefore money is a necessary lubricant to facilitate practice. There's no state support for the arts in India and I haven't inherited any family wealth, so I have no conflict with money. The fact that I was born in a middle-class family with very modest means and one that always valued education more than wealth is deeply engrained in my psyche.

So do you feel that galleries push artists too hard on production?

I don't think so. In fact the entire equation of the artist-gallery relationship has gone through so much change in the last decade. I find the old expression of a "stable of artists" really funny; it makes artists sound like horses. There is of course a close collaboration between the studio and the gallery, but when it comes to making work I'm my motivator and not the gallery.

Do you think making art for eternity is still possible today? To have eternal recognition: is it important to you?

I would like to see my art in a hundred years; I'm very interested in the idea of the "view from the coffin." I want to see good things when I'm lying in there; and I hope to be watching with satisfaction!

OLEG KULIK & JACQUELINE RABOUAN

Moscow/Paris

Oleg Kulik, *I Cannot Keep Silence Anymore*,
European Parliament, Strasbourg, 1996

Jacqueline Rabouan and Oleg Kulik
during FIAC in Paris, 2001

Through decades of political oppression and arrested development, Russia's visual arts were all but invisible internationally. Only in the past few years have artists from the former U.S.S.R. reemerged from the shadows, thanks to the fervent commitment of gallerists like Jacqueline Rabouan in Paris. Oleg Kulik, known for his politically radical performance art, is one of the most important contemporary artists in Russia. He lives and works principally in Moscow.

The Russian artist and Jacqueline Rabouan began working together in 1998. Kulik's first solo show in Paris presented photographic series and video installations. At the same time Rabouan organized *Two Kuliks*, a series of performances in the courtyard of a townhouse in Paris's Marais neighborhood—which led to massive complaints being lodged with the police!

"Just what is a globalized world?"

You were born in Kiev in 1961, and you are mostly living and working in Moscow. What does Moscow means to you?

Oleg Kulik: I could live anywhere. I have the spirituality of a man who belongs to the planet, and nobody can find my space.

Russia is three countries: the Kremlin, Moscow, and the rest. When I moved to Moscow, I set up behind the Kremlin, because it's the quietest spot in this noisy, frantic city. It's a place where bureaucrats never go, and nobody else either. Nobody ventures near the Kremlin, so you're free to head out along the river on your bike. There's a parallel between this place and my work. I'm constantly searching for somewhere in the world where things look better and you can love everything. That somewhere is between the Kremlin and the rest of the world.

What kind of character is Oleg?

Jacqueline Rabouan: I've been working with Oleg Kulik in Paris for eleven years. He's a cultivated man, with an awareness very much shaped by the collapse of ideologies both political and human. Having experienced this, he instinctively looks at humanity with a universal eye and dreams of a world guided by wisdom (for example, *I Believe*).

We all know that decades of political oppression put a stop to cultural development and left only the art of Soviet propaganda. What would your own propaganda line be today?

OK: My propaganda line is that no political system, such as communism, and nobody, from Sarkozy to Bush, will ever stop an artist from creating, from becoming and remaining an artist. All an artist needs for that is a pen, some paper, and his brain. It's very important to understand yourself and understand what's going on in the world.

How did you keep in touch with what was going on in the wider world?

OK: Information circulated via the underground, which was a really powerful movement of people living according to their own laws and openly criticizing the regime.

So could your work be described as a criticism of the Russian regime?

OK: Never. That atmosphere of criticism doesn't exist in my art. My art criticizes humanity in general, but most of all myself. As I see it, there's no difference between the bloodiest regime and the most pacific one.

You are well known especially for your provocative performances, like in Stockholm in 1996 when you appeared as a dog dressed only in a leash. Are things like that needed to keep art in view?

OK: Yes, maybe in that performance there was the idea of getting people to relate to something. There's no danger for an artist in wanting to attract attention. I wanted to talk about myself and the fact that I don't understand the world. The more time passes, the less I understand what's going on. That's why, as an objective man, I visualized myself as a social animal with no understanding. In that performance there was a link with human savagery.

But what about your work *Holy Family*, of 2004? Isn't that a political critique?

OK: It's not a critique, it's a work about love. It's an image of a contemporary Madonna. True, what drove me to make this work was obviously the events in Chechnya. But it's a work of love.

Is your art an overall expression of what's going on in the world?

OK: I find the conflict in Tibet and the attitude of Westerners to Tibetans very upsetting. I've never seen anything more horrible, more ghastly. When Westerners need oil, their lackeys always find a way of taking action—the way they did in Iraq, where in fact there was no real danger; they can always find a pretext. But since Tibet has no oil, nothing is done and the Tibetans are dismissed as a bunch of separatists. It's this regime—the most ghastly of all, in my opinion—that I'm trying to combat: the regime that represents the West's pragmatic approach to the rest of the world. That's the most serious problem. All the violence is produced by this approach, which is purely pragmatic and not in the least spiritual.

What is the vision of your art?

OK: In my work I speak of personal experiences that I try to share with the public, and I hope the public will remember that. And yes, I'd like the "Oleg Kulik Project" to live on in people's memory. This project is my inner transformation in relation to the rest of the world. For example how this man, Oleg Kulik, adapts to today's world and understands it. So the means used—books, music, photos— are less important because behind each object produced is an artwork, by which I mean a human being, a man, and mankind is always interested by another man.

The main thing I'm working toward is the space that unites everybody, the example of a highly organic organization of irrational space based on a new belief—a belief arising from the fact that the world is deeply conscious of what's going on. We say, either you love everything or you love nothing. This will be the first artwork in which the European viewer is faced with the absence of choice, by which I mean a place where the main source of human suffering no longer exists. Difference will be absent. It's so easy to accomplish, it's almost unimaginable. Many people have understood this, but

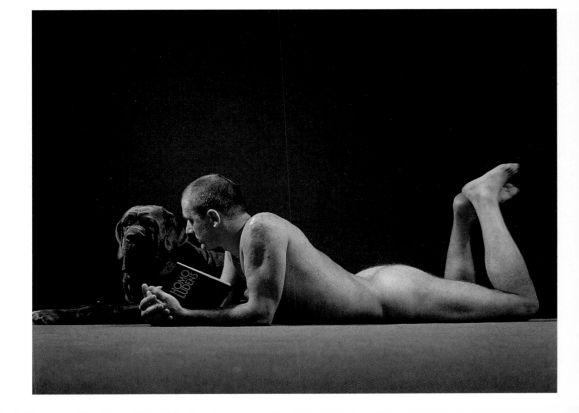

they haven't managed to apply it. This lightning bolt of understanding of the world makes life very serene, but people can't keep this state up very long.

Do you see art as a vehicle for peace?

OK: Art is directed by an ideology, by a vision of an ideal world. Not all artists make use of it, but this idealistic zone only exists in art. To take an idealistic stance, you have to think clearly and not believe that everything we see is true. The pragmatists dismiss this idealism, but the real pragmatist realizes that his life is directed by his mind; if we believe that life is directed by money and politics, we're blind. When people ask me if I know Putin, I reply, "Who's Putin?" Personally I know Jacqueline, I know Nastya, I know you, and I know me.

In this context, how has art evolved in recent years? What is its role and function today?

OK: Art today has become an addition to the supermarket. You go into a store, you buy the most beautiful diamond they've got, you put your name on it and you sell it for twice the price. If you can't double the price, you sell it at cost. That's how this pragmatic approach to art works.

As you see it, who has the key role in art today: the gallerist, the museum, the collector, or the auction room?

OK: I have seen lots of situations you maybe don't know about, like the crisis when the social and cultural institutions collapsed. That was a very difficult time in the U.S.S.R., with no galleries, no curators, and no auction rooms, and the reason was the political and economic crisis. When the pragmatic sense of art disappears, all that's left are the artists. But today all the institutions are there and important, and they help artists a lot; but for me the most important place is the gallery. The artist's activity is strictly artistic. Everything to do with promotion and connection between the artist and the outside world takes place via the gallery.

I am not trying to seem original. When I am happy with what I do, everything else seems magnificent to me. But when I am unhappy, everything seems ghastly.

Where does Russian contemporary art fit into globalization?

OK: Russia is the most ambitious country in the world. God was banished from Russia by Communist legislation, and this sent the Russians off into space to make sure God didn't exist. Russian art looks for the spiritual. Gagarin didn't see God, but God saw Gagarin. I don't believe in all these institutions like the FBI, the CIA, the Vatican . . . , because their sole aim is people-control. I'm talking about the opposite of that.

It was a blow to Russia to see everything collapse, to see this terrifying power come to an end overnight and the world change shape. But the artist, wherever he's from, lives things individually

and recreates them individually. Now we have a redistribution. I didn't denounce what was happening because I didn't understand it. That's why I became a dog, because a dog is a companion that doesn't make judgments—incidentally, the Japanese are making artificial animals now. As Napoleon said, paraphrasing Voltaire, "If religion did not exist, I would create it." There's a return to spirituality because if the material side is all we have we don't have any dignity.

We've formed a big team to try to create a contemporary liturgy that will get people talking about what they have in common rather than what separates them. This would be a great experiment: the creation of a religious liturgy for this globalized world.

JR: It's true that there's a global redistribution taking place, and it's affecting all the emerging societies. We're hoping for an art situation which, ideally, would be creativity-driven. In the old days art was backed by the church and the nobility; now it goes out initially through the galleries, which often have first pick, and then the public institutions, business collections and foundations and, very largely, private collections.

Is it feasible to create something new and unique in a globalized world where the boundaries of art are constantly changing, not only between countries but also within different genres? Is that a consequence of globalization?

OK: It *is* feasible to create something new and unique—and it's important, vital even. But just what is a globalized world? It's something nobody actually understands. Who knows what "globalized" means?

Imagine that we're all extremely complex products: the products of a very long life, of the entire existence of the human race. Today's version of this existence is a highly conflictual society in which the notion of the foreigner lives on: we have the French, the English, the Catholics, the Jews, the blacks, the whites, et cetera. We're used to all that: us and the others. We're permeated by that idea. Now, a globalized world would be one where the other didn't exist, where the notion of foreigner didn't exist. This notion would be the equivalent of setting boundaries to our bodies: an arm, a leg, the head, and so on. The human race is a madman who's trying to achieve awareness of his madness. I'm self-conflicted on this. Personally, I can see a way out and I realize that the solution is a very easy one.

How do you see the art of the future?

The art of the future—not only aesthetic, but ethical as well—will be a place where a harmonious state can be maintained. The art of the future won't be based on concepts: its goal will be to explain how you can achieve happiness and wisdom. The world needs to be run by an idealist, and not by some pragmatist asshole.

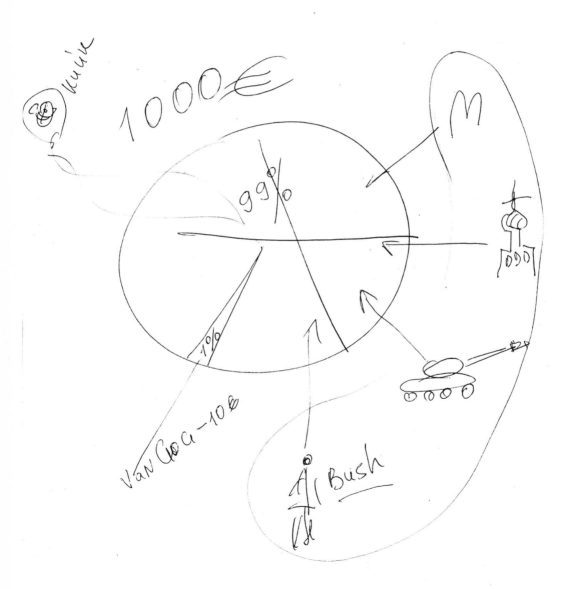

Imagine our planet with a global budget of €1,000, all to be used for spending on people. Ninety-nine percent goes to the army, war, security, Bush, the bureaucrats. Money doesn't get spent on creativity or artworks. One percent goes to sensitive, creative people. The money earned by the idealists is divided up among the other ninety-nine percent. Imagine if human beings tried to harmonize things among themselves. As in the sentence spoken two thousand years ago: "Love others as you love yourself."

VIK MUNIZ New York

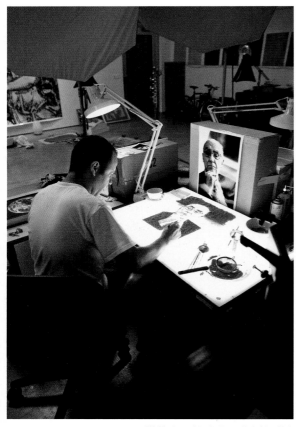

Vik Muniz working in his studio in New York

Born in 1961 in São Paulo, Brazil, Vik Muniz first started to work in advertising, which got him interested in the manipulation of images. He moved to the United States in 1984 and has been living in New York since 1986. He uses unconventional materials such as chocolate, dust, and diamonds to recreate images from mass culture or famous works of art. After having reconstructed these images in his own way, he takes photographs of the new intellectual interpretations of these replicas. Vik Muniz is married to the artist Janaina Tschäpe, and they live together with their daughter, Mina.

"I want to be remembered as someone who made a difference."

Does the geographical and cultural context play a role for you?

I was born in Brazil, but I have been living in New York for twenty years now, so one could say that I am an American. Not too long ago, Sotheby's held what they called a Latin American auction. Why do we have to separate "Latin American" from the rest? If we do so, then we have to qualify it. There was a big article that came out in the *Wall Street Journal* about Latin American art, and they said that this art never fetches the same prices as other art. They were basically saying that there was some kind of discrimination going on.

People have a tendency to buy from their own market, and they are very chauvinistic about the art production in their own countries. So European and American collectors will tend to buy things in Europe and America before thinking of buying in Latin America.

If you have a little bit more knowledge about cultures, you recognize that those cultures don't come to you in their raw form—they have to be packaged somehow. There is a very funny metaphor—in the eighties I used to go to this deli on the corner, and one day I saw guavas in it. I said, "Wow! Before, I had to go to Brazil to eat a guava," and now they were packaging this South American food and sending it to the United States. I looked at them, bought one and ate it. The same season that South American fruit began appearing at the supermarket, there were shows of Chinese, African, and Russian art in New York museums. One started to have a kind of "package show." I wrote a text about packaging culture that was called "The year the guavas came," and it was very clear in my head that right around the time I started seeing tropical fruit in the markets, we started getting very clear packages of culture. It was like importing culture.

Last year I was invited to curate a show for Tokyo Wonder Site in Japan with three Japanese artists and three Brazilian artists. TWS sent me a selection of artworks from a range of Japanese artists to look at. From Brazil I had picked two women and one man whose work I already knew. After my selection was finalized, the director called me and asked, "Why are you doing this show the way you are doing it?" I said, "What do you mean?" She asked, "Why did you pick only women from Japan?" I said that I didn't know they were women. I couldn't tell from the Japanese names. Did she think we were saying it was much more interesting to have a show that included a lot of women artists? One does a show with good art, and actually five of the six artists just happen to be women. They don't

have to be necessarily all Russians, Chinese, Latin Americans, women, or black artists. It could just have a lot of women or a lot of men. I find it strange that an artist would be shown just because he or she is Brazilian.

How important is your Latin American heritage to your work?

Mass culture is my background. In Brazil I was influenced by popular culture and commercial art and literature. I am an American artist, but I am a Brazilian person. Of course you can feel something Brazilian in my work, but it is very personal, very intimate. I am a son of the dictatorship. Growing up in the sixties or seventies in Brazil, you could not say what you wanted to say—you would get arrested. You always had to think about what you heard because there was a lot of coded information. In Brazil the situation was like in Spain coming out of the Franco years. My generation is very cynical about communication and information. We are very careful about things we see and listen to. We don't take anything for granted, and we also know that communication and any kind of information has a lot of elasticity of meaning.

What is the role and function of your art and has it changed during the last few years?

At the very beginning, they refused my work in Brazil. Now my work lends itself a lot to education, for example in public schools where they get kids to make drawings inspired by the relationship my work has to art history—I love that. In art textbooks for elementary schools, they teach children art through my work nationwide. I have an interest in education. I didn't go to art school, because I came from a very poor family in Brazil.

Now I have a school that I founded in Brazil called the Center Spatial Vik Muniz just for inner-city youth. I am actually working at Stanford with a few people in the field of teaching in order to develop a pilot program for visual literacy. The aim is to get people to look at images in the same context that we experience language; for example, with English or French we define a grammar and we figure it out. We don't do this with images as they are part of our environment. In my opinion it is going to be one of the challenges of the twenty-first century to survive in a society where the visual document does not exist anymore. Until the early nineties, you could trust something for what you were looking at. Nowadays, for something to be true or for it to be real, you have to rely on non-visual information. It has to be coded. You have magnetic strips inside bank notes and on credit cards. Everything has to carry information that you can't see, because everything you can see can be replicated. I think for us to be able to survive in a post-document society, we will have to rely on discernment, on being educated about images. Words are something we trust; we have always known what they mean. For example, we sign a contract and consider it to be true. Images, however, are too mysterious. We live in a world of images, and we don't really know what they are. We just consume them. I think that, through discernment and education, an ethical system can evolve. We must create a new ethic

about our relationship with this world in order to understand it. I would like to believe that my work is somehow geared toward this sort of education.

What do you think about art's explosive global development?

I think that this explosion has more to do with access than with practice, and it really goes both ways. The West—Europe and the United States, especially New York—became a lot more aware of international artists. But these artists always existed, and once these people were getting more exposure in Europe and the U.S. they went back to Brazil or wherever they came from with that credibility that inspires other people to do the same thing. For instance, today if you go to São Paulo to visit an art school, you would realize that they don't work the way you would have imagined. They read *Art Forum* from cover to cover—they are very well informed—and what they really want to do is to be international artists and not only Brazilian artists. Regarding the boom associated with the globalization of art, I think what really improved in the last fifteen years is communication. For example, local gallerists such as Marco Antonio Vilaça realized that they could not come to fairs and show only Brazilian artists; there had to be an exchange. Vilaça started bringing European and American artists to Brazil, which gave him leverage with really good international galleries and enabled him to show his own artists at the same time. Marco Antonio died in 2000. My work with him was actually very interesting, because I had absolutely nothing going on in Brazil. I had already built a career in the United States. When I met him in Paris the first time during a show with Claudine Papillon, he bought something from the show and I was happy that a Brazilian guy had bought something from me in Paris. At that time he was just a collector, and a few years later he opened his gallery. His work with me consisted in presenting a Brazilian artist to a Brazilian public, but it was tricky because I had a career, and there was a lot of discrimination from the Brazilian establishment. It was a lot of work for him to overcome all those academic obstacles.

Do you think that people read images in regard to their cultural background?

India, Mexico, and Japan are rich visual environments. Brazilians consume a lot of visual information but they are more geared toward sound and the spoken language. Visually we are always a little bit behind as we had to make a lot of compromises—that is a historical fact. Modernism in Brazil only happened in 1922, and the country is still very provincial. In the sixties people like Max Bill, a talented designer from Switzerland, came to Brazil and created a whole movement. Brazil was so thirsty! But what if instead of Max Bill, someone like de Kooning had come? It would have been completely different. You can tell how thirsty they were for someone like Max Bill because he influenced every single artist. That says a lot about globalization.

Is it still possible today for an artist to create something unique within globalization?

It is possible if you just forget what uniqueness or originality means. If one would just start producing work based on this notion, one is already following a trend. People ask me if I like contemporary art. I have limited interest in contemporary art because I am a contemporary artist. If you are driving, you look ahead and in the rearview mirror, but you don't look to the sides. I like Old Masters and the history of communication. I am a big consumer of information. I like to look ahead and see what the future will be.

Does information technology have an impact on your work?

A lot of what you see in terms of what is happening culturally has to do with the revolution of the Internet. Now I get emails from people in Bhutan or anywhere around the world, even from French Polynesia. I got an email the other day from someone in Papeete who was asking me questions about the size of my works. I get emails from all over the world. I try to answer as many as I can.

What do you think the future will be for art?

What I see is a crisis of relevance. Up until the twenty-first century, we have learned to place our personal as well as our collective histories in a certain format. The history of photography, especially black-and-white photography, enabled us to do so. The whole history of the twentieth century is in black and white. What is the importance of it being black and white? We think of the past in those basic colors because that is what we experienced through the media. We had that format, this vessel, in which we could put our information and organize it, but the media has changed and now we have tape recorders, but we cannot play them anywhere. At the same time we figured out a laser to read vinyl records that sounds just like an ordinary CD. So right now, we have not really made an investment in terms of education and discernment with regard to the image, because the photographic image gave us assurance that what we were seeing actually happened. For an entire century, we just became very lazy. We were trusting what we were seeing, until the point at which a new media came and made the photographic document irrelevant; now we don't know how to place our history—personal or collective—anymore.

Professional Photoshop is something that people are not talking about now, but in the future it is going to be paramount—we have crossed the threshold of visual discernment. We will not trust something visual anymore. Before we were conscious people, we were animals, and this is what our entire knowledge is based on. Our civilization is based on visual recognition. But now we look at things and we cannot trust our eyes to know if they are actually there or not. The history of representation is such that when people learn the concept of representation, they start seeing shapes that look like things—the way the cave people did in the south of France. They must have thought, "Oh, this looks like a bison or an elephant." Then they would look at cave drawings and think of a

Vik Muniz, Janaina Tschäpe, and their daughter, Mina

hunt, and they would relate to the drawings very specifically, until somebody who actually went on a hunt realized the scale didn't match. So the moment you become acquainted with a medium, you start using it in a rhetoric form. You find throughout the history of representation that there are moments when there is abuse—and then there is a rupture, once people realize they have been fooled. They will distrust the medium and will find another one. We are at a moment of pure cynicism. We don't have anything to trust anymore. We are at a very curious moment in the history of media because we are just taking things as they come. Colin Powell came a few years ago and showed these very blurry pictures of trucks and said they were manufacturing biological warfare; this was enough to invade a country, to kill people, and to bomb an entire nation. It was not true. The actual information—its codename was "Curveball"—was never mentioned. In 1840, one year after the invention of photography, a man named Hippolyte Bayard brought out a picture of himself drowned and dead. But he was not dead! He was one of the first photographic liars. It has always been possible to manipulate photographs.

What do you think the effects of the financial crisis will be?

In New York and London, people are really hurting because they are very close to the financial markets. These are the cities where most of the economy was based on banking and security markets. You see that the art business in both New York and London—a largely regulated market that is hugely profitable—was able to corner certain sections, speculate on them wildly, and then make a killing. Especially hedge fund managers: they realized that art represented a great commodity to put their money in, and they figured out ways of dealing in which they could make a huge profit. These people are not there anymore—they have vanished. We are going back to an art market that is the way it was in the recession of the early nineties. People are going to the FIAC here in Paris, and they are much more upbeat. We usually like to think of the French as more careful and always complaining about *courants d'air* (drafts). The first person to complain in a room is a French person: they love complaining, they love demonstrating, and they love to say what they think. Then you come to FIAC and the people are okay; they are much better off than the English. It is a fair that suffered enormously from the market shifting to London. People think FIAC is a good fair, but not amazing. The collectors and other buyers from this market were all here at Janaina's show. For example, a collector like Pearlstein, whom I've known for many years, has been buying works of art regularly since the last crisis. There will always be people like him; they are real collectors.

This influx of money—the speculation in the art market—makes the market swell in both directions. There is a lot of money and a lot of demand, so there is automatically more supply. With the crisis we will have fewer suppliers. Some people will survive and some won't. Whether this is bad or not is hard to say. There will definitely be less money around, but I have lived with less money before and I can do so now. I won't complain, because I was pretty happy when I had less money. What is one

going to do with it—buy a Ferrari? No! At one point I started doing charity work because I had money: I started working on the garbage project in Brazil, and I also worked with children. There are other ways to do things you like. One can be a good artist, but one of the essentials for being a good artist is that one has to be a good person. One can be a much better artist if one is a great person. That ability to inspire people in relation to what you do is somehow connected to who you are. Concerning my relationship with Janaina—as we are a couple, I can only say that it would be very hard for me to be married to a bad artist.

Who occupies the most important place in the art market today—the artists, the museums, the galleries, the auctioneers, or the collectors?

From the point of view of the artist, I think now we are basically working through the supporting structure of the gallery, the dealer, the auctioneer, and the collector, but it is just a means for us to get the work into a public place and to be open to a much wider audience. I don't know if that is true for all artists. For myself, when I am making art, I don't have a target public. I don't make art for curators, critics, gallerists, or collectors. I am very ambitious in terms of reach. I try to make a kind of art that is at once extremely sophisticated and also accessible. Those two things are hard to combine—accessibility and a certain level of intellectual sophistication, something which becomes a vessel for the public. I really think I make art for people who can look at what I am making; that is how I figure out my place in my own little universe. It is not that big, but it relies on physical experience. I rely on presence—to go and see something on the wall. This is a very small corner of the universe, but I make it for these people, and as a result, I get feedback just by looking at them. I am always learning more. I am sort of like a Pavlovian scientist, figuring out if what I am doing is making sense. It's a very ambitious project. If you are asking whom I make art for, I might reply that I make art for children, grandmothers, museum guards . . .

The second part—the gallerists and auctioneers—they are the loudspeakers, the means for me to get where I want to be, which is ultimately the public institutions—the museums. Museums are where you can actually access art directly, have access to media as a physical experience, but also as a ritual experience of images. We are bombarded by images all the time, but for us to wake up, take a shower, drive or take the subway, go to a museum, and walk toward an image is a very important decision. You are in control—it is your choice, and you are going to face it and think about it. This is the beginning of you polishing your relationship to the world of images. I wish this would become a habit, and that schools would more often teach us how to do it. Maybe through this ritual interaction, we could create more ways of evolving the discernment of images that we need to survive in a post-documental culture. This ethics of image consumption will exist and develop once we are more educated about images, in the same way that we are educated about the written word. That is why we mainly still connect education to books. I am a big book collector, and I like reading books

because just the physical experience of holding a book and turning the pages puts you immediately in a ritual position. We experience media in so many ways but we still lack the tools to understand it a little better.

Do you have the impression you depend on one of these players of the art world?
Going through the middle man helps you develop a reputation more easily. It also allows you to work in different ways. I have been doing this for twenty years now, and I can go to a museum like I am going to do right now—I am going to the Louvre and ask if I can photograph a very famous painting. I have done this at MoMA. Then I ask if I can work with the conservator and they will agree. So doors are always open to me.

Vik Muniz, you are a curator as well as an artist and art journalist. What is it like to combine these activities?
Normally you can work directly with institutions. It is very pleasant as an artist to be able to have a dialogue with individuals who are making it possible for people to come and see your work. But you can also present your ideas in different ways—for example, as curatorial projects. Recently I wrote a book and I am about to write a second one; I teach and do a lot of talks. I am a born teacher. I have a commitment to posterity because I want to be remembered as someone who made a difference. I am very serious about that. I also want to teach by example—that is the only way you can actually teach someone something. To be a leader in your field, you have to think that people are looking at you from all directions; it is very hard to be an amazing artist and a failure as a person. I think the whole thing is very holistic. I feel that the artists whom I admire—they may have their problems, they may not be perfect, but they were amazing human beings. Take Picasso, for instance. What a person! What a personality! He built this "brand" and became very important and very inspiring to other people. He was a very complex person. People talk to me about Duchamp, but I was never interested in Duchamp: I always thought Picasso was amazing. This is why I am married to the woman I am— she is more like Picasso. She makes stuff, she learns by doing, and I envy people like that. You know why I don't care about Duchamp? Because I am pretty much like him. I am just someone who has ideas and makes them.
The most important thing for an artist is to have a continuing public that will exist after the artist is gone. This is the most meaningful thing—to be somehow understood. We all want to be loved. All artists want to feel like they are misunderstood, because it gives them the excuse to create more stuff. But basically you want to be loved and understood. I get very lonely doing what I do. I sort of divide what I found to be a little niche—I have been digging in this hole for twenty years and I do something that nobody does. I am very unique. I don't care about originality—originals only start being relevant when people start making copies. I sort of put a stamp on my work and after fifty years

of doing this, when people see something advertised that looks like my work, they will say, "Oh, this looks like Vik Muniz."

NEO RAUCH Leipzig

Neo Rauch

Neo Rauch studied at the Hochschule für Grafik und Buchkunst in Leipzig, graduating from there in 1990. In 1997 he was awarded the annual art prize by the *Leipziger Volkszeitung* (a local city newspaper), and given a one-man show at the Museum der bildenden Künste in Leipzig. His exhibition *Rundgebiet* followed in 2000, and was shown at the Galerie für Zeitgenössische Kunst in Leipzig, the Haus der Kunst in Munich, and the Kunsthalle in Zurich. A series of works on paper was shown for the first time in a separate exhibition at the Albertina in Vienna in 2004. The exhibition *Neo Rauch: Neue Rollen* at the Kunstmuseum in Wolfsburg showed works from 1993 to 2006. The Metropolitan Museum of Art in New York dedicated an exhibition to Rauch's works from 2007 entitled *Neo Rauch: Para*, making him the first living foreign artist to receive such a distinction. The exhibition was also shown at the Rudolphinum in Prague and the Max Ernst Museum in Brühl.

"I like to think I'm very receptive to the color-fulness of the world; but I'm repelled by the crass garishness that a false notion of globalization has brought to the field of art."

What is the role of art today in relation to what it was in the past? Do you think its function has changed?

I see no change in the function of what is commonly referred to as art. To me, art is an anthropological phenomenon: what *has* changed are the mechanisms of perfection, the theoretical perspectives, and the nature of the discourse that surrounds this phenomenon. Art itself is a scarce resource. My own view is that it involves people focusing on the conditions of their life and the experiences that have come out of it—people, that is, who have a particular aptitude for doing so. That might be a rather romantic idea, but it's something I profoundly and firmly believe. And it is of course a point of view that seems totally out of fashion these days. I think art involves a way of being where you are constantly ready to encounter new things, and which proceeds with the simplicity and spontaneity of a natural process. You don't need any theoretical grounding for it, just an attitude of genuine openness to the subtly charged fields one encounters in life and the world. Anyone possessing these basic necessary qualities might have some chance of being considered an artist. It is the interconnectedness of the world, its networks and its lines of conflict, that matter today: the issues of whose right to exist is disputed by whom. It's always been this way, and all that's new is the nature of the approaches to it, which are totally concept-oriented and cerebral and claim to be the only ones relevant to the field of art.

Since the cave paintings of Lascaux, there have always been remarkable people, generally quite peripheral figures, whose peculiar influence is often only recognized after they die. These are people advocating things like shamanism or necromancy, things which involve channeling energies and confronting desires and all the stuff that rational thinking can barely comprehend.

Is art important to us as a source of spiritual nourishment?

It's becoming increasingly important to bring subjects of spiritual significance into our lives by appealing to the senses. Artworks function by overwhelming people through their physical presence, which enables them to offer spiritual nourishment by the back door, as it were. They are first and foremost phenomena that confuse, assault, and flatter the senses. It's not the kind of thing you can teach in a university seminar, which can only be understood if you've taken the relevant courses and

read the relevant books. Rather, it's something that must address the senses and have the ability to draw the viewer in.

You grew up under the constraints of the East German regime. How have you dealt with that as an artist?

Growing up in that environment has inevitably left its marks, at least on my childhood self. We've all of us been deformed to some extent or other, whatever the regime we may have grown up under, and I don't think I see that ceasing to be the case any time soon. My own method of circumventing myself through drawing or painting inevitably also led me to build something of a cocoon around myself. This provided me with a degree of padding against the worst intrusions and outrages of that society, and to this extent I probably managed to survive those circumstances without getting too badly damaged. The process of introspection that painting and drawing require amounts in effect to an inner emigration; it's a response a lot of people made, a kind of automatic reflex. What I'm doing today isn't really all that different from what I was doing when I was a child. It's an attempt to create my own places of refuge and companions for those places, to magic up something out of nothing. That childish playing can still be found in the work of the adult painter.

You had a traditional training as a painter. Do you think that's something artists still need today?

Painters certainly still need it; whether other kinds of artists do I can't say. Decades of upheaval in the West German art schools have caused extensive damage, with people thinking everything needed to be changed. Things are different these days, but back then people thought you didn't need to teach painting anymore, and that in any case technical skill was the sign of a reactionary mentality. You can teach basic knowledge and painting skills to someone who's moderately talented, but not to someone who has no talent at all. You also need to have a highly specialized and motivated staff that is capable of handing on these skills. But it's difficult keeping these kinds of people at art schools, which are on the one hand burdened with bureaucracy and on the other having ever greater numbers of students forced upon them by the ministries.

How are younger art students dealing with the new media?

I keep coming across younger colleagues who are deliberately cutting themselves off from the constant information stream, and who just won't put up with being pelted with so many distractions anymore. You can only really hold back this global flood of information from the Internet and other outlets when focusing on developing your own position. I can perfectly understand why people say to themselves: I just want to crawl back into my shell. In the nineties we painters were able to do just that; we could tinker about with our canvases because painting seemed to disappear completely during that decade, with the art-going public turning to video installations. What I don't like is the attempt by certain art theorists to demonize or ridicule a certain discipline on ideological grounds, and this

Neo Rauch: Der Zeitraum, exhibition view at Galerie Eigen + Art, Leipzig, 2006

tends to be directed against painting. Personally, I believe in peaceful coexistence, in the productive exchange that comes from all these media existing alongside each other. Occasionally art and the media get entangled with each other, and then need to disentangle themselves from one other so they can exist again on their own terms.

How did we return to this sudden boom in painting?
An entire medium had just been suddenly abandoned by the international art world, and the laws of physics meant that a counter-reaction was pretty much inevitable. It was like holding a ball under water for a long time and then releasing it when your arms get tired—suddenly it hits you in the face. There's nothing necessarily pleasant about that, and it was also predictable that this ball would have taken some pretty ugly hues. A lot of slime and mud got stirred up, slicks of oil flew through the air, and suddenly painting was everywhere. Even I found myself looking away with a certain shudder.

How did you arrive at your global success?
In the nineties the art world's attention had largely turned away from painting, and this offered it a certain critical respite from scrutiny. I used this opportunity to push forward my own work. This reached a point where I felt I had discovered myself, and that I was not the only one. After wandering through a succession of valleys, I suddenly came out upon a range of hills, from where I was able to look myself in the eye for the first time. It was the first time I was able to circumvent myself. Judy Lybke, whose gallery took me on in 1993 and who would later become a close friend, felt this as well. I had my first exhibition in Leipzig, which went totally unnoticed. He simply took the risk of exhibiting works by a series of painters. Back then there were very few exhibitions of paintings, and for me it was a very important show, not only because I'd had exposure in a gallery but also because I'd taken the first steps toward consolidating my work. Looking back at it today, I still think the exhibition was very solid and strong, although at the time no one else seemed to notice this. There was never any sudden success for me; it's really artists ten to twelve years younger who had the chance to become overnight sensations. It was a long, hard route, and in Judy Lybke I found someone who was inspired and ambitious and willing to accompany me along it, and who did a great deal to oil the starting rails. Our relationship is incredibly close, because if I had met the wrong person rather than him, then I'd probably just be happy enough today keeping my head more or less above water with a teaching job. To some extent it followed logically out of things, but it was also a stroke of luck, and one I cannot be grateful enough for. My relationship with David Zwirner is also very good—we all like being part of this trio, which on balance we all benefit from.

How dependent are you on the global market?
That's difficult to say, because my studio door is guarded by my "Cerberus" in the form of Judy Lybke. He plays this role with great fervor, keeping away people who really only want to steal my time and

energy. It means that a lot of very distasteful stuff that has to do with marketing is kept hidden from me. I am spared the haggling, some of it with collectors and museums, that he has to endure as part of his job. And as I result, I don't feel under any pressure. The story about me having a whole list of pictures that have been sold before they've even been painted should really be laid to rest.

Can art make a contribution to social or political issues?
As a born East German, that's the kind of question that makes me wince and takes me straight back to the kind of self-image that artists had forced on them—"art needs to be a weapon in the struggles of the age," that kind of thing. Those are the phrases that immediately come back to mind. Art is something spontaneous that makes itself felt, and in this respect it is not unlike a natural phenomenon. If you also manage to refer to a predicament that has been recurring over millennia, to show the "phenomenon in its entirety" as it continually manifests itself throughout human existence, both for good and ill, then you have something that you can export, both literally and metaphorically. It is something that all great works of art have in common. And in that case something has suddenly become enflamed in the affected area, rather like a recurring case of gangrene whose existence is revealed by the specialist covering it with gauze. So sometimes it can have some kind of an effect, but only on the minds of a few people—though perhaps on the hearts of many more.

You were one of the three German artists commissioned around the same time to design windows for churches. You have produced designs for some windows in Naumburg Cathedral. How did this come about? Was there any particular brief on how the subject was to be treated?
Yes, it's a funny combination—Gerhard Richter, Markus Lüpertz, and me—but I'll let the theoreticians work out for themselves how this process developed in each case.
They asked me, and I immediately felt it was something I had to do. I liked the idea of being able to make a small contribution somewhere so nearby, a place richly sedimented with centuries of fertile cultural soil—and of working in a sacred space that offers people a place to pause and reflect. There are three small windows, each one hundred and twenty by forty centimeters, for which they had asked for scenes from the life of Saint Elizabeth. What they specifically didn't want were the usual sort of abstract works that have set the tone in places of worship over the last few decades; they wanted a figurative approach. It's a lot riskier tackling a religious subject this way; there are a lot of dangers lurking, and an awareness of all those countless requirements makes it very clear to you that you're not a free actor. When it comes to deciding on certain motifs, you *are* constrained and also a bit scared, but at the same time that's a fascinating position for an artist to be in. You know that something could go wrong, that there's a risk involved, and that is an intriguing position for an artist. As far as I'm concerned, I haven't finished with windows yet; rather, this has been a prelude—a way into the glass through the glass.

How important is it for you to make art that might last forever?

I wouldn't aim directly at making anything that might last forever. But the thought that what I make won't just disappear but will still be around in a generation or two's time is something that matters to me. Using traditional materials is relevant to this, since you can reasonably rely on them to last that long. I also try to bring a certain amount of traction and robustness to my work. This is most clear in certain formal inventions. I find I'm constantly trying to eliminate clichés from my work that would tie my pictures to a particular fashion or moment in time, and which would make them seem important tomorrow but not the week after. I am very preoccupied with the idea of timelessness—what is it about an artwork that makes it able to endure? I find I'm constantly dogged by the feeling that I might be heading in the wrong direction. But this kind of self-doubt is part of the job, one of those negative oscillating swings that artists have to face in their relationship with themselves.

Whenever I'm in front of a newly stretched canvas I get the feeling that "now I'm going to do every-thing completely differently, I'm going to rule out all possibilities of going wrong in advance." That never happens of course, but the need to make something of great relevance to the world is the engine that keeps the whole thing running.

KIKI SMITH New York

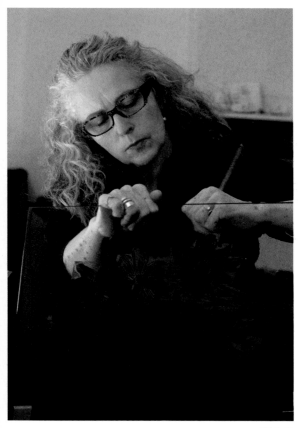

Kiki Smith

Kiki Smith was born in Nuremberg, Germany, one of three children to sculptor Tony Smith. Growing up in South Orange, New Jersey, she helped her father to build paper models for his sculptures. From 1974 until 1976, she studied at the Hartford Art School in Connecticut. In 1985, she trained as an emergency medical technician at the Bedford Stuyvesant Brooklyn Interfaith Hospital to obtain more insight into the human body for her work. Kiki Smith participated in the Aperto of the Venice Biennale in 1993. She has had important solo exhibitions in various museums internationally, including the Museum of Modern Art in New York in 2003 and the Krefeld Museum, Germany, in 2008. In 2005, she became a member of the American Academy of Arts and Letters. She is an adjunct professor a Columbia University and New York University. She works mainly in sculpture and printmaking and describes herself as a "thing-maker."

"Art has a very significant role. It is artists that have contributed, kept cities afloat, and have saved whole sections of cities."

What is the role and function of art today? Has this changed recently?

I suppose I do not think in terms of how art is functioning socially. Bruce Nauman said that the role of the artist is to reveal mystical truths, I don't know whether intended ironically or not. I feel closer to that creative expression. Art has all forms, and in all cultures it manifests itself differently. Art is a way that particular people synthesize or coalesce their experience into some sort of visual, material form. Artists are making a creative investigation in all different versions of being here. Why people feel compelled to make a bundle of energetic impulses does not seem to change so much; what it looks like, or how it socially or culturally functions—that changes. Although different generations have different expectations, the curiosity or desire to investigate is pretty much similar across all generations.

Certain cultures have very different relationships to visual stimulation or visual representation, and many are suspect of the image as an extension of idolatory worship. Each place has its own cultural, historical condition that informs what people do. Some cultures are writing essentially, others are using language as music. There are cultures where the signification of objects is paramount, whereas in another culture you could say the signification of the word is paramount, but does not necessarily have economics attached. If you look at the pop music industry parallel to the art industry, one can see how radically the industry is reconfiguring itself. All of this informs people's desire. I would say people are interested in their own economics and in general economics. I think people used to have a romantic idea of artists being pure, naïve, and childlike—which is a ridiculous notion.

You come from an artist's family. How did this influence you and how did you get your start as an artist?

I grew up with my father's practice as an artist, and I saw that his devotion to his practice had many different aspects. I think that at a certain point I found that I was most satisfied by making "things." My sister Seton already wanted to be an artist as a teenager and having my father, my father's assistants, and her as a model and growing up in an artists' community with my father's students, well-known and not well-known artists—all were a tremendous influence on me.

What is your impetus for making art? Does the relationship between art and money also have an influence on your personal work?

For me, the interest in making art is a combination of the action of actually doing it with the necessity of having your work seen. You can give it to your parents, your best friends, or to a local place like a church, airport, or mausoleum. There is a necessity to be mediated through the art object. How artists get their work out changes. The phenomenon of art galleries is for the most part a very recent situation. Speculation does not have a lot to do with art production; it still appeals to people like a "thing" and has a "thing" value to it, like gold. There are other esoteric values of art that are pursued by some collectors—you can see that some people are completely consumed by art. Some have been buying art since they were sixteen years old, and art is a part of how they construct their identity and how they learn. I think particular people have a desire to make things and also to learn visually from these "things."

When I look, for example, at postwar decorations and folkloric low-relief sculpture on buildings, it is completely fascinating. I can consume hours of my day thinking about what these things mean— decoration on buildings and pictorial information on façades—and how it was all part of constructing a new identity. I can look at paintings from the Middle Ages and think about how the representations are attached to belief systems, and then think about what it meant in the Middle Ages for people to look at these same paintings. It is similar when you see something from a different culture but you do not understand or have access to the psychology of the other culture: you can have the experience of looking at an object from several thousand years ago and maybe not understand its cultural function but still have a very "visceral experience" of it.

I think that it is cynical to always look through the focus of the economic situation of the art market, which loses the depth of what artists are doing culturally. More important is how they are changing consciousness, and also how artists are, in a way, at the center of economics. The city of New York is a good example for this: in the seventies, it was a city losing tremendous revenue in the manufacturing business. Now, the fact that artists desire these warehouse spaces for working and living completely changed the economic reality of New York. Art has a very significant role. It is artists that have contributed, kept cities afloat, and have saved whole sections of cities.

How important is a classical education as an artist for you personally?

"Classical" in Europe means something completely different than it does in the United States. We do not have a mentoring system in the U.S.—you take academic courses. It is to empower you with some basic parameter of skills. At the same time, there are many theory classes. I went to art school for a time and I am a bit self-taught also, but as an adult you are responsible for figuring out what you need to know. As you get older, you become more interested in history of art and thinking about your work in relationship to history.

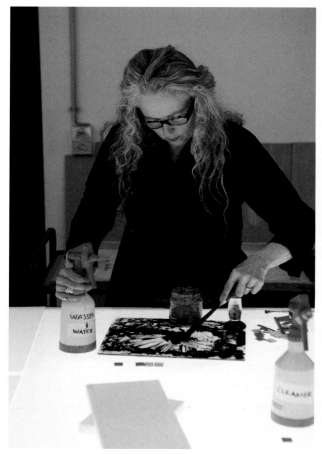

Kiki Smith working at the Mayer'sche Hofkunstanstalt, Munich, 2008

How do the younger artists you are teaching perceive this classical education in art?

I am teaching printmaking, which is in a way an unpopular activity, not like painting or other media where people have fantasies of high return. Printmaking is really something that either fascinates you or doesn't. Obviously, it is affected by the art market and also by its own market and its own economics. There are many different art worlds, there are local ones, international ones, and global ones. There are different versions of the art world, and maybe one exists simultaneously in a couple of them, but maybe not. People can be artists and have completely fulfilling lives and just exist in all different versions, at all different levels of it. An artist's global success has to do with very strange factors: what captures cultural imaginations at a given moment, or what is popular or considered to be an economically viable investment. Often people are making great art and it is not apparent at that moment. Then twenty years later people suddenly get it. Maybe there is no paradigm—maybe there is no way of understanding the complexity, or the simplicity, of things or the genius of things at a given moment. Sometimes that happens later, or it doesn't happen at all. People hold simplistic beliefs about what "good art" is: such as that only art that is culturally known or sustainable is good. This is just not the case: art moves around. This is one good thing about knowing a little history. I always tell

my students they should learn something they can make a living at. It does not necessarily mean that if they do not make a living by being an artist they are bad artists. Art is not about what you do on a given day: it is about a practice, something that happens over long periods of time.

How independent are artists from the art market today? There are many more biennials and triennials and many artists are under pressure.

I think artists have historically been under pressure, and today it is just a different kind of pressure. In the past it was maybe more artistic or intellectual pressure. If you read Dürer or another of his contemporaries, they were traveling all over the world and they were getting in trouble insulting the people who were sponsoring them—they were kowtowing to people and they were kicked out of countries. Today there are more participants, whereas before it was a very small crowd. I do not think that artists' lives have been so immune. If you read of Rembrandt's life, you find it apparent historically that they were dealing with the economic situations of their environments, sometimes successfully and sometimes tragically for their production.

Biennials give more artists opportunities, because obviously only a certain number of artists can make things for ten different places at once. I think it is great that artists are supported in these venues. Sometimes in large show situations, artists can be in competition with themselves, with their own work. There can be a spectacle aspect that tends to make people's work sometimes either subjugated to curatorial intent—trying to fit artwork to an ideology or agenda of a curator—or to make the work more ambitious than is appropriate to the practice. For me the best way to work is to do things that are coming out of my own impetus—I sit at home or I go to the museum and I get an idea and I just do it. For other people, the best way is to be given an opportunity. All artists react in a different way, and there is a lot of space in the art world in this regard.

I really do not think the artists are cynical when you see they are devoting twenty, thirty, forty, or sixty years of their lives to their own imagination. I think it is like being in freefall—you have no idea where it is going, you have no control over it, and you are still willing to do it full-time.

Could Damien Hirst's solo auction at Sotheby's in September 2008 become a trend for artists in the future?

I think he is playing with the means of distribution and questioning historically recent situations of distribution. It might be a way that artists preserve in the future or it might not. The way he made a decision for his own work is radically different from what other artists have done in the past, but the way to sustain yourself as an artist is always changing.

It will be interesting to see what he will do with this money, maybe he will do something different with it, something another artist or person would not do. Bill Gates made changes in the world with his money. If you gave some artists millions of dollars, they might take better care of themselves, but it would not necessarily change their work. Maybe they could buy better canvas, but their work does

not soley come from economic power. Money impacts you and the way you live, but it does not enable you to make good work. It might take financial pressure off, but it also adds some other financial pressures that you did not need to think about before. All of this in terms of the future of artists is irrelevant. You cannot buy yourself into a good brain or into talent. You are who you are. But money sometimes allows artists to play out or expand their vision.

Are there still differences today between women artists and men artists?
I feel that I have had a very lucky time as a woman artist. The generation before me—Pat Steir, Rebecca Horn, Nancy Spero, or Katharina Sieverding, for example—insisted upon making their work. They had to pay much more than I do to make my work. It is their ferocity and love of their art that enabled my generation to be able to work. Still, in the twenty-first century, there are many fewer women artists than men artists, which has to do obviously with historical and cultural misunderstandings of the universe. It is as if women's art has some female content that cannot be related to. I think this will change. It has changed in the United States because people fought to change it and because of cultural-economic necessities that changed people's situations socially and that changed consciousnesses. I think the next generation will feel a larger sense of entitlement and have the possibility to be working artists. The culture suffers for only subsidizing one gender's view. This is a very complicated and substantial problem—it is a psychological, social, spiritual malady that permeates all of our cultures.

Often what moves history is fear and uncertainty with the marketplace. Maybe globalization will have some positive effects on the art world, as more people become included: more artists, more collectors, more gallery owners, and more museum curators, more viewers. But who knows, the things that effect change are unknown.

JANAINA TSCHÄPE New York

Janaina Tschäpe working during her
residency at MOCA, Tucson, 2008

Born in 1973 in Munich, Germany, Janaina Tschäpe grew up in Germany
and in Brazil. She explores themes around landscape, sex, death, renewal,
and transformation in paintings, drawings, photographs, and video instal-
lations. The female body is often a starting point in her work, which focuses
primarily on issues of identity and the self. Janaina Tschäpe lives together
with the artist Vik Muniz and their daughter, Mina, in New York. Both
Tschäpe and Muniz place a great emphasis on their artistic independence
from each other.

"Art has been and will always be a form of survival and fundamental living for generations."

Does geographical and cultural context play an important role in your artmaking? If so, how do you think your country of origin has influenced your work?

I currently live and work in New York and was attracted to this location for its multiplicity and diversity, which allowed for open interpretations and mentalities for me to work with and respond to. I don't believe there is a difference or a movement for artists working in Latin America. A newfound exposure does not mean there is a new movement or artists are more active than in the past. There is just less focus on American and European art and a more global visualization of art in general. Brazil was under two decades of military dictatorship, which limited internal and external artistic experiments. I grew up in this environment but studied in Germany and have now been in New York for the last decade. I do not consider myself a German or a Brazilian artist; I would hesitate to label my work and process to a specific country. I am influenced equally by all the countries I visit, live, and work in and am not part of any specific geographical movement.

Do you think geographical boundaries will become inconsequential as a result of a unified and global movement seen in contemporary art today?

Art has always fallen under multiple classifications whether divided by geographical location, cultural difference, personal history, or sex. It used to be that a female artist had to insert her location to receive validity. Being branded as a female Latin American artist might have brought more opportunities than being deemed just a female artist. These divisions might be less clearly defined and intermingling with each other but the separation still holds. In terms of geographical boundaries, the location of an artist or an exhibition will always maintain significance despite impermanence and multiplicity in traveling—from the artist who lives and works in different countries throughout her career to the temporary exhibition shown in many countries.

What is the role and function of art and how has it changed during the last few years?

Art serves both individuals and groups (family, community, society, and the world) as a means to visual survival and understanding. Through art we can understand ourselves and our surrounding environment as it provides both an alternate and reflective reality. Art has recently joined the industry force in its globalized production and distribution and has become as much of a commercial endeavor as any marketable product. Art has been gradually injected into everyday pop culture, and

the emphasis is no longer focused on art being an autonomous entity outside of reality's rules and conundrums. To my mind, knowledge of art history and academic education is important and influential but not a necessity to create.

Is it still possible today for an artist to create something unique within globalization?
Yes, it is certainly possible to create something unique and new, whether for a globalized world or for a privatized world. Art has been and will always be a form of survival and fundamental living for generations.

Artists are under immense pressure to produce work. How independent are artists from the art market today?
Artists and the art market are interdependent upon each other. Although there would be no market without the artist, there would also be no self-supporting financially stable artist without a market. There are always new opportunities to produce work, pressure or no pressure. This is purely subjective, as some people work great under pressure, others do not. As long as focus is not lost on the act of creating rather than selling and showing, then there is plenty of room to develop something new.

What are the advantages and disadvantages arising from the new "model" of a collector (such as investors, art funds, and so on)?
Hedge fund investors as collectors have been a pretty new phenomenon, and they left just as swiftly as they came as a result of the economic crisis. As long as they are art appreciators and can respect and appreciate a work of art without consulting its projected price a year from point of sale, then they offer no disadvantage. Unfortunately, though, many of these new model collectors take price and investment before content, form, and beauty.

Who occupies the most important place in the art market today—artists, museums, galleries, auctioneers, or collectors?
The artist plays a key role, as without an artwork produced by the artist, there would be no gallery, fair, collector, or museum. The object must exist first in order for a system to be built. But, in order for a cultural and economic foundation to be built there has to be an interchangeable influence between these institutions, a collaboration must occur between artist, gallery, museum, and collector in order to produce, display, and historicize art.

How do you feel about the cult of the "art star"? How do you consider the relation between art and money today? Does this relationship also have an influence on your personal work?
Younger aspiring artists these days are more concerned with becoming the next "startist" who creates a distraction and diversion away from the context and process of art-making. As long as focus

can be reverted back to the studio and the self, there is no harm in thinking about one's art and money. This relationship does not influence my work; if I were concerned with my public reputation and becoming a star, I would have practiced playing guitar for a rock 'n' roll band.

AI WEIWEI Beijing

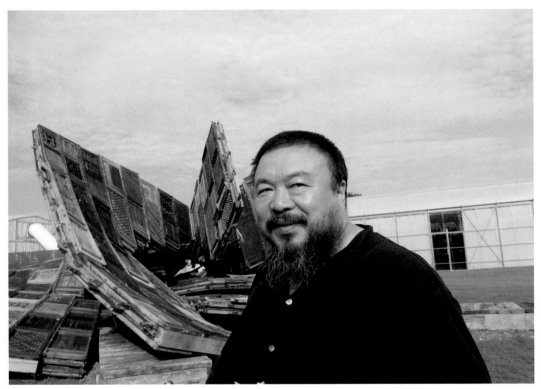

Ai Weiwei in front of *Template* after it was destroyed by a storm, Documenta 12, Kassel, 2007

Ai Weiwei, born in 1957, is one of China's most renowned contemporary artists, not only due to his participation at the Documenta 12 in 2007 with *Fairytale,* a spectacular art project involving one thousand and one Chinese citizens who were brought to Germany to visit Kassel during the exhibition. For twenty-five years he has constantly been the leading innovative figure in China's art world. He was the founder of the first non-commercial exhibition space for conceptual art, China Art Archives & Warehouse. With his own artistic production as well as through his curatorial, editorial, and design projects, he has helped to direct the course of Chinese art. Since 2000, he has worked extensively on architectural and urban development programs, including a close collaboration with the architects Herzog & de Meuron designing the Beijing National Stadium for the Olympic Games in 2008.

"The differences and changes are the main theme of this time."

What do you think about the position of Chinese contemporary art in the international art world?

I think the Chinese phenomenon is a very interesting one. China happened to be a big economic phenomenon in the past twenty years with dramatic growth. Politically also, it's incredible what's happened. And we participate in the huge process of globalization, the information age with the Internet being a new way of communicating. At the same time, after the Cold War period, we face a complete reestablishment. Some people call it "a new order." It is a moment of really broad and general analysis of these new conditions of the world. China—without the old kinds of conflicts like ideology—is rather expecting this big space in the cultural field and also expecting something to come out of it. China is an old nation, but newly introduced to the world again.

China introduced itself at a dramatic pace to the world again—can artists cope with this speed?

Yes, the pace is fast, very fast, but the Chinese can deal with this. It is like an explosion once you give it way. People have been waiting for so long, especially since we had this extreme situation with communism for the past half century. All the information was very limited and resources were also limited—much like North Korea today. Now it's open and flowing, there is quite a lot of freedom of the market. The Chinese culture itself is quite amazing. Whenever there is a change, Chinese people have the strong tendency to heal and to readjust themselves at once. Maybe it is because we are such a big population in this world so we have to make changes at a fast pace at the very beginning of the market. But the openness and acceptance toward the production market and the consumer market is in a way shocking to me, as problems with the rising consumption and energy demand are inevitable. In the end it might even lead to political instability.

What effects does globalization have on the artists in China? Will they be able to really define a special, authentic Chinese art?

I think they're working on both sides. The Chinese artist is working in his tradition. China's performance in the arts has been—over the centuries—the strongest of any country in the world. They have a unique history of art and collections, so it's not a new deal for them. To be involved with art is normal, is natural here. People still think art is the highest form of expression that can be created by humans. Very much unlike in the West when parents think their children have failed because they want to become artists! In China the parents always praise the children and are proud if their

children can study art. So it's a very different history. On the other side, I think globalization for an artist is about exploring new borders, finding new possibilities in every field, and that is an inevitable chance to develop.

It's fantastic for people who welcome and are excited about the new conditions and about change. And people just want change because they are living in a completely different world now. I think differences and changes are the main theme of this time. Of course, there are more conservative views to protect, to think of what is lost in this change. With any change you have to lose something. But I think as humans, humanity—change is always there, through war or religion. We have a lot of ups and downs, lefts and rights, but it doesn't matter—there's always the beauty of this process.

When you call a culture a culture, it has to have at least two characteristics so that each culture will be different from the others, which means you can introduce and communicate between them. So communication and the need to reestablish and to re-challenge positions is a characteristic of so-called originality. Otherwise, it's just fake. So I think this is an exciting time for technology and for understanding the needs of our time, for us to have a chance to really challenge these needs, to re-shuffle, to see the possibilities of another game.

I personally feel quite happy and excited about it. It is also important for my work. I don't want to create art for eternity. I hope my art will be forgotten soon, because I hope in the future people will have something more interesting to charm them. You know, artists should adjust their position, not just stay in some kind of old situation. Times have changed and the conception of time has also changed. We are not living longer, but our minds change faster.

Your work is often satirical-political. Is it necessary for an artist to make a clear political and ethical statement in his work?

My answer is a very definite yes. If art is a creature that is always seeking expression through the cultural conditions of the times, it should reflect something about those times—it can be politics, it can be war, it also can be comedy or something else. So I don't think there's a limitation there, and we are living in very political times with many different interests and different shifts. We never envisioned times like these, so we have to have clear judgment, to be alert—that's always the best quality of art, that's what art should be about. That is why I want to seduce or to disturb, to irritate: to see that the effects can be interesting. But at the same time I always have to step away from this so that I am not victimized by it. It's very dangerous. You have to make sure you're producing a product, but not a final product, because you have to continuously have the strength for the possibility of change.

Do the Chinese people understand your art?

I have very little exposure in China. I never really had a show there, and I think it's difficult. I think it's not that my art has any mysterious qualities, but we are still living in a totalitarian society with no

open discussions and very limited possibilities for self-expression. So everything that comes out is a little bit twisted and crazy.

Why is Chinese art especially successful in the Western art market and what are the dangers associated with this?

First of all, it is a Western concept to even talk about the contemporary art market in the world. Nonetheless, historically, Eastern and Western philosophy are different. The Western world creates an illusion of this big new territory and generates a lot of curiosity—people are eager to see what is in there. So, as there are expectations, the artists try to meet them.

But although here in China there is a lot of creativity and people are really hungry and they just want to give something away, there is a danger, because there are a lot of artists who are losing their strength—the speed and the skills needed to make profound art have changed. Instead it's easy for them to just create illusions for the people who think the world is like that or the world is not like that. In this case, Western culture has built a much more profound establishment over the past few hundred years, so their artists can search outside of this continuity and announce new possibilities.

Is classical art education of any importance to you as an artist?

I think it's a treasure. It's a treasure when you're moving a house to know who built it and why it's like this. I call it evidence of cultural crime. It's important to realize where we come from. To me, it's so important not just to talk about tradition but to relate yourself to it, to really put your mind in context with the physical world outside of you. It's not so easy. It takes time, patience, understanding, and tradition—it's like a wine.

What do you think about evolving art markets like the United Arab Emirates, which have no cultural history?

I think the new no-real-culture phenomenon *is* a cultural phenomenon, and it has developed because art and culture are always getting us to revisit and adjust our positions. Among humans, if a position exists and can be identified or named, then that is something we call interesting. But who knows what's going to come out of it?

In my opinion, the phenomenon of the Emirates is due to curiosity about what this desert with this oil money can produce. But somehow, curiosity has always been a factor in art history—like the art from the United States at the very beginning. The United States was originally a land of no tradition and no history, but then the first generation like Jackson Pollock developed this lack of tradition into a new kind of expression. And now we accept it because we think it reflects a new condition.

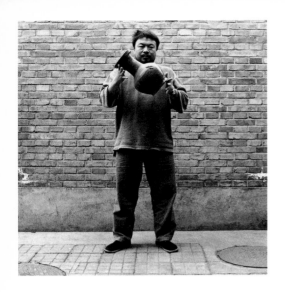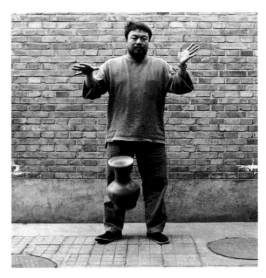

After your time in the United States you went back to China. How important for your work is the
geographical and cultural environment?

At the very beginning, my reason to go back was to see my father. "Father" in this case is not just
a physical being; it is important to relate yourself to a certain position that has a significance for
you—you have to recognize your own position and conditions, the relation to your reality and who
you are, where you come from. I think this is important because it's all about position, volume, and
proportions, and if we talk about culture or the so-called past and future, we need some kind of bal-
ance to see how other people act and what the traps are that we always fall into and what are the
conditions we are locked into.

You are working with big installations, and artworks of our time in general are getting bigger and
more spectacular. Does art need this these days?

Well, it's in order to be noticed. It's a challenge of our knowledge, which has become much, much
more developed in the last half-century.

Of course, one reason is that we have many more technical possibilities now, but size is also very
much a matter of how humans relate to the universe. That has exploded, maybe up to a hundred
times. Compared to that, I consider the artworks that artists produce now to be far behind. The kind
of ambition, the kind of light and strength—you can see it's a very crippled situation. So this phenom-
enon is a mirror of our understanding of ourselves. It's not really even just one artist's ambition or
some kind of vanity or some kind of vague ideas; it just reflects today's condition.

What influence does the Internet have on art?

To me the Internet and computer technology are the best gifts of the gods. Because to talk about
something outside art like human nature is the first best gift. With the Internet we create something
that can contemplate with us. And we already now realize that it is teaching us humans to learn from

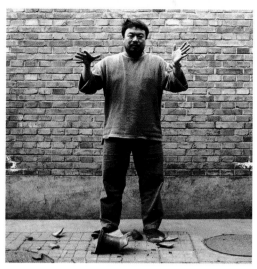

Ai Weiwei, *Dropping a Han Dynasty Urn*, 1995

our own illusions. No other species would do that. It is so interesting! And people eagerly go through that virtual world phenomenon and depend on it in their real lives. That is very sad but very poetic at the same time—it shows our nature.

A lot of Chinese artists sell directly to their clients or to collectors. How important is the gallery for Chinese artists in China?

Right now in China the gallery is not important for an artist. You see it's much more wild, you see the auction houses playing a role, you see the art fairs and the biennials everywhere—it's a big mess. There is no establishment, not only concerning galleries but in the society. There is no aesthetic, no moral establishment, no good critics, no good collectors, no museums. It is destroyed. But I think it will be starting; in fact it *is* starting and eventually we will have all this. At the moment the artists here enjoy the freedom of the messiness. And in the end what does it matter? All depends on the ability of the artist. The gallery is just an agent, a management.

Superman doesn't need another man's help, and also it can be that artists help each other. And the exisiting gallerists? Some are very steady, some play the wild fashion. It's like in the casinos. Some will fail, but the house is always winning.

What do you think about the relationship between art and money today?

There has been this big hype about art. In relation to the previous records, the prices in art have been so high. But thinking about the new economy in the global sense and the amount of money that had been made in other fields as well, art is comparatively nothing—it's just peanuts, no big deal, just an abstract game. But then money is always money, it doesn't really give you passion or craziness, while art does. Humans desire passion, they crave wildness in their hearts. So that is what is important for society, not the money.

In what ways do you think the international financial crisis affects the Chinese art market and art scene? How do you think about it as an artist?

I think the international financial crisis will affect the Chinese art market as much as it affects any art market anywhere. Since China still appears to be less overshadowed by the crisis, it does not show here that strongly. To sell artworks at crazy high prizes is a contemporary Western phenomenon that is not considered normal practice among Chinese artists. I guess the market will now go back to normal. This crisis is the latest lesson coming from globalization, and it is influenced by the Internet and technology. It is possible that a new option will come out of this crisis, and it will certainly change the perspective on the political and cultural landscape of the world today.

Who is the key figure in the art world?

I think the collectors. I think they are the true players in the market, as they are the ones who are paying. All this mess is set up by the collectors, because they are the ones who set the rules. I mean, if you have collectors going directly to artists, why should the artists refuse? It's very difficult. If you have the collectors playing with the rules, then everybody has to obey them because that's where the money comes from. And I don't mind if collectors know nothing about art or if they see it only as an investment. If you look historically at the different dynasties, none of the emperors really knew art—but if he or she favored art, then art was booming only because of that stupid reason. Art is at one end and the collectors are at the other end. Both have very conflicting reasons and it doesn't have to match. In fact, it's never going to match, but in the end it just provides a chance for something to be created.

How do you estimate the importance of the biennials in times of globalization?

It's hard to say, because maybe the biennials are still creating important roles—you have human contact. On the one hand, everything is digital, everything is a computer. People get all the information about you. They know exactly what you said and what you did. But then, on the other hand, that biennial or art event makes people realize: he's alive! So it seems we are still a little bit dependent on the physical presence.

China faces a boom of new museums. Is there such a need for it?

In general, the museums all over the world are really fantastic. Because of the physical evidence of artworks, they give you the possibility of easily understanding art's past and the differences between different locations and people. They tell you everything. But in China, there are still no museums that are based on the understanding of humanity and the nature of the human being. Instead they are really based on some kind of bureaucratic decision. Those people never value the culture or think we need two thousand museums each year. It's still a society that can survive with a surprisingly strange logic and reason. Nearly all the new museums are private initiatives. I think the government does see

the necessity of doing something about it, because everything is failing: there is no culture and no philosophical or aesthetic discussion, and there's no creativity in the society really relating to today's life. So they've lost this kind of edge in competition with the economy internationally. I mean, they cannot afford to just be cheap labor anymore. They have sacrificed too much for that—the problem is only that they realize that, but they say: "Yes, tomorrow we need culture." It will take time.

What do you feel about the cult of the "art star"?
It's a special phenomenon, but it's a product of human desire. It's not really that those people have anything special, but they are the product of the mass desire, like soap opera stars. People need some color in their lives—they do not necessarily like it or agree with it, it's just decoration. They see it and then they forget about it. That may mean something—it's like when you put some salt on your dish. I sometimes feel myself that I'm just like a mammal wandering around. Maybe in the future people will laugh at the time when somebody would call himself an artist. It is not a profession, I think, it's a mental state. It's like meditation: it used to be a Buddhist or Zen act and now a housewife will do it in the morning.

COLLECTORS

PETER M. BRANT Greenwich, Connecticut

ELI BROAD Los Angeles

RATTAN CHADHA Wassenaar

HARALD FALCKENBERG Hamburg

INGVILD GOETZ Munich

GUILLAUME HOUZÉ Paris

DAKIS JOANNOU Athens

JOHN KALDOR Sydney

RONALD S. LAUDER New York

IGOR MARKIN Moscow

GUAN YI Beijing

PETER M. BRANT Greenwich, Connecticut

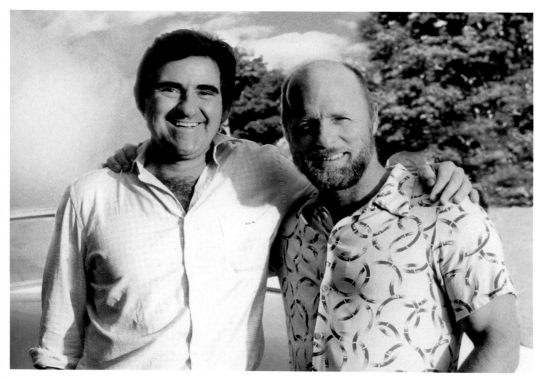

Peter M. Brant and Ed Harris during the filming of *Pollock*

Peter M. Brant comes from a family of collectors. While his father focused on works of the Old Masters, Mr. Brant turned instead to contemporary art, starting his own collection at the early age of eighteen and becoming a close friend of Andy Warhol. He is Chairman and CEO of White Birch Paper Company, a privately owned, family-run business headquartered in Greenwich, Connecticut. White Birch Paper is the second-largest producer of newsprint in North America. In addition, he is owner and Chairman of Brant Publications, Inc., which publishes *Art in America*, *The Magazine Antiques*, and *Interview* magazines. Mr. Brant founded The Brant Foundation, Inc., an art-related foundation, and serves as a member of the advisory council of The Andy Warhol Museum, Pittsburgh. In addition, he has been Executive Producer of several successful films examining the lives of important artists

of the twentieth century: *Basquiat* in 1986, *Pollock* in 2000, and in collabor-
ation with the Public Broadcasting Service (PBS), *Andy Warhol: A Documen-
tary* in 2006, winner of the 2006 Peabody Award and an Emmy Award.

"The word is out there about art."

How did you start collecting ?

My father inspired me to collect and to be interested in art. He was a collector of French Rococo
paintings who appreciated art and owned a mix of quality pictures by artists like Jean-Honoré Frago-
nard, Baron Gros, Jacques-Louis David, as well as a lot of "School of . . ." pictures, which were in
the manner of these famous artists. Many times he took me to different museums in New York like
the Frick Collection or the Metropolitan Museum of Art.

When I went to college I stayed interested in art, and I bought my first paintings from a professor
of mine to decorate my student home in Colorado, whereas other students would buy posters and
such things. My parents and I often went skiing in Switzerland, and as a teenager I met Bruno
Bischofberger there, who had a big influence on me becoming a collector of contemporary art. He
understood that I was knowledgeable in the Old Masters because of my background, but he told me
that I really should buy American artists and suggested to meet with Leo Castelli in New York. In
1967, I met with Leo at the age of eighteen; the first works he ever sold to me were drawings by
Jasper Johns and Robert Rauschenberg. In 1968, I bought some works by Andy Warhol, I was intro-
duced to him and we became very good friends. We started to do films together—*L'Amour* and *Bad,*
as well as *Interview* magazine, which I own again today. That was also the time when I published
some prints with Andy in 1973, and Leo Castelli and I commissioned the Mao paintings. We shared
the same interest in collecting Art Deco and American furniture, and we spent a lot of very fun mo-
ments together, along with Fred Hughes, Jed Johnson, Bob Colacello, and Vincent Fremont.

Is it important for you as a collector to know the artist?

I think, in terms of being a collector, there are big advantages and disadvantages to knowing artists,
because a collector should never let his or her personal feelings about an artist's character influence
his or her opinion of the work. If you become friendly with artists, then you realize they are human
with normal human traits; and then again if you look at an artist's work without knowing them, then
you don't let their human qualities or faults influence your opinion of their work: you just see the
work. It can discourage you as a collector when you might see that an artist did not put so much ef-

fort into a work and has done it very easily. But sometimes the best creations are the ones which are done the quickest! Although I think it is helpful to be friendly with the artist and to exchange ideas with them as friends, you should really judge the work based on your eye and what you feel inside. You can get the opinion of artists—how they look at a work, and how radical a certain work is to them—and in that context knowing the artist is a very important part of collecting contemporary art.

How dependent or independent is the artist today from the art market ?

I think that artists today have returned to a position of what it must have been when Velázquez was part of the court of Philip IV. They are stars and they are absolutely at the highest end of our society. They are almost their own business managers, when you look at Murakami, Damien Hirst, Richard Prince, or Jeff Koons. Within the past five years this situation has exploded—there will be an end to it at some point because you cannot be always at the top of the game. I think the artist should not be a dealer as well; the artist really should have a group or constituency of dealers that work for them and I think traditionally that is the best. Right now a lot of artists are hiring business managers to run their operations: the whole relationship between the art dealer and the artist has been changing recently.

How do you feel about the fact that there are more and more collectors globally?

I look at this historically. If you go through the centuries, there were times when art was very much collected and there was a lot of interest in art, and then there were times when interest waned. There were very rich times in art, when artists could express themselves and work on a large scale and had patrons who were royal or papal and could support the imagination and ideas that certain artists had. The Renaissance certainly was a period like this, as well as the sixteenth and seventeenth centuries. There was that kind of sponsorship that encouraged large-scale works of art that resonated through that time, like the Italian church, the kings of England and Spain, the emperors of Austria, and later Napoleon Bonaparte. This was obviously only visible to a very small group of people who were part of court life and who had the ability to buy and who lived in vast, palatial homes. Today, I think we are returning to a time like that. There are some very wealthy people who have tremendous resources, like in the time of the Gilded Age as well as at the turn of the twentieth century. Oscar Wilde traveled to the United States and lectured on how it was important to be responsible in the arts and spread aesthetics like religion: if you made a fortune, you should spend part of that fortune in the arts. He really spoke to the Vanderbilts, Morgans, and Rockefellers of the world at that time and he instilled those aesthetic values in them: decorative arts and classical arts. At that time England was at its very height and was dominating the world and all art blended in together: architects, decorative artists, and the serious classical artists were working together.

Then you had times like post–World War II, when artists did not have enough money to buy material and there were very few collectors in America. In 1950 and 1951, it was hard to fill an art gallery

opening, for example at a Jackson Pollock exhibition there were fewer people to attend and they were not in line to buy his work. The world had just come through a world war and the public persona had this impression about art, which was present also in the Impressionist time, that an artist had to be starving in order to be a real artist and that all great artists starved at some point and never became famous until after they died.

How do you explain the fact that art these days is being treated ever more as a commodity and an investment?

Very, very wealthy people in the world really believe in art; it is like "spreading religion" globally. This is still a small portion of the population, but a larger portion than ever before. People are more educated, they understand it more because they have been to museums, and art is more available because you can see it on computers. There are more books published on art than ever, because today the research is easier to do—the archives are there and you can publish these books for far less than you could years ago.

There is the aspect of the aesthetic side, the cultural side, and the monetary side, and people believe that art is another alternative to owning gold. They think that it is liquid, with all the record prices being made in auction, and therefore feel more competent investing in it. Today you have a combination of investors and real collectors. The real collector, who usually is the person who makes the best investment, does not care what it costs. He is passionate about what he sees, he collects it, and if he has to overpay for it, he does so. And those are mostly the ones who have the rarest works and the most connoisseurship. It is a long-term intention for them: putting together a great collection with master works like the Lauders, who are connoisseurs of the highest level, or François Pinault. There are a lot of reasons why you can and why you can't—money is just one of them. Many people globally believe that art is an important part of our existence, more than before. I think what counts is connoisseurship and being passionate about art, otherwise you are not able to "preach the religion" in an honest way because your whole makeup is commercial—you have to be interested in art, you have to understand the commercial side and the historical side—it all works together. If you buy a work of art because you think it is going up in value, you cannot even relate to it, you do not even really know what it is about. It is like buying a stock, and there is no room for it in the art world. In the end it is about believing in what you do, being a believer in the "religion" and in history: Is this artist important? Is he or she influencing the younger generation of artists in a positive way? Will his or her aesthetic or influence last?

Which role do public museums have today, given this increase in private foundations and private museums all over the world?

The way I see it, we are creating more great works of art faster than we are creating museums, therefore anybody who builds space to show works of quality is helping to encourage an interest in

art. If you are going to build a space to show the mediocre and without really having the dedication, you are not doing a service to anybody, I think. In that case you are better off giving your collection to a museum, and if, in their opinion, twenty percent of your collection is worth showing, that is what they will show. But if you think you have a great collection and you can afford to house it, then you really should house that collection permanently, because if you look at the history of the large institutions, you see they are competing for wall space over such a large body of work, over such a long period of time, and through the eyes of so many different curators, that they might not get to your work until it becomes really famous twenty-five or thirty years later. Until then it won't be seen. This is my experience with some of the museums in New York.

I will be opening up The Brant Foundation Art Study Center in Connecticut in 2009. The space is in a beautiful setting, a 1900 building at the end of thirty acres of grass. I will be showing selections from my collections over the past forty years, the older generation of artists such as Andy Warhol, Jeff Koons, Richard Prince, Cindy Sherman, Mike Kelley, as well as the younger generation like Urs Fischer, Elizabeth Peyton, Karen Kilimnik, and Cady Noland.

Being a publisher, how important is the media and the art critic for you today?

Art is a very important part of our publishing business, but personally, as a collector, I do not read critics on art. I own an art magazine and I am very interested in the publishing side of art.

Sometimes I will read a critic after I have seen a show, but never before. The reason is that I don't want to have any preconceived notions based on what somebody else saw that I might respect or not respect. I really feel that I have to see it on my own. I try to see as much as possible and to stay in touch in terms of collecting younger artists.

You have to get to know the work and to intellectualize it, you have to study, and you have to know what the artist is all about. It is what Mike Kelley says and I quote: Aesthetics are a socialized thing! You are socializing the creativity, which means somebody sees the creativity and uses it in the commercial side, in advertising, et cetera, and it becomes part of the aesthetic of what you accept as being interesting and this will affect design, concept, or advertising.

What significance do biennials or art fairs have for you as a collector?

I visit the Venice Biennale and the Whitney Biennial and also Art Basel. The historical side of it is more important for me than just going there. The idea of documenting what was there and then following it for the next two or three years—revisiting it—this is more meaningful to me. The way you look at things changes over a period of time; you have to be flexible and open and willing to travel with your ideas. I cannot make up my mind so quickly without knowledge, and I cannot have the knowledge of so many artists in such a short period of time. For me, it is not just walking around and saying: that is great. This is not the way it goes. If you see a Mike Kelley piece but you do not read

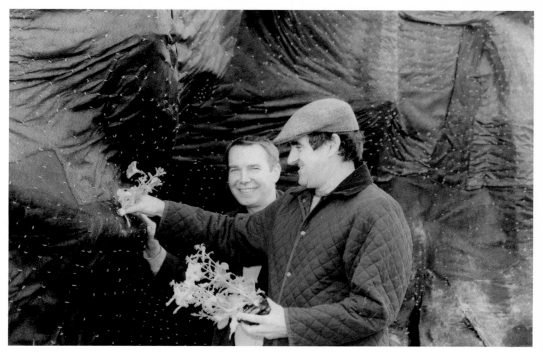
Peter M. Brant and Jeff Koons planting Koons's *Puppy*

Mike Kelley's writings or about Mike Kelley himself and you do not understand the performance and craft and philosophical side of the work, you may walk right by it.

Collecting art is very complex and complicated; it takes time. I think it is a great privilege and honor to be an artist, and I think it is an even greater privilege to collect.

ELI BROAD Los Angeles

Eli Broad in front of Roy Lichtenstein's *Live Ammo (Blang!)* from 1962

Eli Broad is a renowned American business leader who built two Fortune 500 companies from the ground up, SunAmerica Inc. and KB Home. Over the past four decades, Mr. Broad and his wife, Edythe, have been devoted to philanthropy in education, science, and the promotion of contemporary art. In 1984, the Broads created a unique foundation, The Broad Art Foundation, with the sole purpose of lending artworks to museums around the world so that the works would be seen by the widest possible audience. This foundation has gone on to make over seven thousand loans to four hundred and fifty institutions. Throughout the United States, Mr. Broad is on many museum boards, including the Museum of Modern Art in New York and

the Smithsonian Institute in Washington, D.C. The Broads' two art collections, The Eli and Edythe L. Broad Collection and The Broad Art Foundation, include two thousand works by more than one hundred and fifty artists and contain the largest holdings in the world of works by Jeff Koons and Cindy Sherman, among others. Mr. Broad is the founding chairman of the Museum of Contemporary Art in Los Angeles, a trustee to the Museum of Modern Art in New York, and life trustee of the Los Angeles County Museum of Art, where the Broads made a $60 million gift to build the Broad Contemporary Art Museum as well as to fund acquisitions.

"Los Angeles will become the contemporary art capital of the world."

What is your strategy in collecting art in today's global art world?

My wife, Edye, was the first collector in our family. About forty years ago, I became curious about art because she was buying art when we went on business trips. The first work we bought was a drawing by Van Gogh from 1889. I was fascinated to meet a whole new group of people: artists, art dealers, and curators, and it became more than just collecting, it became an educational and an intellectual activity. The more we continued collecting, the more we wanted to focus on the art of our time because we found it more interesting. Contemporary art is a reflection of our society.

I was a founding chairman of the Museum of Contemporary Art (MOCA) in L.A., which opened in 1980. By 1983–84, our collection became so big that we were not able to hang it at home anymore, but we wanted to continue collecting. At the same time we saw that the museums were having difficulties in acquiring art because their budgets were spent on exhibitions, administrations, security, et cetera, and we came to the idea of a "lending library for works of art." We still own a private collection, but we created the art foundation with the purpose of building a collection of contemporary art, starting with works from 1975, and making it available to museums. As of today, the foundation has lent to more than four hundred and fifty museums globally, and since we started, we have made seven thousand loans.

Have you been lending to the new markets as well, for example to Abu Dhabi?

So far, we have lent to almost every country in the world but not yet to the Emirates. We would consider that as long as the venue has museum standards, professionals, and a proper insurance

system. We don't want to have a collection sitting at home, we want to share it, like sharing a passion with someone. Millions of people have seen our art, and if it had been only in one place, far fewer would have had the opportunity.

How do you see the role of private collectors like you versus public museums?
I believe in public museums. We have our foundation, which is open by appointment to museums or museum professionals. Its fundamental mission, in addition to building the collection, is to lend works from our collections to art institutions all over the world. It has gallery space that for zoning reasons cannot be opened to the public. We're exploring the possibility of building a new facility that would bring all of our art foundation's functions under one roof, something we can't do now. Our collection has grown to the point where we have works stored in five different locations, when it would be much better for the collections to be in one location. And, a new facility would allow us to offer public exhibition space.
In order to have your own foundation or your own museum you need several things: you need a fairly large-sized collection, you need staff, curators, registrars, and so on, and you need facilities, space, and warehouses. This costs several million a year, and there are very few people who are able to do that. All of our art is going to end up in The Broad Art Foundation and will be lent to museums. We are not selling our collection, and we will continue to lend to museums around the world.

In your opinion, what is the role of art today in a global world? Is there a role?
The role of art has not changed—it is educational. I think the more people get involved in art, the broader their thinking is. I believe it makes people feel better where they work, and it increases creativity in their way of thinking—this is why we always had art in our offices. People who are surrounded by art get curious about it. Often they start going to museums, and art makes them better educated and better citizens. It changed my life up to the point I traded careers. For two years I was a certified public accountant, and then I became an entrepreneur. I spent my life with other business people like bankers and lawyers and once I got involved in art, it was a broadening educational experience. I hope it has the same effect on others, and that's why we like to share.

How do you choose an artist?
When we decide to buy works by an artist we follow him or her through his or her career. The first piece by Jeff Koons we bought was *Three Ball 50/50 Tank* (1985). We continued buying his work and still do today, and he has become a friend. The same with Cindy Sherman: we started buying her first film stills in a basement on Mercer Street in New York, and since then we've bought her work every year. We like visiting artists' studios. Some of them have died, such as Jean-Michel Basquiat or Keith Haring. We have a large collection of works by Ed Ruscha, John Baldessari, Cy Twombly, and

Jasper Johns. What makes them great artists for me is that they are constantly evolving and don't continue doing the same things.

How independent are artists from the art market today?

I am afraid there are many who are closer to the art market than they have ever been. They may not start that way, but when they get close to art dealers who are very competitive, the dealers raise the prices and the artists may lose their independence. I think artists can preserve their freedom and have a dealer, but they don't have to listen when their dealer asks them, for example, to make a work of a certain size. Artists don't have to do that.

The borders of art are becoming ever more fluid, not only between countries but also within art forms. Is this a consequence of globalization?

Art has always been global and does not have borders. With the Internet and telecommunication, our geographical borders do not mean as much today as they used to in the past. However, we have seen in recent years the emergence of Chinese art, Russian art, Korean art, Japanese art, and I think this is going to continue. If you look at Chinese art, it is clearly Chinese, if you look at Russian art, it is clearly Russian. But artists are influencing each other to a certain degree. They travel and their work gets in various places. That has always happened in the last several hundred years and is not unusual. Today it is just a quicker process thanks to transportation, information, and communication. Also, the forms of art have changed because of new technologies—look at the work of Andreas Gursky or Cindy Sherman. Media in art is changing and becoming more interactive. This is an exciting time and will continue to be so.

There are an increasing number of people involved in the art world. Does this affect you as a collector?

For me as a collector, I realize that there are more collectors than probably ever before, many for good reasons and some for not so good reasons. The good reasons are: people are in love with the art, they are reading about it, they meet the artists, they visit the galleries, they study and they spend time with art. One not so good reason is: people think art is a great investment. I don't think art is a great investment. The dramatic appreciation for art in recent years followed the stock markets and real estate, and I do not think this can go on. The consequence is that we pay more and more for insurance. When we bought a painting by Jean-Michel Basquiat in 1982 or 1983 for $5,000 to $10,000, the cost of insurance today for this one painting is more than we ever paid for it.

If you look back in history, it shows that those who had no passion for art typically did not choose good art. Also, over a hundred-year period, you are better off investing in real estate than in art. The art market goes in cycles as we all know, and right now we are in a heated cycle that will cool down eventually.

Do you think that art has become a status symbol today?

No question about it, it has always been a status symbol. But today it has become a bigger status symbol. Now you have hedge fund managers and others who want art. They changed the art world, and they spend an awful amount of money very quickly. Once you have your home and automobiles and extra money, art is interesting. You are socializing via art on a very high level, it is joyful and you meet many people you would not meet elsewhere. Art has become something to talk about more often and with more people today than in the past.

How do you feel about the record profits that have been made on the contemporary art market?

If you go through the auction catalogues, you will find works that have been bought less than a year ago coming up for auction! People are selling art far more quickly. It used to be, when someone bought a work of art they kept it at least three to five years. Today, many people follow the rule: buy now and sell tomorrow. This is not good, and I think there will come a major adjustment in the contemporary art market. Damien Hirst went straight to the auction house this year with a show of two hundred new works, and then Sotheby's sold almost all of it. That may turn out to be the last act of this overheated market. When a work by Jean-Michel Basquiat can sell for more than $10 million, and you are looking at Old Masters that are getting less, there is something wrong! Obviously, you need deep knowledge about the Old Masters or Impressionists to enter that market, and it is very difficult to get the greatest works of that time because they are mostly in museums, which is where they should be. In contemporary art, buyers can acquire masterworks being made today, almost as soon as the works are produced.

How do you see the role of Los Angeles in a global art world?

The opening of the Broad Contemporary Art Museum at LACMA (Los Angeles County Museum of Art) put Los Angeles into the focus of the art world. It was attended by twelve hundred guests from all over the world. Collectors like Dakis Joannou from Athens, who is very supportive of younger artists, or Victor Pinchuk from the Ukraine, who has a foundation in Kiev and is building a museum, came especially for the opening. With our contribution to LACMA, the museum is able to show parts of our collections, including works by established mid-career contemporary artists such as Jeff Koons, Cindy Sherman, Ed Ruscha, as well as the older generation such as Jasper Johns, Robert Rauschenberg, John Baldessari, and Roy Lichtenstein.

My support of different art projects for the city of Los Angeles derives from the idea that it will become the contemporary art capital of the world. There are several reasons for this: Los Angeles has more and better contemporary art museums than anywhere else in the world, like MOCA, the Hammer Museum or the Broad Contemporary Art Museum. Also, we have the best art schools in America: UCLA, CalArts, Art Center College of Design, Otis College, and others. Forty percent of

the artists at the 2008 Whitney Biennial in New York are from California. We have an emerging art dealer scene, not like in New York or Berlin, but it is emerging, as well as the collector scene. There is a new energy of art experts from the East Coast like Gary Garrels or Michael Govan. And last but not least, Asia is very close, and Los Angeles has three times more port traffic than New York or any other city on the East Coast. Asia is becoming more and more important in world commerce, and art often follows world commerce. I am really excited about all that is happening in Los Angeles.

RATTAN CHADHA Wassenaar

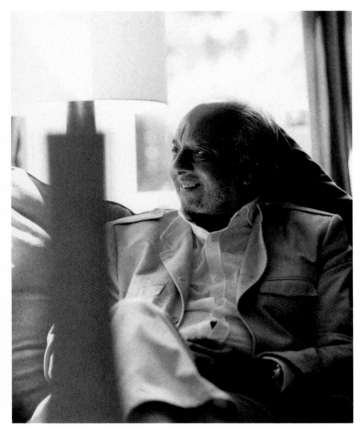

Rattan Chadha

The Indian-born Dutch businessman Rattan Chadha is by nature a very creative person. Founder of the fashion company Mexx, which he sold in 2003, he has gone on to develop a luxury hotel group and has recently acquired the swimwear label Vilebrequin. In 1989, he discovered the work of the Indian artist Satish Gujral, whom he asked to design his guest house in India; his contact with Gujral marked the beginning of his interest in contemporary Indian art. His latest project is the opening of his own museum in Amsterdam.

"Art helps you to think outside the box."

You left India in the seventies. Did Indian people already collect works of art at that time? What do you think Indian collectors are collecting nowadays?

In the seventies, there was no art market, actually most people sponsored artists simply because they liked them. Collectors gave artists some money and acquired art in return. Not many people were buying art at the time. Today India is booming, but it had a slow start; as time went on, buying art became more and more socially acceptable. Indians started out buying a Picasso or modern art rather than contemporary art. Art has to be socially acceptable: we call it "wall power." People in India build themselves a beautiful big home which costs tens of millions of dollars, and they want to go and spend $5 million on a Picasso without any real understanding. Only within the last three or four years have Indian collectors really started collecting primarily Indian contemporary art. So from an Indian point of view, I'm a pioneer.

How did you become driven by collecting works of art?

I came to art through my traveling. For example, in New York I used to always go to art galleries, but more looking at it from a fashion or a graphic point of view, never from an artistic point of view. In fact, in 1985 or 1986, I remember going to Greenwich Village and I bought a lot of Andy Warhol Queens. At that time he was really hot in New York. I bought the Danish and the Dutch queen in all colors, because I was fascinated by the graphics! I loved the colors and the sense of style, but I was so busy with my work that I was collecting sporadically. When I started going to Art Basel, I didn't understand anything! I always try to work professionally, so I needed professional help. I recruited a curator for, at that time, one day a week, to go to the fairs with me and tell me a little more about it. So I started researching and getting to understand some of the artists. Initially, in the late nineties, I wanted only Dutch artists because I lived in Holland and I wanted to support the Dutch art movement. By 2002, I had bought all the Dutch artists I needed and wanted to look at other art scenes. The first artists I collected were Bas Meerman, Bent van Looy, and Atelier Van Lieshout; later I bought Marlene Dumas, and then collected some photography by Erwin Olaf. It became like an addiction, working and discovering new artists. Initially, I was very busy with discovering young artists, until about five or six years ago. I started traveling to other fairs, and every time I would go to a city I would go round all the galleries. I used to travel a lot, because we were opening one shop a week in many different cities; and as soon as I'd worked two hours, I would run into a gallery because I knew there was a good show going on. First of all, I was discovering the new Leipzig movement; I bought a lot of that. Then I discovered this whole scene "Made in the U.S." and then of course Indian art became quite popular and more and more important to me.

When did you start collecting Indian contemporary art?

I started collecting Indian contemporary art five years ago. The first work I bought was by Subodh Gupta; at the time he was a young, budding artist! Then I met his wife and I bought works from her. I was not buying art from a futuristic or an investment point of view, it was more because I wanted to support the artists; I felt like a sponsor.

Did you since connect your business with art in certain ways or not at all?

No, but I am developing a new chain of hotels, and we have asked local artists to paint the fronts of these hotels. The first one opened at the airport of Amsterdam, the second will be in downtown Amsterdam, with a design by a different artist, then the third one in Glasgow; two in London next year, one in Berlin, and then we will go to Barcelona, Madrid, Dusseldorf, and Budapest; about twenty hotels will be opened using twenty different local artists painting their façades. This way I am still supporting artists from all over Europe.

Basically do you think that art is heading toward total globalization?

Yes, totally, the big debate in the art world is about this whole cross-cultural/cross-border art. The Indians are looking at the rest of the world and creating contemporary art not only with the philosophy of India but also with the fusion between India and the rest of the world. Now you can notice that even European and American artists are looking toward India for inspiration. It's fascinating to see what is happening!

Do you think artists can live and work everywhere? Do you think it's not threatening the authenticity of the artists' works?

Yes, because the whole world has become global and the culture has become global. Everybody is watching the same movies, reading the same magazines, listening to the same music—almost at the same time. For an artist to be original in this context, that's a real challenge. It is new for them, but it is not new for the rest of the world. You know Andy Warhol became important because he saw the consumerism in America: he was very close to it, he could smell it, he could eat it. Whether it was Campbell's soup or any other consumer product, this was his world. If you look at the painters of the Leipzig school, they reproduce the world around them, in a more diluted way. They inspire themselves, but I don't know if that inspiration is unique or deep enough. I like two- or three-dimensional art that has a deeper sense for me. One becomes a collector as one gets better and better at it and has learnt more and more about the subject. Anselm Kiefer tells us so much through his art. You have to connect to the emotional side of creation.

How important is the marketing side of art?

What I see now more and more is that the marketing side of art is becoming very important, as art is now being collected by so many new generations of collectors coming from different parts of the world and the branding of art and artists has become much more important. This has become such a big phenomenon in the last two or three years. An artist can be brilliant, but if he is not marketed well or is not with the right gallery, he's probably not going to make it. I find that is a pity. Quality of art can deteriorate but branding is essential. Look at Damien Hirst; he paints a little red nose and signs it "Damien Hirst" and it becomes a million pounds' worth of art. So branding is something that is becoming almost more important than the art itself.

So what do you think about the strategy of Louis Vuitton with Takashi Murakami or Richard Prince and so on? Is it good for the artists or just good for the company?

In a way, it is art merging into society. It is art that is now merging with the wider public through objects, so everyone can afford a Richard Prince or a Murakami. The same thing happened when they started fragrances; you could not buy a Dior dress but you could buy a Dior fragrance. You can spend €50 and you have a "Dior." So it's good for people—they own something from the artist for a price that they can afford. That's also good for the brand.

More art is being produced than ever before. Is this the start of a rediscovery of a new aesthetic or could it just fizzle out?

No, I don't think it will fizzle out. Society today has got everything—you know, there are no boundaries; we already have every single technological product; and now we see that all levels of society are getting involved in art. We see the success of Art Basel Miami and Frieze for example. The movement has become much wider. It is from there that the addiction comes. People start to understand more, and it is always the same pattern—I've never seen anybody escape. You get interested for different reasons, and then you want to understand more and more, so you start asking questions, and then you start discovering and say to yourself: "Hey, there's more to it than just a painting that hangs on the wall!" This has happened to so many friends of mine, and that movement is getting wider by the minute.

Art on order—how dependent are artists on the art market today? Are galleries absolutely necessary?

Art galleries are crucial, because I think there exists a partnership between the art gallery and the artist that makes things happen. The art galleries know the customers; the customers trust the art galleries. I would not buy something if I did not know the gallery. It's a support system that exists. Very few people understand art, truly. So if you're going to spend a million dollars or whatever, you need to have that trust. An artist will always remain an artist—normally artists are not good sales

people. So that's where the gallery owner, an agent, or a curator plays an important role. Fifty percent of the artist's success is based on the quality of his art and fifty percent—and not less—is based on the artist's personal marketing. If artists are not able to market their works and they want to hide, for example, in India or China and try to make something beautiful, nothing is going to happen. Galleries are telling them that they can do their promotion, but artists have also to promote themselves to become a brand name. The gallery cannot become the brand because the gallery has got twenty artists to represent. The gallery is a brand of trust, but it is also important to meet the artist to get his full breadth. I've often seen an artist being a bad marketer. These artists never last. If they are not aggressive and vigilant, no matter how clever they are or how good they are, they won't succeed. Damien Hirst is very aggressive. Andy Warhol was very aggressive. They all basically really wanted to succeed.

How do you consider the relationship between money and art?
I think that after a certain time, people want to display their wealth—that's why they buy big homes, jets, and so on—and once that is all done, there's still art. I don't know in which category to put it, but art is what I call "wall power." Not for me, so I don't care: I live with my art. I can take off expensive works of art that I have in Holland, great works of art, and display in their place young contemporary artists. I want to have young artists around me for the next years. I'm not collecting for "wall power," but maybe this is because a lot of people already know that I have a lot of art so I don't need to show it off.

Tell us a bit more about your new project concerning your private museum.
We are busy with the transformation of a tram station in Amsterdam in which we have got a lot of space. They are also building a concert hall and library; and we are currently waiting for the necessary authorizations. I would really like to do it, and it would be great for young people because young artists from all over the world will be promoted there. There will be special spaces for the artists so they will be able to work, there will be classes in the mornings where they will teach art students. I think that many museums are dying places—they can be very boring, one has to be quiet, and entrance fees are expensive. Museums in general keep a large distance with their public, and therefore young people (twenty to thirty years old) do not like to go there. I want to make my museum a fun place, more interactive, because I've learnt so much from art in my life. I think art helps you to think outside the box, because it tells you why the artist is thinking this way, what he is trying to say to us, why he is doing what he does. Therefore I want young people to start thinking the same way because, from my own experience working with a lot of young people at Mexx, I know that it is not easy for them to always have new ideas. The world has become so competitive, and inventive ideas have become more and more important. For example, the iPod was a great idea, and although Phillips had the technology much earlier than Apple, Apple is the one that had the idea. Google is an idea,

Raqib Shaw, *Untitled*, 2004, Chadha Art Collection

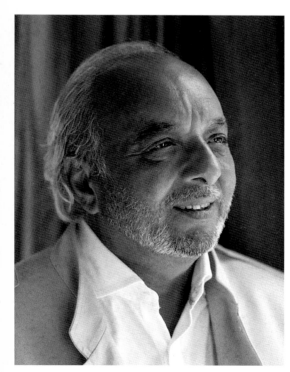

Rattan Chadha

but the technology existed long before. Art can help people to think out of the box and show them that things don't have to be limited. This is the only reason why I want to open this museum. I don't want to show a collection, I don't want to name it after myself. I want to call it "Nowseum," because it will be a Museum for Now: it will be free, it will be open late at night, there will be music, and it will be interactive. A fun place to be!

Who do you think is playing a key role in the art market today: the collector, the artist, the gallery, the auctioneer, the museum?

I would say first the gallery and then the artist. Of course everyone is very important; they are all making the process happen in a very efficient manner. It's not that they are all creating the demand— anything can be put up for sale but nothing will happen if there are no buyers—but they are, however, smoothing the process of purchase. In auction, if I am willing to pay $10 million, I know there's an under-bidder who will pay at least $9.5 million, but if I go to a gallery and they ask me $10 million for the same work I will probably not pay this price, because I will never be certain what a second buyer may offer. Galleries do not profit from the prices made at auction because there are very few buyers at this price level anyway. Usually galleries are selling much more at a price level of $3 million to $5 million. If a work shoots up to $25 million, then that is the new value. When this happens, galleries get into trouble with the artist, because he starts to think, "Hey, I'm Jeff Koons, that was a small bal-loon which made that price and here is a bigger heart so this work is worth $30 million." Obviously, there are not many buyers who will spend $30 million. At auctions, collectors will pay higher prices than in galleries. It's like if you're on a street which is full of houses and the house prices were half a million dollars and somebody comes and pays $1 million, everybody will start thinking, "My house is also worth $1 million, and mine is even better because I have a bigger garden, so maybe mine is even worth $1.2 million." All of this happens because one person originally bought a house on that street for $1 million. I think everybody is scared about prices shooting up. I think this is the beginning of art being globalized. There are not a hundred collectors anymore, there are ten thousand collectors; there are not ten billionaires anymore, there are a hundred billionaires. Ten years from now there will be ten thousand billionaires. Right now is the beginning of a new movement. The only people who are scared are the people who have been in the art business for the last fifteen years. These are the people who are saying, "Oh, the price is going up—it's crazy, it's a bubble." The financial markets may be in a terrible state but art remains.

HARALD FALCKENBERG Hamburg

Harald Falckenberg in front of a portrait by Andrea Stappert

Born in Hamburg in 1943, Harald Falckenberg is a collector, chairman of the Hamburg Kunstverein, and the author of numerous essays and books on contemporary art. Having studied law at university, he became managing director of the family business in 1979, and since 1992 has been an honorary judge at the Hamburg constitutional court. In 2001, he founded the Phoenix-Stiftung in Hamburg-Harburg, which regularly shows works both from his own and from other private collections. The foundation has collaborated with several museums, mounting exhibitions that show a selection of works from his private collection, frequently curated by the collector himself. He is friends with a large number of artists.

"The faster the world moves, the faster the 'new' becomes old again."

What makes you collect?

Well, whatever it is, it isn't enthusiasm. Every artist has a particular preoccupation, and it's really this preoccupation that concerns me. For me it's always the artist that is of primary importance, not the work of art. An artist doesn't produce art. Art becomes a work of art when it is accepted as such by a third party. You can apply objective criteria to art, but at the end of the day it's always subjective opinions that count. On the other hand, the sum of opinions that decides about the status of art is itself an objective fact, just as styles and movements can be objectively understood. The latter is the business of the art historian. My collection covers only a small section of the realm of art, from Dada to slapstick; art that stands in the tradition of the grotesque and is characterized by subversive humor.

Is art heading toward total globalization? Is there also a threat of increasing standardization within art?

For several years now there's been a process of globalization in art that has run parallel with the globalization of the world economy. The result has been an enormous broadening of the spectrum. There are various positions and various ideas, and art is influenced by these different approaches. There has always been a reciprocal effect. On the one hand, there have been attempts to influence the market with certain artists and their art, on the other the artists themselves have taken their cue from what's going on in the art market. This process of leveling out and adjusting within the art world is today taking place on a global scale.

Do you see this development as an opportunity or a risk for the authenticity of the artist?

That kind of authenticity doesn't really exist. Each of us lives in an individual environment, which we can only free ourselves from in a limited way. It's true that we try to gain as much autonomy as we can, but no one knows exactly how far this is really possible. It's just the same for artists. Most people have not one but several different personalities, we live in different parts of the world, in different circumstances, in different walks of life and social milieux. Just recently we were at an exhibition by a German artist, Dirk Skreber, in Baden-Baden, who has been living for four years in New York and who has clearly adapted himself to the tastes of the American public. Is that a good thing or a bad thing? The artist has come to his own decision.

Is it still possible these days to make art for "eternity"? How long-term do you think the art of today can or should last?

As a rule, we have concepts like "new" and "old" for this. If you then say that what's "new" is now decisive and sets the overall criteria for the market, then you need to consider that what's "new" will very soon be old again. The faster the world moves—and globalization has brought with itself an enormous acceleration—the faster the "new" becomes old again. This acceleration is the reason for the opacity and short-term nature of contemporary art. Pop Art brought an important change by shifting the focus from high to low culture. Since then, everything has acquired the potential to become art, and nothing is any longer the preserve of the elite. In the past, artists struggled for their work all their lives. Today, young artists are considered old by the time they're thirty. This means that we simply don't know how the art we are collecting today will be regarded tomorrow.

What is the importance today of public and private museums?

These days museums have to register visitor numbers that can only be obtained by having changing exhibitions, and which—with the exception of international capitals—can no longer be achieved with their own collections. This is another reason why collectors are increasingly setting up their own museums. Collectors tend to be concerned with preserving collections that have been put together with a great deal of love, effort, and money, and this is something that public museums can no longer guarantee.

More art is being produced than ever before. Is this the start, or the rediscovery, of a new aestheticization of life, or could art just "fizzle out"?

Art has been a lifestyle item for a long time now. You could say it's a good thing that it has now become "democratic"; you could also regret the fact that the old intellectual elite circles no longer exist. But this process cannot be stopped. And it's for just that reason that art mustn't be allowed to deteriorate. In a large market, there will always be a lot of rubbish on offer, but that doesn't mean that the best art to be found has got worse. There are first-rate artists and first-rate works of art, just as there have always been—perhaps even more than there were before. The broad generalization that "art is getting worse and worse" simply does not describe the current situation.

Has today's art market become more democratic?

Democracy doesn't mean the right of the majority, but the protection of the minority. That is my definition of democracy. With the current globalization of art commerce, which is always looking to come up with the "latest thing," the "last word," the "greatest," the "newest," it's difficult to set individual standards and stick to one's own position. Insofar as it's a mass industry that's determining content and form, you could, with only a certain degree of exaggeration, speak of a dictatorship of the market. For gallery owners and collectors, resisting this process is no easy thing.

How do you regard the fact that art is being treated ever more as a commodity and as a financial investment?

Art has been a commodity ever since artists stopped being servants of the church and the nobility. Since then they have been tradesmen. For all the excitement, love, and enthusiasm one may have for art, one shouldn't lose sight of this side of it. There's nothing wrong with the fact that art is bought and sold; and for the same reason you cannot in principle object to people speculating in art. Everyone has to decide about that for themselves. What is so great about art is that it survives everything and can laugh about everything. An art market without speculation would only be boring.

Who do you think is playing a key role in the art market today?

The current market depends on a variety of different factors. There are the fairs, the curators, the museum directors, who are increasingly mounting special exhibitions, the critics, who take on commissions just to make ends meet, the gallery owners acting as art dealers who serve the secondary market, and the collectors, who are pursuing their own agendas with their private collections and museums. This interplay with its constantly changing coalitions isn't easy to disentangle. Nevertheless, I think we can at least say that the museums and established critics have lost their central role in how art is judged. They are only ever going to be able to exercise a limited influence over an art industry that is developing globally and is constantly orientated toward the "new."

How important do you think gallery owners are today?

Gallery owners and art dealers play a central role in the distribution of art. They find out what kind of art sells and seek out artists offering a similar kind of work. They supply the art fairs, support special exhibitions at museums and public art galleries, and also now to a great degree the biennials and the triennials. I think that at the moment the trend is toward the art dealers and the secondary market, and that the established galleries are concentrating more on the fairs. Compared to gallery openings and private views, fairs offer collectors a far wider overview that can be obtained over a much shorter period of time. The result is that galleries and art dealers remain irreplaceable, and the fairs remain, as before, the most important places for showing art. Even the large auction houses, who for several years now have been dealing successfully in new art, don't dispute the gallery owners' and art dealers' right to this position. Auctions are limited to the secondary market. It is galleries that have to deal with nurturing artists' careers. They are of course not happy about the fact that auctions are muscling in on the pricing system they have built up. On the other hand, they are benefiting from the high auction prices and the increased prominence for their artists that have been the result; and by participating in the bidding, one can control the outcome.

What significance do biennials have for collectors as "world congresses" of contemporary art?

Biennials and triennials are political and economic events aimed at achieving locational advantage and realizing profits. There is a human aspiration for culture, and art must serve as a kind of "cultural means of production." Artists stand in opposition to culture. Culture is encrusted art, something for the jaded bourgeoisie. Artists want to create something new, something revolutionary. Nevertheless, biennials and triennials are important institutions from which, at the end of the day, artists also benefit.

Has supporting the arts become a crucially important way for firms and banks to improve their public image?

Yes, banks are a good example. In the past there would have been a Rembrandt hanging in the boss's office; these days you would only find a Rembrandt in an office of the bank's supervisory board. Since young bankers want to be creative, they'd rather have abstract, creative, and dynamic art hanging on their walls. The financial crisis has meant that presently banks are significantly cutting back their involvement. In Deutsche Bank's VIP room at Art Cologne 2008, they were serving only water, not wine—an indication of the present atmosphere. In bad times there are fewer resources available for image promotion and consequently also for art. The same is true for other businesses. Since the state has largely withdrawn from financing art commerce, attracting resources from private sponsors is encountering increasing difficulties.

Can art be an "experience" or an "event"?

For me, art means "experiencing" something in the literal sense of the word, confronting society, history, and your own ego as a way of testing yourself and broadening your consciousness. But on the other hand, what's wrong with traveling down to sunny Italy to have a look around the Venice Biennale? Art has long held a position at the center of the social spectacle. This social development has reached a dynamic and a depth that can no longer be reversed. You cannot dictate to art. We should make the best of it, each of us in our own way.

Harald Falckenberg in his Phoenix-Stiftung with works of art by Klaus Staeck

INGVILD GOETZ Munich

Ingvild Goetz

Ingvild Goetz, one of the most important international collectors of contemporary art, began collecting in the late sixties. Her first acquisitions included works by artists from the Arte Povera movement. Since then she has been systematically broadening her collection, which currently focuses on media art and constitutes one of the most comprehensive collections of its kind in the world. Her museum in Munich, designed by Herzog & de Meuron, is believed to be the first private museum for contemporary art in Germany. There she curates exhibitions of works from her collection, changing them every six months; works from it are also shown internationally in collaboration with other museums.

"The trend is toward a *Gesamtkunstwerk*. Our globalized world is reflected in an art of this kind."

What fascinates you about collecting? How would you characterize your approach?

I'm a Taurus, and Taurans are people who like to own what interests them. That's why I have to have my art around me and live with it, even in my museum. At home I change around the artworks every two or three months, and in my private museum every six months. In the meantime, my collection includes about four thousand works. I only collect very young art—and I do it globally. My approach is very strategic, but also quite wide-ranging. At the back of my mind I'm always asking myself whether an artwork could be used to broaden one of the ideas I have for an exhibition, or even whether it might be used to develop a new idea for an exhibition. For what interests me above all is curating exhibitions from my collection. That's how I got the idea of having Herzog & de Meuron build an adequate space for me. But I also need this little museum as a way of checking quality, as a kind of instructor. I go back through my exhibitions again and again to check whether they work for me and whether the works retain their effectiveness.

Where do you find young talent in an art market that globalization is threatening to make ever more confusing?

I find myself in a permanent process of exchange with young gallery owners and artists. I take a lot of time over this and try not only to become properly informed, but also to understand. Sometimes I discover a whole group of artists through a gallery owner and develop an idea from that. Like in Berlin, for example, where an interesting art movement is developing around Andreas Hofer, Jonathan Meese, and André Butzer. It's important for me to visit an artist's studio to see more of their work and to be quite certain about it as far as its authenticity is concerned. At the moment that isn't easy, for in painting especially there is, as far as I'm concerned, a good deal of work being done that is like work being done everywhere else, work that is interchangeable. Along with the good art, there's also a lot of bad, insignificant, but nevertheless expensive art these days. At the same time it's more difficult than it was to find something really original. And the same is true of the new art markets in other countries, in China, India, and Russia. A lot of people are trying to adapt to Western tastes in art in order to be able to sell in the West. As far as I'm concerned, that's just "branding," not art at all.

Why does the work of very young artists interest you so much?

I want to know and understand what each generation has to say about itself, and I have done so for the last forty years. That's why I'm interested in everything that moves these young people—the music they listen to, the political background, social issues. I try to get involved in every generation. What's most important is that I don't interfere with these young artists and their art. I don't draw any comparisons, I don't look for any connections with earlier generations of artists.

What originally got me interested in media art was the Venice Biennale at the beginning of the nineties, where I saw three or four video installations—compared to everything that had gone before, it was a completely new field. Video art has existed since the sixties, but the new technical possibilities mean that something completely different is emerging. It was immediately clear to me that media art had to be the future, since the young generation of artists had grown up with television and film.

What are your criteria for selecting works for a collection that focuses on media art?

I've got a very well-trained eye by now, since almost every evening I sit down and watch films that have been sent to me. That's how I train my judgment and gather experience. Along with checking the quality, I also need to work out whether the material is an art film and not a documentary film, as I am interested only in art films. Unlike many other collections, I draw a very sharp distinction there. The way in which it's done must strike me as new and of course leave a lasting impression. At the end of the day, I have to be sure that I haven't just come across a work that happens to be good by some fluke.

There's a limit to how long media art can be physically conserved. Is the durability of an artwork important to you in these fast-moving times?

I certainly want the art in my collection to be preserved over the long term. That's why I've even appointed my own specialist and set up refrigerated rooms for storing photos and film. Since media technology is constantly developing, I have an agreement with artists that allows me to use any future technological innovation for showing films. The technology is developing so fast that in the future many kinds of equipment will no longer exist. But we can't easily transfer films or videos or DVDs to the new technology without the artists' permission.

How would you define the role of public museums, which see themselves as being strongly challenged by globalization?

The public museums are under increasing financial pressure and becoming more and more dependent on collectors and gallery owners, all of whom are pursuing their own—primarily economic—interests. For this reason many museums are putting on shows aimed at drawing in large numbers of people. Success, so the reasoning goes, consists in having as many visitors to your exhibition as spectators at an international football game, and letting them set the cash registers ringing. This is

The Goetz Collection building in Munich designed by Herzog & de Meuron

a pretty dangerous trend. I think it must be possible for public museums to show important artists who don't have great popular appeal, who are perhaps reserved and difficult to understand. That really would be exciting. And it's really the only way for public museums to fulfill their mission of educating the public.

You have your own museum which is open to the public. How do you see the position of the collector in relation to public museums?
I think collectors should either build their own platforms or leave their works to a museum without any conditions attached. I think donations that come with conditions prescribing their content or anything else are dangerous. For me there's nothing more exciting than developing my own exhibitions. Unlike a museum curator, who has to meet an obligation to the public, I can act subjectively and also make mistakes.

Would you ever part with your collection and have it transferred to a state museum?
I personally would find donating a collection a very difficult thing to do. It's part of who I am, it means really everything to me. If I were to part with my collection, then it would have to be done properly, and I could not allow myself to be further involved with the works. I would find it hard seeing how a different curator might judge my works of art differently and possibly end up putting them in the storage depot. And I'm against the idea of collectors linking a donation with a publicly funded extension to a museum, because of the high costs this imposes.

Are public museums likely to become superceded over the long term?

In the long term the idea of having a system of publicly funded museums may well indeed peter out, particularly if they no longer fulfill their educational mission. This is less true of Europe, where we are still very much rooted in a museum tradition and in the idea that the purpose of these institutions is to educate the public, than in the new markets such as, for example, China or the Emirates. In the future there will probably be two models. The mixture will just get more diverse. Examples like Victor Pinchuk in Ukraine or the sheikhs from Abu Dhabi show that there will always be people who have both come into money and really want to do something for their country and their own culture. They don't only show international art but also national artists—and that's how you find out what's going on in these countries. It reminds me of the patronage of the great princes and royal houses, who had money and collected great works of art. Why not? At least it's a parallel model to the large public spaces whose position as institutions of quality goes unchallenged.

Who has the largest influence over the globalized art market?

Artists have more influence than people think. Many artists demand that gallery owners operate international branches, and that they have a say over the price. The type of artist has changed enormously, since many these days want to earn serious money, even if they often don't approve of such a thing themselves. "L'art pour l'art" is definitely over. The long-established, serious gallery owners are, of course, extremely important for the art market, but so too are the very new galleries. They are the only ones who are still innovative and really able to get involved. Above all they tend to live the same kind of life as the artists whose work they exhibit and who express this way of life in their work. That interests me. And gallery owners these days have a pretty tough job. Along with handling the monstrous economic competition caused by increasing globalization, they really have to have done a course in psychology. Both artists and collectors want to be looked after individually and every hour of the day and night. In addition to this, gallerists have to protect artists from hype and encourage them when they are in a slump, even if it's against the gallery's economic interests.

Rapid success increases the pressure on an artist. Do artists have time now to develop slowly?

It's gotten more difficult, not least because of globalization, which has led to an acceleration in all areas. These days an artist has got to be positioned on the market within a given period of time. Things have changed a great deal. In the past a good artist had a certain amount of experience, which was connected with having enough time to work and certainly with having enough time for some reflection. There are artists who no longer worry about going through a serious process of development. The obligation to be constantly showing prevents them from taking a step back and reflecting on ideas and how to develop further. The best work comes from people who sometimes resist the market and concentrate on their own work. If I notice that an artist is no longer engaged in this process, then it's very often the case that I part with his work completely.

What do you think the next development is going to be in art?

Perhaps three-dimensional computer simulations. People are going to make whole physical spaces come to life, creating three-dimensional virtual worlds that see space as a kind of stage. I think that whatever's going on around us technologically gets taken up by artists. What's going on around us affects our lives—and therefore also art. Just as music, too, is increasingly affecting art. The trend is toward a *Gesamtkunstwerk*, a totally integrated work of art. That's why I'm interested in artists who play the entire range, who can make use of all media. They can paint, film, photograph. Our globalized world is reflected in an art of this kind.

GUILLAUME HOUZÉ Paris

Guillaume Houzé in front of a work by Marlène Mocquet from 2007

Guillaume Houzé is a descendant of the family that founded and still owns France's Galeries Lafayette group (Galeries Lafayette/Monoprix/BHV), whose international reputation dates back to 1918. He took over there as head of marketing in January 2008. A real commitment has very quickly made him one of the key players on the contemporary art scene in France and internationally. Houze's family has collected art for generations. His introduction to the visual arts came through his grandmother, as fervent a collector as the rest of the family. His first artistic revelation, he recalls, came with Chaim Soutine's distorted faces.

"Art allows for consciousness-raising."

Where does your passion for contemporary art come from?

From generation to generation we have always collected the art of our time. For my great-grand-parents, this meant the Impressionists and the Moderns—mainly Impressionist pictures by Pissarro, Renoir, and Monet—to which they later added more contemporary works. My grandparents were more drawn to the School of Paris, Soulages, Poliakoff, and others. Then they rounded off their collection with Surrealists like Max Ernst and Victor Brauner.

At the time they were basically collecting French artists, but they also caught up with more international trends such as American abstraction. Their choices were highly personal and reflect no particular strategy. They made no attempt to fit with established taste. My grandmother frankly admits to having got it wrong sometimes: for example, she failed to grasp the importance of the big Jackson Pollocks she discovered in her New York friends' homes in the fifties. This leads me to think that getting interested in art requires a certain incomprehension: you need to be unsettled. This means you miss some things—some movements and artists. At that time people were already traveling and finding themselves faced with these aesthetic challenges.

Your collection includes many radical works. How do you explain that?

Everything I do now I do in a pretty forceful way. Starting with the choices I make. Very early on I was confronted with creativity and art, and I molded myself as time went by. When I bought my first work, which is a seminal moment, I must have been fourteen. It was by Erró. And even if I no longer have any great interest in that artist, I most definitely do not disown the tastes I may have had when I was young. I was fascinated by everything that was a bit colorful, a bit Pop . . . and gradually I came to feel the need for a crash course in art history; above all I wanted to get involved with the art of my time, to commit to the contemporary. This confirmed my idea that art is also a battle, with oneself and with others. An important period I would like to mention here is the Second World War. As a Jewish firm, the Galeries Lafayette group was plundered by the Germans. We managed to recover some of the works thanks to the Nazis, who were very orderly and had made lists of everything. In particular we found some Pissarros which were in Hermann Göring's office, but some of those missing pictures have never been found. All this family history has made me the young man I am today.

Is there a strategy to your way of collecting? And is your collection private, or does it belong to Galeries Lafayette?

No strategy. And our collection is private, it's not the Galeries Lafayette collection. Actually Galeries Lafayette doesn't have a collection, it just serves as a venue for our exhibitions, a kind of launchpad.

Everything is bought personally. Basically I look; I don't listen much, except to a few people—certain dealers and artists—who are important to me. This is what guarantees my freedom of action with regard to the collection. This is a very personal thing for me. It's only very rarely that I sell items from our collection. The artists we buy are not often to be found on the second market, even if some of them—Tatiana Trouvé, Saâdane Afif, and Mathieu Mercier, for instance—are really starting to make a name for themselves. They don't yet have major status on the international market, but we're gambling on showing that we helped them get there. What delights us is when someone presents Tatiana Trouvé, who hadn't been shown at the Venice Biennale when we bought her four years ago; Saâdane Afif, who had not yet been at Documenta in Kassel; Mathieu Mercier, who had not yet had his exhibition at the Musée d'Art Moderne de la Ville de Paris; and Laurent Grasso, before he showed his famous neon work in New York. This gives us the feeling that things are on the move. And lastly, when I'm really interested in an artist, I try to build a story. I want to build up groups of works that are strong, impactful, and representative of the artist's world. I keep tabs on change and try to move with the career.

Since 2005 the "Antidote" project is further confirmation of a major Galeries Lafayette commitment to contemporary creativity in France. What makes this project part of the business's history?

On the one hand there's my grandparents' collection, which is a private one, and on the other the Antidote project, which I launched with the invaluable assistance and backing of my grandmother in 2005. Right now the project is focused exclusively on the French scene. I was determined to have my say in the unusual context of a big store and become part of a significant historical continuity involving engagement with the art of today. Galeries Lafayette and big stores in general have always anticipated and supported art trends and foregrounded artists: visual artists as well as designers and fashion people. With interior designer Jacques Adnet (assisted by Charlotte Perriand) as artistic director for the supervising staff, and Peter Knapp followed by Jean Widmer (1959–61) as art directors for the advertising workshops, and now Jean-Paul Goude, Galeries Lafayette have been out to be part of the art avant garde at all levels. And lastly there has always been a real kinship between the world of big stores and that of the creative arts. As the venue for the second Salon de Mai after the war, in 1946, Galeries Lafayette showed the little-known work of artists including Giacometti, De Staël, Pignon, and Tal Coat. And in 1978, the "France Has Talent" exhibition, once again at Galeries Lafayette, celebrated the work of such New Realists as César, Dubuffet, Arman, and Niki de Saint Phalle.

In your opinion who is the main player in the contemporary art world today?

For me the business of collecting is above all a very close relationship between the artist and the dealer, the art lover and the institution. Each is equally important. The artist is the wellspring, but I

think it's crucial to take account of the dealer's role: these days it is very difficult both for the artist and the collector to do without the dealer, who plays an absolutely vital part. With the passing of time it seemed to me paramount to set up links with certain dealers: you can't afford to forget that they are first and foremost professionals, and that they inform and partly shape the collector's way of seeing. So it's the dealer who acts as go-between for the artist and the collector. I don't know what being a collector actually signifies, but for me it is not something you make up as you go along; you become a collector over time and the dealer helps you do that. Some of them have sharpened my eye and helped me develop. Of course, I have a free hand in making my choices. But I have regular discussions with dealers when I need confirmation on certain decisions.

Yves Carcelle, the CEO of Louis Vuitton, has said that artists need "loudspeakers." Your Antidote exhibitions bear witness to this. You're very open about your attachment to the French art scene.
Antidote is an opportunity to show that we can spotlight a scene that for too long has been disparaged as inferior to its Anglo-American and German counterparts. Above all, it's a different way of putting French artists on show—especially given that the setting is a store. In France we like things to stay in their place. What I find interesting is showing that artists and their works can be taken out of the standard creative venues—out of galleries and museums, that is. And while the exhibition area is in the store, it's separate from it in the sense that there's no selling space intruding into it. Nothing is for sale, in fact. Antidote is an exhibition, but primarily it's a collection project.

At a time when all the art markets, including Korea, India, and Latin America, are really taking off, your collection remains focused on the French scene. What governs this stance?
Lots of people ask me: Why the French scene? Why just France when there are also the Indians, the Russians, and the Chinese? Today I am what I am: I have no advisors and I can't be everywhere, so I concentrate on certain things. I can't take an interest in all the emerging markets like Latin America, India, China, and Korea. This does not mean, though, that I don't buy foreign artists. In our collection we have Swiss artists like Ugo Rondinone and Americans like Wade Guyton. As for the artists of lasting value, I think the sole criterion is time. I'm very busy, I go to the art fairs, I go everywhere I can, but I think you have to manage to stay focused. You have to stay focused on a core artistic idea. You have to have a rigorousness and a radicality that really fit with the situation—the social context—we're living in today. There has to be a return to a core idea. With the present proliferation of artists, works, and, as a consequence, artistic supply, it's clear that we need a return to ideas and practices that are much more precise, and that the content and the underlying artistic notion have to be much stricter. Regarding the emerging markets, China, for example, is not my thing. But we do have plans to acquire works by foreign artists like Ryan Gander, a very promising young Englishman, and the Polish painter Piotr Jonas. And as for France, there are Michel Blazy, Tatiana Trouvé, and Saâdane Afif. To come back to the question of the emerging countries, I can only be honest and say

that I don't really know too much about them, even if I've been seeing Chinese artists on sale over the last few years. I don't know those scenes well enough to be able to judge them accurately. I only buy what I like. Speaking in purely market terms, we're moving at high speed from the old world, run by the West, to the new world, and the economic crisis is symptomatic of this. It's obvious just how badly the United States has been affected, and soon a lot of things will be happening in Abu Dhabi, Moscow, and Shanghai. The crisis is speeding up this process, and the emerging countries will reap the benefit.

By spotlighting contemporary art in a retail space where the public is different from the one you usually find in places exclusively devoted to exhibitions, you're coaxing people toward a genre that gets little recognition or appreciation from the man in the street. Could there be an educational intention lurking behind Antidote?

It's not easy to promote contemporary art to a public for whom art is not necessarily a central concern. Nonetheless, it would seem that the policy of guidance implemented by Antidote and the Galerie des Galeries, directed by Elsa Janssen, has succeeded in attracting and holding a new public for contemporary art, and it is really helping our approach. Our space is primarily a laboratory for all kinds of artistic practices, with activities covering the performing arts (dance), art, design, and graphics. The major asset of the Galerie des Galeries is that its varied program means it offers a broad range of educational items. The education side, with five exhibitions a year, is based on the possibility of a different kind of encounter with contemporary creative work. The goal is to help the public take a look at today's world through art, to learn to recognize and anticipate the distinctive signs of contemporary art, and to think about art's role, forms, and meaning.

What do you think of the new tendency among artists to become the promoters of their own art?

It's true that some artists have a real ability to communicate about their work. Today the most talked-about artists are doing better than their elders because they have more bounce and communicate more. They've got what it takes to set up networks, and that's an important point. Even so, what ultimately counts for me is the artist's ideas; it's all very well to go selling yourself all over the place, but if there's no actual substance then it's all just hot air.

Art production is currently beating all records for quantity. Does this mean the beginning of a new aesthetic conscience in our society? Or could it mean the opposite—that art is gradually becoming extinct?

We need to get back to deeper artistic considerations. You can already see this happening with Italian artists: there was a whole generation of interesting people like Maurizio Cattelan whose message works through irony and humor, and now a new generation is taking shape, one including artists like

Antidote 2007 (Antidote 3), Ginette Moulin/Guillaume Houzé Collection, exhibition view with works by Didier Marcel, Mathieu Mercier, and Tatiana Trouvé (from left)

Diego Perrone and Piero Rosa Salva. You sense an underlying artistic notion that is much deeper and more intellectual. I think that for art not to become extinct there has to be a return to much clearer ways of seeing things.

As you see it, what is art's "global player" role in the economic sector of the industrialized countries? How do you see the association of businesses with artists, as with Louis Vuitton?

I think it makes sense, even if our way of doing things is different from theirs. When we promote artists it's not in the interests of some new communication strategy, it is first and foremost a style of patronage and a family activity. Of course there are all the tools that Galeries Lafayette put at our disposal; but in the case of LVMH it's a tried and true strategy, there to help the artists, for sure, but above all to help the brand.

What LVMH is doing is perfectly calculated, there's no doubt about that. The great thing about it is that it allows for extraordinary encounters: when you've got Olafur Eliasson and Ugo Rondinone working with LVMH . . . At the same time it's very difficult to get artists to accept things they would normally find unacceptable, although everyone has to make concessions in certain cases. And it should be up to the company to make more concessions than the artist.

What emerges from all this—what I find elating—is that art is talked about more. You can see that art has become as much a necessity for the consumers as for the people from the company. People need to be taken elsewhere, taken higher. Art allows that. Art allows for consciousness-raising.

What do you think of the proliferation of art events all over the world and the partying that goes with it? What impact can that have on collectors?

Only the best will endure. And that applies as much to fairs as to artists. There will be a verdict in the same way as for the market. Some fairs will survive and others will go under. Basel, Miami, Frieze, the Armory Show, and the Fiac will survive. But we have to be careful with this new outbreak of fairs: that bubble can burst too. Right now we're going through a worldwide economic crisis of colossal proportions, but art, up to a certain point, seems to be safe. What I find really exciting about the fairs are the fringe events like Liste and Nada and Zoo, where there are young galleries and young artists. There you can easily make a real find.

There are very few private-sector art patrons in France. How do you explain that?

There are probably several reasons. The first certainly has to do with a political and fiscal problem. Up until now official policy wasn't sufficiently conducive to private initiatives—unlike the United States, where most of the big museums and concert halls have always been privately funded. In France, with its Jacobin tradition, corporate patronage in the domain of culture was long a marginal affair, but now it's starting to expand. The "Aillagon law" of 2003 has really changed things: by providing

fiscal incentives it encourages business to finance art and the resultant private/public collaborations see both sides coming out winners.

Having said this, there's still enormous potential for further expansion. In France there are still lots of private sector players who don't know about the new fiscal incentives and how interesting patronage can be.

What do you see as your next move?

We will probably provide backing for Laurent Grasso, who has an interesting project planned for the Palais de Tokyo. But what we want most of all is to have the Antidote exhibitions travel to our different stores, as they do to Berlin. Then comes the medium-term plan to find a permanent venue for showing the collection in Paris.

And next year we'll be putting out a major book to mark the fifth anniversary of Antidote.

DAKIS JOANNOU Athens

Dakis Joannou

Dakis Joannou studied architecture and engineering. Today he is the CEO of a private group of diversified companies operating in construction, tourism, and other sectors. He started collecting twenty-five years ago and in 1983 founded the Deste Foundation in Athens, which shows parts of his collection as well as guest exhibitions. In 1999, he created the Deste Prize, which is awarded every two years to an emerging Greek artist. He is on the board of trustees of the New Museum in New York. Additionally, he is a member of the International Council of the Tate Modern in London, a member of the International Director's Council at the Guggenheim Museum in New York, and a member of the Committee for Painting and Sculptures at MoMA, New York. According to his wish, the following text is not an interview with questions, but rather his pronouncements with regard to a series of themes.

"There are no '-isms' anymore in art."

About the strategy in collecting art

The only strategy I have is: be connected with today's culture and try to be relevant. My interest is to be involved with what is happening around us and the way we are feeling about this. The participation in art can be expressed in many ways, and my primary expression is to have a personal dialogue by building up a collection. How you make choices for your collection is a very complex process combining who you are, how you feel, what you know, and what you don't know. I get a lot of input. I visit some of the art fairs, galleries, and biennials, but most important to me is to have a connection and a relationship with the people in the art world on a permanent basis, most of all with the artists.

Open borders, new markets, and the effects for the art world

There are obviously several effects in today's art world. The market is huge and there is a lot of art around, which I think is positive. The artists are more encouraged and empowered to produce. One negative aspect is that the artists do not have enough time to take distance and to think about which direction to pursue. The speed of today does not allow them to go into depth.

I think we are not helping the art world if we say we are collecting Chinese, Indian, or Greek art. This is geography. One should look at the artist, at what he or she is doing and how one relates to this art or how this art relates to the viewer. There are only individual artists who produce individual works, no movements. There are no "-isms" anymore. I remember in the eighties they were trying to find a term to define what was happening, but nothing stuck.

Change of Greece's art scene due to globalization

It is changing. The growth of the environment where artists are living in Greece has changed a lot. There are many more collectors now than there were twenty years ago. The extent of the market here shows that there are more and more people engaged in art, and Greek artists are much more confident, more ambitious, more productive, and they get more exposure and exhibitions abroad. They are becoming more and more a part of the global scene.

Being authentic as an artist in a global world

We have to start from the premise that all of the artists are authentic. The ones who are not authentic are not artists. There is no question about the influence of the global situation on the artists—and it is an appropriate input for their work. The environment where an artist lives and works is important for his or her work. Ashley Bickerton, for example, lives in Bali; Chris Ofili and Peter Doig live in

Trinidad. The style or even the content of their work may be influenced by their environment. The "self," however, never changes.

About art for "eternity"

This is the essence. An important piece of art is as fresh one hundred years from now as it is today. On the other hand, the collection needs breadth, context, and interaction with the art world and contemporary life. Some pieces may be stronger than others but they are all relevant: that is what makes an exciting collection. One may want to build a collection of which every piece will be as important a hundred years from now as it is today. I don't know if this can actually be done. Such a collection may lose its dynamism. In the end, it is time and only time that decides everything.

The key role in today's art world

I think everybody's role has become more important. Artists of course are the major players. The galleries have a key role in seeing where the work is going. Auction houses have a key role in pushing the prices up and accommodating people who cannot buy at the primary market. Museums of course are always influential, but lately the collector's influence has increased.

The position of "old" and "new" collectors

There always has been competition. Now there are more and more collectors who are after a good piece. Sometimes it is not about choosing—it is about being chosen. Some of the new collectors are very young. They are starting, they are tentative, and there is so much information around that they are kind of lost. They have no access to major works because these pieces go to more traditional collectors or museums. They have difficulties getting into the art market, and may have to buy at auctions. Some of the new collectors choose to remain collectors, others choose to become investors or dealers. I am not really concerned about that. They are contributing in their own way, and they are part of the system. The only negative development in this aspect is that you have to be more careful with your decisions because of the high commitment.

Public museums versus private museums

My structure has nothing to do with a museum or a traditional foundation. Deste has a very distinct way of operating here in Greece. We don't have a program, we respond to specific circumstances. I enjoy this freedom of choice, and I intend to keep it this way.

I don't think that public museums are in a crisis of survival. Many people donate their artworks to museums or lend them on a permanent basis. The current art climate leads to generosity toward museums. The New Museum in New York raised $70 million for its new building. We are not ready to write museums off, and I don't think we will have to. Europe should look at the American model with tax and incentive structures that benefit the taxpayer and encourage the generosity of the in-

Fractured Figure—Works from the Dakis Joannou Collection, Deste Foundation, Athens, 2007–08, exhibition view with works by Terence Koh, Ashley Bickerton, and Jeff Koons (from front)

dividual collector toward public museums. Private museums invariably have to face the challenge of changing their character once the collector is gone, and they may encounter funding difficulties along the way.

Art as a lifestyle in a global world

I think art is really a genuine way to truly improve your life. With some people having the ability to acquire just about everything they want, you really need something else. Philanthropy is a way of expressing yourself, and art is another way of participating and getting involved.

JOHN KALDOR Sydney

John Kaldor in front of a work by Ugo Rondinone

John Kaldor, who was born in Budapest and emigrated to Australia in 1949, has been one of the most committed supporters and patrons of the international contemporary art world for the past fifty years. He studied textile design and technology at the Textile College Zurich under the direction of Johannes Itten, previously from the Bauhaus in Germany. In 1970, after working as a designer in Australia, he opened his own company, John Kaldor Fabricmaker with offices in Sydney, Melbourne, New York, London, and Osaka. In 1969, he invited Christo and Jeanne-Claude to Australia, which was a turning point in his life. The success of Christo and Jeanne-Claude's project led Kaldor to establish Kaldor Public Art Projects, which brought international artists Nam June Paik, Gilbert & George, and many others to Australia. He was twice appointed as the commissioner for the Australian Pavilion at the Venice Biennale and is on the board of the Biennale of Sydney.

He is also a member of the International Council of the Museum of Modern Art, New York. In 2008, he and his family donated his private collection to the Art Gallery of New South Wales.

"Artists have never been independent from the global art market, same with any other profession."

What makes you collect? How did you start your collection? Is there a strategy?
I was born in Hungary and emigrated to Australia in 1949. Before reaching Australia, we spent four months as stateless refugees in Paris. I was a twelve year old, and my parents took me to all the great museums—the Louvre, the Musée d'Art Moderne, the Rodin Museum—so that I would have an opportunity to see great art before taking the long trip to Australia. This is when I became interested. I started collecting in my early twenties and have been collecting ever since. You asked if there has been a strategy: if there was, I am not aware of it. I collected works that appealed to me; it was not an intellectual quest, it was an instinctive and emotional reaction to the work.

In 1969, you created Kaldor Public Art Projects in Australia for international contemporary art. How did you start this project?
This year is the fortieth anniversary of Kaldor Public Art Projects. It has been an exciting journey. In 1968, I met Christo and Jeanne-Claude, whose work I knew and admired from magazines. f asked them if they would be interested in coming to Australia to do an exhibition and give a series of lectures. Instead they asked me to try and find a coastline! Christo and Jeanne-Claude's *Wrapped Coast One Million Square Feet, Little Bay* became a reality in 1969. The success of the work and the impact it had on the Australian art scene made me realize how it important it was that this endeavor shouldn't be a "one-off," and so Kaldor Art Projects was born.

Over the past four decades, the journey has continued and we have had a number of projects, some quiet—Richard Long, Sol LeWitt, both at the Art Gallery of New South Wales—others very much in the public eye: Gilbert & George, Nam June Paik, and Charlotte Moorman. Jeff Koons's *Puppy* in front of the Museum of Contemporary Art won the hearts of Sydney and thousands of visitors before its permanent installation at the Guggenheim Bilbao in Spain. The exhibition *An Australian Accent* took us to New York and Washington—groundbreaking works by Imants Tillers, Mike Parr, and Ken Unsworth were shown to critical acclaim. In 2007, we launched an unprecedented three projects;

Urs Fischer on historic Cockatoo Island in Sydney Harbour, Gregor Schneider on Bondi Beach, and our first educational project *Move: Video Art in Schools* for five hundred public schools in New South Wales. In 2008, we showed the work of Bill Viola, *The Tristan Project,* at St. Saviour's Church, Redfern, an inner-city suburb of Sydney. Also the Scottish artist Martin Boyce's *We Are Shipwrecked and Landlocked* in the courtyard of the Old Melbourne Gaol in Melbourne.

What was the idea behind Kaldor Public Art Projects, and how has it developed up to today?
Our mission is to operate beyond the gallery. This is an approach that has resulted in some of the most ambitious and memorable work of recent decades. Each artist has created unique, often site-specific works that have been enthusiastically received by the art world and the general public alike. Ours is a very specific role; we do not want to compete with art galleries or biennials. Our aim is to bring to Australia at least twice a year an outstanding international artist to do a project. From time to time we will also take an Australian artist to do projects internationally. Based on the outstanding success of our first educational project, we will continue to expand this new endeavor. The journey that we've been on for forty years has a very simple destination. As in the past, I want to share my passion for contemporary art with the Australian public, and so that it should continue, I want to build an organization that will make a significant contribution into the future.

How has the local contemporary art scene developed in Australia in the past years?
The Australian contemporary art scene has grown for several reasons: we have dedicated contemporary art spaces now in every state; we have the Museum of Contemporary Art in Sydney, the Australian Centre for Contemporary Art in Melbourne, the Institute of Modern Art in Brisbane. Our state galleries have important contemporary programs. The Sydney Biennale plays an important part, and the last one under Carolyn Christov-Bakargiev was a tremendous success, one of the best biennales I have seen. There are a lot more commercial galleries that specialize in contemporary art. Collecting contemporary art has become much more of an interest in Australia and has attracted a wider audience.

You have twice been the commissioner for the Australian Pavilion at the Venice Biennale and have been on the board of the Biennale of Sydney. What significance do biennials have for you as a collector and patron of the arts?
Biennials are important on several levels. If the biennial is successful, it creates a synergy and reflects the latest global trends in contemporary art. It brings artists, curators, and collectors together and is a great opportunity to gain firsthand knowledge. My concern is that there is an abundance of biennials; every city with two traffic lights wants a biennial of their own. Forty years ago there were only three; Venice, São Paulo, and Sydney. Now there are over one hundred. I believe a new formula

could be a more specialized biennial or triennial like the Asia Pacific in Brisbane, which doesn't compete with every other, but concentrates on establishing a new point of view.

More and more collectors are building their own private museums for their collections. You donated your collection to the Art Gallery of New South Wales in Sydney. What is the function of public museums today from your point of view as a private collector?

This is a very large question and really depends on the museum. You have specialist museums and then you have those whose collections go from antiquities to contemporary art. If I can sum it up in one sentence, the role of a museum is to educate, to open the eyes, from young to old, to the wonders of art regardless of the period or the style. One of the greatest pleasures I have when visiting a museum is seeing the excitement of young schoolchildren being guided.

The borders of art are becoming ever more fluid, not only between countries but also within art forms, for example art, design, and architecture. Is this a consequence of the global world?

I believe the "borders of art" have always been fluid. If you go back to the Renaissance, architecture, sculpture, painting—they were all part of their vision. It just takes different forms as our society evolves.

Art on order. How independent or dependent are artists from the global art market?

I think there is a simple answer to that: artists have never been independent from the global art market, same as with any profession. Take architects, designers, business people, they all depend on the global economy.

What do you consider the relationship between money and art? How did the current economic situation change this relationship?

I consider the relationship between money and art a necessity, even artists have to eat! Seriously, the last several years the acceleration of the contemporary art market has been unhealthy. Too many artists have become superstars. Also, many young artists are not given the chance to mature. As soon as they show promise at art school, they are given solo shows. I believe this can be counterproductive. I think all that will and has changed and we have entered a much more serious and saner period.

What are the advantages and disadvantages for the art market in the current economic world?

I believe that the current economic situation will be a period of severe readjustment in every area of the art world—museums, commercial galleries, collectors, artists, who have to adjust to the new reality, to the new austerity. Economic hardship has never stopped good artists and great museums,

committed galleries and collectors, and I am convinced that art will overcome the global economic crisis and will be there as always to point the way to the future.

RONALD S. LAUDER New York

Ronald S. Lauder

Ronald S. Lauder holds a Bachelor's degree in international business from
the Wharton School of the University of Pennsylvania. He studied at the
University of Paris and received a Certificate in International Business from
the University of Brussels, before joining the Estée Lauder Companies,
his family's business. Appointed as Ambassador to Austria by President
Ronald Reagan in 1986, he brought to his diplomatic post fluency in Euro-
pean languages and the experience he gathered during his previous service
as Deputy Assistant Secretary of Defense for European and NATO Policy.
Mr. Lauder founded the Neue Galerie New York, a museum of German
and Austrian art, in 2001, and is its President. He is also the Honorary Chair-

man of the Museum of Modern Art in New York, after having been the
Chairman of the Board of Trustees for ten years.

"In building great collections, money is obviously critical; but that does not compare to the importance of an excellent knowledge of art and, above all, a great passion."

What makes you collect?

Collecting art has been a passion of mine for as long as I can remember. I began by collecting
baseball cards. This passion represents a wide and deep cultural experience for me, and whatever I
collect, I do with my whole heart.

**You collect Modern and contemporary art, and your collection is really global. What is your focus
today, and how do you make your decisions?**

When I began collecting, I chose what I thought was the great art of the time: Picasso, Matisse, Kan-
dinsky, Klee, Manet, Cézanne, Toulouse-Lautrec. I find that I am becoming more and more interested
in much earlier works—the fourteenth and fifteenth centuries, and even going back farther in time. I
see what is available and what I like, and then I decide.

What was your idea and intention in opening a museum?

I wanted to create a museum for Austrian and German art between 1900 and 1939. This is a very
special time period, and there is no other museum of this kind anywhere else in the world.
The Neue Galerie was similar in concept to the opening of the Museum of Modern Art, which, when
it began in 1929, was not bigger than my museum. People were offered the chance to see what was
then entirely new art—Cézannes, Van Goghs, Matisses, Picassos. When I opened the Neue Galerie,
the audience was able to see Gustav Klimt, Egon Schiele, Wassily Kandinsky, and Paul Klee for the
first time in this context. It was very exciting.

You are a private collector. Does a public museum have a different intention or duty?

Not at all. To me, a museum and a private collection are one and the same, because a museum tries
to show the best of all artists of a type, and my collection is as well. I did not collect for museum
purposes, but for myself. When the Neue Galerie opened, it was the culmination of two people's

dream: Serge Sabarsky's and mine. We showed what we had and what we loved, and what we had and loved filled a museum.

When people start building a museum with the idea of having committees and looking for works of art, it is never as successful an enterprise. A committee always takes what is usually the least interesting piece, because there must be a consensus. A collector, however, has a very personal eye and a very personal passion.

How do you explain the fact that art is being treated ever more as a commodity and an investment, especially by a new group of collectors?

Many people who are buying art today have made a great deal of money recently in business, and unfortunately, they look at art as a business venture; they pay a certain amount for a painting, regardless of whether or not they really love it, and then wait for the value to increase. My purchases had nothing to do with monetary value. When I was buying Egon Schiele and Gustav Klimt originally, the works were selling for $100 each, because there was no market for them at that time. I love them just as much as the last picture I bought, for which I paid $3 million.

The reason that auctions are so successful is that, when people are bidding, they are competing in the same way as in the stock market; the amount of money they spend is public knowledge and gives a certain status.

What are the consequences of this phenomenon?

One consequence is that many people overpay for a piece that is not worth the price; they show their lack of passion, feeling, and understanding.

Do you think the auction houses are more important than the art dealer today, or who is playing the major role?

The auction houses have a great deal of influence on new collectors, giving them a level playing field with older collectors. The equalizing instrument is money. In private dealings, or galleries, the person who gets first choice is the collector who is a favorite client; the new collectors might not even get offered good pieces that way, so auctions are perfect for them.

Is it important for you that the works you collect will still be important in the future?

The best art will survive, and I hope my collections will; the rest will disappear. When we talk about Modern art today, we talk about maybe fifty or one hundred artists, but there have been thousands of artists over the years. I do believe that in the far future, Picasso, Matisse, Brancusi, and Kandinsky will still be regarded as great artists. Only time will tell.

Must art become an event in order to attract people?

I have not been to an art fair for some time because of the scene. For many people, art fairs are an extension of auctions and the party atmosphere they create. It is the same reason some people go to concerts—not to hear great music beautifully played, but to be seen as appreciative and cultured.

Do you think your type of collector and patron—one who is totally dedicated to the arts—will increasingly disappear in the future?

I think collectors of my kind have mostly disappeared; only a very few remain. Of the fifty collectors I knew in the sixties, only perhaps five are still alive. This is a new generation. When I began to collect, there were at least ten collectors of Renaissance and Medieval art; none exist anymore, because none of this art is left to buy. The best works are in museums or private collections; it is the same with Modern art.

Do you think under these circumstances there could be an end of art in the sense that it becomes a real consumer product?

I think that as long as people live, there will be art, because it can take many forms: glass, a table, a book. Art is all around us. It is a consumer product already. Every box one buys is a piece of art—the shape, the color, the texture; it may not be a painting, but it is still a work of art.

Could art become an ambassador, a non-verbal bridge for tolerance and peace?

I believe that it helps. Sometimes special exhibitions traveling to other countries can be a step in the right direction. This is a positive side of globalization.

IGOR MARKIN Moscow

Igor Markin in front of *Warhol in Moscow*, 2000, by
Alexander Vinogradov and Vladimir Dubossarsky

Igor Markin, owner of the Moscow plastics manufacturer Proma, Prolex &
Realit, is one of the biggest and most dedicated Russian collectors of con-
temporary art. While his education has nothing to do with art, he neverthe-
less began collecting at a time when contemporary art in Russian culture
was a subject that had little interest for the Russians. Young, rich, and
passionate, he opened, in the center of Moscow, the first privately owned
public and informal museum for postwar and contemporary art: Art4.Ru.

"The market was able to see farther than Warhol, and so the market will probably be able to live on after Hirst and will be able to fight the Chinese."

How long ago did you start collecting and why?

I started about fifteen years ago. I simply had to hang something on the blank walls of my new apart-ment, so I bought a couple of artworks: one by Zverev, the other by Yakovlev. That's how I started. At this time everything was completely different. I was not introduced to the market and to the system of how things go on in contemporary art; by chance I entered a gallery which is just at the end of this very street. It is not a significant gallery—nobody knows about it today. I bought two pictures of those artists because I had heard about them at the time. Ten years later I realized that Zverev's work was a fake, but the graphic by Yakovlev is still here! Step by step, I have practically become a professional art collector. I own every important Russian artist. For example, I bought three pieces by Kabakov. At that time almost no one took an interest in Russian art: it was a risky investment! It was just my own decision to risk my money; so I could choose, think it over, and wait if I wanted to . . . not to mention that the prices were infinitely lower. I never bought official or mainstream Soviet art. I have collected mainly Russian post-Soviet era art, and now I concentrate on young Russian contemporary artists. I bought pieces of art which I liked and then I threw them out, almost all of them, because they were not good enough. It wasn't until six years ago that I seriously started to deal with art in my mind and to think about it more and more. At the Art Moscow fair I met the leading gallerists. I choose art following my taste, but for the past six years I have been meeting with a great number of art critics, gallery owners, and artists themselves. They helped me to tell the "good" from the "bad," because I think that a high-quality collection should not be created just by personal preference. It should be balanced. Nowadays, I show only established artists in my museum, because if you start to work with very young artists and try out everything, it reduces the value of the collection.

How are you related to the Moscow galleries?

Moscow gallerists such as Aidan, XL, Gary Tatintsian, Marat Guelman—all those galleries are good now, but six years ago those leading galleries existed already but had nothing for sale. In 1988, the first Russian Soviet auction took place in Moscow, and there was international interest rising all over the world for Russian art. This interest stopped in the mid-nineties until 2003 or 2004. Galleries could not sell contemporary art, so artists did really badly. There was no interest—outside or even

inside the country, because Russian businessmen with money wanted to do business and not invest into art. Actually six or seven years ago, I was alone on the market; nobody bought art—Russian contemporary art—so I was just actively buying everything. I was mostly in touch with this group of leading art galleries. They gave me tips and advice. I never bought any art without discussing it with the gallerists and specialists. I learned about the artists and met with them. The goal is not to build a collection of garbage. One needs to know an artist, his place in history, and his innovations. Collections based on personal taste are often of lesser quality. Little by little, I built my collection by acquiring different pieces. There are now about twelve hundred works in my collection. Approximately two hundred and fifty of them can be displayed in my museum, and two hundred other works are permanently traveling all over the world.

Your collection is unique and renowned for being focused on Russian art. What is the place of Western art in your collection?

I have already started to buy international artists. In 2007, I bought a black-and-white-photo-based triptych of a shrimp and Asian children dressed in white by Matthew Barney. He is one of the strongest artists in the world, and I was glad to begin to acquire non-Russian artists with him. I would love to buy more but I would need more money. But now there's a financial crisis in the world, so I go slowly, step by step.

What is the function of a private foundation today in Russia?

I am very lucky; I have the very first private museum in Russia created in the last hundred years. It is a responsibility being the first. The museum is open to the public six days a week and each Friday until midnight. I would love to create connections around the world with other foundations or art centers with whom I could exchange exhibitions. The problem here is that there is not enough space to invite another institution from the outside to have an exhibition. So I organize exhibitions in other museums or institutions, of everything from postwar to contemporary artworks I was able to collect up until now.

Do you provide any educational activities in your foundation?

Nobody teaches contemporary art here in Russia. I give lectures here but only concerning the development of Russian art. It is well attended, by about eighty people, each time, which is quite little but a lot for Moscow. I am planning to enlarge the museum, but this would only be possible if I collaborated with someone else. I'm not interested in investing my own money anymore into the center of Moscow. If this foundation were to move to a bigger place, it would mean a large investment, because a large space in the center of Moscow is very expensive. That's why I would try to share with somebody else, but not with the city because Art4.ru should remain a private foundation. There

actually exists the possibility to do so, not with another collector, but with an enthusiast whom I know and who really likes the idea.

What is the place of Russian art in the emerging art markets today?
Russia is a part of the European context and civilization. European, Russian, and American art should be considered alike. Their fields of ideas and interests are equal. India is a different matter. It is constantly producing new ideas, both in the economy and in the art world. The world is attentive to the directions India takes, and their ideas are more easily accepted. On the contrary, Chinese contemporary art appeared like a big bang, and I don't like it anyway.

Do all of those new emerging markets, where so much art is produced, represent a danger to the individuality of an artist?
I don't think there is any danger, because genius artists will always remain—it doesn't matter if they are mainstream or if they're part of a boom. Japanese art, for example Murakami—he is an outstanding artist who would have been noticed even if there was no passion for Japanese contemporary art at all. Some Chinese will also remain, maybe three or four.

Is it important to you personally that an artist stays popular? How important is art for eternity?
It is very important to me. Everyday I ask myself the question whether I am on the right track, and I don't have the answer. If some of my artists were still important and a star in a hundred years, then this would be a sign that I made the right choices. Money is not a priority, but for me the commercial side is very important and very interesting, because when I see the auction results and I see that some works I paid £60,000 for a couple of years ago are now going for a million, this for me is the sign that I made the right choice at the right time. I see art as an intellectual exercise.

Russia's new rich, who are already spending millions of pounds on their art collections, are now moving into contemporary art. How do you explain the phenomenon of the boom of billionaires in Russia and their brand-new interest in art, and not only in Russian but in international art?
Contemporary art is also glamorous. It becomes fashionable and Russians are very much into fashion. Most of them buy art to furnish their houses and apartments. If somebody like Abramovich is collecting here, it means there will be a thousand people who will start collecting. I set the trend, Abramovich sets another trend for more modern and postwar art, and then the Russians follow, even if they don't know anything. They came into the art world with little experience and knowledge, compensated by enthusiasm. It has been a kind of explosion until recently. It was something new, and now it will probably calm down again.

With its well-established fine art fair, now attracting Western galleries, and the Moscow Biennale launched in 2005, the city is firmly on the global art world map. Do you think there is a place for foreign galleries here in Moscow such as Gagosian?

The first professional gallery from abroad was the Gary Tatintsian gallery from New York. He opened his gallery two years ago and was very successful presenting very good contemporary artists such as Tony Matelli, George Condo . . . He was the first one who was successful in selling Western contemporary art to the few Russian collectors in Russia, living here in Moscow. It is not a bad idea to come to Russia.

How do you perceive the relationship between art and money today?

This is one of the first questions my lectures were talking about. Big money attracts more people to contemporary art. Contemporary art plays a small role in Russian society, but it's becoming fashionable and we want people to participate in it, to show people that it is as interesting as going to a new movie. We're batting for people's attention, by organizing those lectures. People come and they don't understand what this art is all about, but if they know that the price is $10 million, then they're interested. This is very important. I'm not talking about investors but about simple spectators, people shopping around, and a public that is not interested in anything if the price is low. They don't know anything about it and they don't want to know. If they know it is worth a million, they will be interested. It's the same system on Broadway: it's always written how much the production of a play cost, with a movie there is always an amount of money mentioned. With art it works in the same way. The new Russian millionaires and billionaires don't know anything about art, but they would buy it because it is expensive.

What does it mean for the arts?

In the nineties, there were a lot of very talented people who quit the arts. Artists didn't want to be involved in the art process because they started to do other businesses just because they needed to make some money. Now they are back and are able to finance their lifestyle by creating art. For example six years ago, I visited Semyon Faibisovich at his apartment in Moscow, and the whole apartment was full of big paintings that nobody wanted to buy. Now they cost $60,000 and the gallery sells them very well. The artist is now back to doing art because before he could not afford to create.

How independent are artists from the art market—the galleries, the auctioneers—today? Should artists market their own art?

In my opinion, it's very positive that artists earn a lot, but there are very few star artists earning a lot. More than ninety percent of the artists are very poor and they just struggle. An artist can only marginally promote his own work because his time should go into his own creativity, and that's why

Igor Markin, Moscow, 2006

they need the art market and the galleries. So I consider the gallerist very important in the career of an artist. They bring art to other people by explaining the works; they are looking for new emerging artists to show.

How do you feel about these amazing profits that the auction houses continue to make internationally?
On one hand, it's good that the art market does not have many problems. There is a recession in real estate and all kinds of markets, but so far the art market has not really felt that, which is positive. The negative part is that things start to be less unique. That's what happened to Damien Hirst, who created two hundred pieces and sold them all in one auction. He does his own marketing; he created exactly as many works as he could sell. The other aspect is that he can't stop repeating himself constantly, but he was able to sell everything in one day. I don't appreciate that. I don't like when artists repeat themselves, but at the moment it is actually normal as everybody pushes artists all the time.

Do you think more artists will follow the example of Damien Hirst? Do you think they will devalue themselves? Do you think art has become an inflationary product because people are willing to pay any price?
I think the prices will fall. Art is under the influence of inflation, as everything else. I like Damien Hirst, he is a good artist, but he is playing with fire and auction houses are playing with fire too. It just worked this one time. There are a lot of collectors who are investors, so they probably didn't think about it twice. They just watched this diagram from before, and they said it is a new project and it will go up anyway. Nevertheless if you look around there is good art and there are good artists, quite apart from the question of price. There is no difference between Damien Hirst's concept and the whole of the Chinese contemporary art because Chinese artists produce their art cheaply in a factory. It's all the same quality, but the world gave Chinese art a chance and they were able to do what they wanted to. Everything sold.

What is art now—is it a mass product? Are people still sincere about art?
I am personally sincere about art. I spend my life with art and I want to continue to collect unique art. I refuse to buy endless replicas of famous things. I like to buy the first of a kind.

Artists like Murakami and Richard Prince have worked with corporations, in particular with Louis Vuitton. What do you think about that—the mass market bringing art to the public this way?
I like Murakami very much, but this is certainly mass culture. They have to sell a product. It's not a tragedy that Murakami appears on their handbags, but it is a tragedy when Louis Vuitton bags appear on Murakami's pictures. They use art as a marketing tool, but the artists are doing it and using it as well. Warhol did it for General Electric, and then he sold pictures representing General Electric. So

actually the story of an artist reproducing himself started with Warhol. The market was able to see farther than Warhol, and so the market will probably be able to live on after Hirst and will be able to fight the Chinese.

GUAN YI Beijing

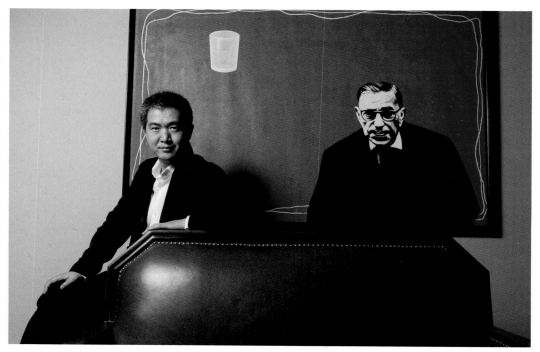

Guan Yi in front of *He Is Himself—Jean-Paul Sartre*, 1980, by Zhong Ming

In only a few years, forty-two-year-old Guan Yi has assembled the largest
and most important collection of contemporary Chinese art within China.
It contains around seven hundred outstanding Chinese paintings, sculptures,
and large-scale installations from the last thirty years, among them artworks
from established artists like Huang Yong Ping, Wu Shanzhuan, Gu Dexin,
Zhang Peili, Ai Weiwei, Wang Guangyi, Zhang Xiaogang, and Fang Lijun to
young artists like Wang Xinwei, Xu Zhen, Cao Fei, Zheng Guogu, Liu Wei,
Zhou Tiehai, and Yan Lei. Guan Yi's collection is on display in a warehouse
in Songzhuang village on the outskirts of Beijing—his private museum. Born
in Qingdao, Guan Yi studied philosophy and art history and is now doing
research on collecting. In addition, he is working on his personal vision for a
revolutionary contemporary art museum concept in China that would cover
the last thirty years of art history.

"Globalization of art: art utopia or the feast of capital?"

When did you start collecting?

After the year 2000. The reason I started collecting was the so-called Chinese culture utopia period in the eighties. In that time a lot of information was coming in from the West, even though the economy wasn't developed. But it all came to an abrupt end after June 4, 1989, when the suppression of the students' protest took place. After that the country met a cultural impasse. During that period, I had been an unknown artist of abstract photography who was infatuated with art and philosophy. When the reforms were launched and encouraged economic freedom, a new road for creativity was open and I decided it was time to cultivate my biggest interest—collecting.

What do you think is the most important thing in art collecting?

The most attractive thing about art is the possibility which it provides for the future, and the capacity of self-denial, self-renewal, and self-revival. Instead of being fixed in a rigid standard, art is changing and enriching our worldview all the time; it brings us a new understanding of things and helps us to find a new way to look at the world, and thus make new discoveries. The freshness and dynamic of art is the most important thing to me—this is why I have such a great passion for art.

Why are you so attracted by large installations?

It's not necessarily that I have a specific interest in large installations, for example I also have a good collection of video art. But it's true that a lot of the artists I'm interested in, like Huang Yong Ping and Gu Dexin, are working with installations so that's what I get to collect.

Why do you want to build a museum?

First, the current space is not big enough to house the increasingly large number of artworks, and a lot of the installation works and projects I've collected could not be realized here. Videos and performance art cannot be displayed either.

Second, I have been collecting every important art node in the last thirty years of Chinese contemporary art history. I want to save a complete contemporary art history covering that time for China and show it to the world as the country's true face. The conceptual art from 1984 to 1989 is not only the cornerstone of the awakening of Chinese contemporary art but also records the powerful development of Chinese contemporary art. This development is closely related to the eighties, when everybody was influenced by the cultural utopia period—it is the most important part of my collection. In those days I was inspired by Nietzsche and Sartre: I was always thinking about the meaning of

life. I cherish those years; it's like what the artist Gu Dexin said: "During that period of time, we had everything except for money and large houses."

What is the importance of Chinese contemporary art in Chinese and world art history?

The last thirty years of development of Chinese contemporary art have coincided with the second modernized ideological enlightenment of China. It is an immensely important period in our history: these were years of great change in China, in our society, in our ways of thinking. Due to the demand for democracy, Chinese contemporary art was changing from formalism to conceptual practice and art language practice. Chinese contemporary art created exquisite works of art.

Chinese contemporary art is absolutely important for China itself. There is no doubt about that. Apart from that, it is the best and the most important addition to the international contemporary art world. Although modernism originated from the West, in China it has already turned into a new kind of contemporary art with a unique disposition, a freshness and dynamism—the singular Oriental worldview and aesthetic have thoroughly permeated Chinese contemporary art. At the same time, there are a lot of problems which cover the true face of Chinese contemporary art: China is the most complex, conflicted, and impulsive place in the international art world. For world contemporary art, Chinese contemporary art is unique and peculiar. It is as important as the Chinese economy is in the world.

What do you think about the impact of globalization?

Capital crosses the edges of countries, politics, nations, and culture: one hundred to one hundred and fifty international art stars have emerged. There would be no further cause for criticism if all of them were the most important artists in the history of art, but what is the truth? Is it an art utopia or the feast of capital? Is the financial crisis the folding wings of capital, or is it the chance for the coming back of the world art spirit? We cannot help asking who cares about the really good art in the world. We call on all the serious art museums, curators, critics, and galleries to hold together in order to give world art history a real and more dynamic future.

What do you think about foreign museum activities in China like that of the Ullens Foundation in Beijing?

I think the Ullens Foundation is quite admirable for what they have been doing in terms of scale, and it has truly been an exemplary model for China. The Ullens' operations experience and their art education program are great examples for China. The foundation offers great access for the Chinese to the international art scene and art practices happening elsewhere, but it is not a self-motivated Chinese museum—it's almost like foreign aid. It is definitely not instinctively locally motivated. However, it is important for the Chinese people to find their own way and express their own positions.

Detail view of Guan Yi's collection with works by Huang Yong Ping,
Ai Weiwei, Wu Shanzhuan, Lin Yilin, and Yan Lei

How important are the biennials here in China for the local art scene?

The biennials, starting in 2000 with the Shanghai Biennial curated by Hou Hanru and the 2002 Guangzhou Triennial curated by Wu Hong, provided China with an international scene for contemporary Chinese art. It was definitely a new art-historical perspective for China and the Chinese audience. It was an art experimentation—for Chinese artists, the art scene, and the public in general. It had such a conflicting impact for the state and the museums in China. But now with the international phenomenon of exhibitions sprouting up everywhere at frequent intervals, the initial impact we had from these biennials and triennials has really became a visual overload. We're exhausted from these events. They have become more ambiguous and more formalistic and have lost a lot of their originality. They increasingly become something rather fashionable.

One curator I greatly admired was Harald Szeemann. Harald Szeemann was one of the key figures for Chinese contemporary art, as he was the one who curated the 1999 Venice Biennale where Chinese art was shown. To me he was the model for all young curators. That is why I keep Szeemann's portrait here in my conference room—to motivate myself and to warn myself that I must always be searching for really good art.

Which art galleries do you think are valuable in China?

The galleries have definitely provided positive input and have pushed contemporary Chinese art forward: ShanghART Gallery in Shanghai, Vitamin Creative Space in Guangzhou, Chinese Art Archive in Beijing, Boers-Li Gallery in Beijing, Beijing Center for the Arts, Shanghai Gallery of Art, Long March Space, Tang Contemporary Art Center, Galleria Continua, Arario Gallery, doART Beijing, Galerie Urs Meile, Pace Beijing.

What does collecting mean to you?

Two sadnesses must be explained to answer this question: First, it is symptomatic of government ideology that there was not only no systematic collection and protection of the last thirty years of Chinese contemporary art, but also no understanding and acknowledgment of this advanced culture. This is the sadness of a country. Second, Chinese people began to accept Chinese contemporary art when the art market began to rise in 2006; Chinese contemporary art was accepted as a way of capital appreciation, not because of cultural awareness. And this is the sadness of a nation.

Because the country failed to do that, it provides individuals the chance to find a way to be related to the society. If you can save the last thirty years of contemporary art history, it will mean a lot to this country, this society, and this nation. So I have to treat my collecting seriously.

Huang Yong Ping, *The Nightmare of George V.*, 2002

MUSEUMS

FRANCESCO BURANELLI Holy See, Vatican City

ROBERT STORR Yale Art School, New Haven, Connecticut

MARC-OLIVIER WAHLER Palais de Tokyo, Paris

FRANCESCO BURANELLI Holy See, Vatican City

Francesco Buranelli in front of the Laocoön in the Vatican Museums

Born in Rome, Francesco Buranelli studied Etruscology under Massimo Pallottino and received his doctorate in 1987. In 1983 he began his career at the Vatican Museums in the department of Etruscan and Italian archaeology, becoming its head in 1993. In 1996 he became acting general director of the Vatican Museums, and in 2002 John Paul II appointed him general director. Most recently, he has actively supported the acquisition of contemporary art by the Vatican Museums, expanding its collection of modern religious art and commissioning important sculptures from distinguished artists such as Giuliano Vangi, Mimmo Paladino, Jannis Kounellis, and Igor Mitoraj. In 2000, he commissioned Cecco Bonanotte to design a new entrance for the Vatican Museums. He held the post of director until the end of December 2007. Pope Benedict XVI then appointed him secretary to the Pontifical Commission for the Cultural Patrimony of the Church.

"After long years of disengagement, the Church has signaled its desire to resume a dialogue with contemporary artists."

What is the difference between the Holy See and the Vatican?

The fact is that relatively few people know the difference between these two terms, and public opinion often confuses or misuses their legal and institutional meanings.

The Holy or Apostolic See is the government of the Catholic Church, with the Pope as its supreme head. It exercises the function of the supreme pontiff of the Roman Catholic Church and is a legal person under international law. By contrast, the Vatican City State is the territory over which the Pope is granted autonomy and sovereignty in both his roles as head of the Roman Catholic Church and head of state.

The Vatican City State—generally abbreviated to Vatican City or even more simply to the Vatican—is, at only forty-four hectares, the smallest state in the world. It is surrounded by the city of Rome, and at just eighty years old is one of the youngest European states. It was founded on February 11, 1929, as a solution to the so-called "Roman question," and was confirmed by the Lateran Treaties between the Holy See and Italy.

What role can art play in both intercultural and interreligious dialogue or relations?

In modern societies, cultural heritage is assuming an increasingly central role in defining identities, both in the rich countries, but also—and more importantly—in the developing ones.

Identifying with the art of their own culture encourages everyone to learn about their own roots, and to be proud of their particular forms of artistic expression. For this reason, individuals and organizations are increasingly using artworks to present themselves in a better light to the people they need to talk to, especially when those people come from countries with very different cultures. Cultural events and cultural exchange have everywhere become important means of opening up dialogue and overcoming political mistrust, even between countries with difficult diplomatic relations.

The importance of this "mediating" role becomes even clearer when the conversation extends to intercultural and interreligious dialogue. In this area, art can transform itself into a universal language that everyone can understand. It is a means of expression that arises out of human emotions. An artist is someone with the capacity to touch the sensibilities and souls of all human beings, and this can prepare people's hearts and minds for an open and constructive dialogue.

We live in a global "high-tech society." What is the Holy See's approach to art in this context (such as the Internet, and so on)?

This question concerns the position of the Holy See on computers and multimedia. The Church has always been ready to use any means of communication available to spread its message of peace and love. Its official newspaper, *L'Osservatore Romano*, was first published in 1861. Since 1931 the Vatican has had the use of a long-range radio transmitter, built with the help of Guglielmo Marconi. Later on, the Vatican television center was gradually added. An official Internet site has existed for a few decades now, enabling people to follow all the activities and official news from the Holy Father and the Church. However, much still remains to be done, particularly in the field of using art to spread our message, and of transferring the Holy See's cultural heritage onto computerized archives.

How did the Holy See come up with the idea of participating in the Venice Biennale of 2011?

I've been thinking about embarking on this particular "adventure" for a long time now, as I've always been fascinated by the idea of a new dialogue between the Church and contemporary artists. But to explain this we need to go back a bit, to the pontificate of Paul VI (1961–78). Over the past years, the Roman Church has gone a long way toward winning back its central role of providing inspiration and guidance, which history has always granted it in the past. Indeed, Paul VI himself announced, in his historic speech in the Sistine Chapel of May 7, 1964, that it was vital to recognize that the "break" between artists and the Catholic Church needed repairing. Since the age of the Enlightenment, and down through Romanticism and the Positivist era to our present times, art has increasingly lost the ability to engage seriously with religious themes. The Pope recognized the Church's own responsibility for this, in that it had not maintained a proper dialogue with artists—the only people "capable of coaxing the heavenly spirit into revealing its treasures, and transforming them into perceptible language, color, and form"; the only ones who possess the divine gift and are able to represent the union between transcendence and immanence. The artists' response was so enthusiastic and generous that in 1973 Paul VI was able to open a special section in the Vatican Museums dedicated to "modern religious art." The same phenomenon also occurred in the dioceses, where archbishops and bishops encouraged and set new standards for contemporary art.

This new course was firmly established and further strengthened during the long pontificate of John Paul II (1978–2005), in particular by the founding in 1989 of the Pontifical Commission for the Cultural Patrimony of the Church within the Roman Curia, and by the pontiff's now famous letter to artists written one year before the Great Jubilee of 2000.

I myself have been following this development with interest ever since John Paul II appointed me general director of the Vatican Museums. I performed this office for eleven years, until 2007, and it offered me the opportunity to put into practice several of the Papal guidelines. During this time, I vigorously pursued a dialogue with contemporary artists and showed a readiness to take new risks in the field of culture. Sometimes I did this to make our collection better known and better appreci-

ated, but my main aim was to turn the museums into a meeting place where people could exchange views. This not only resulted in a considerable expansion of the collection, but also led to the Vatican Museums resuming their role as patrons of the arts. Thus I invited two sculptors, Giuliano Vangi and Cecco Bonanotte, to make a sculpture of Pope John Paul II, and to build a new entrance for the Vatican Museums. At the same time, important artists offered works to help us expand our modern art collections.

This signal was much appreciated. When Benedict XVI promoted me to be secretary to the Pontifical Commission for the Cultural Patrimony of the Church, I had the good fortune to find that its president was His Excellency Monsignore Gianfranco Ravasi. He demonstrated his readiness to take this initiative forward, and ensure the institution continued along the way set out for it by Paul VI.

What are your criteria for choosing artists and their works for the pavilion? Do you have any distinct ideas about this yet?

Unlike the other countries participating in the Venice Biennale, the Holy See finds itself in the unusual position of being the only state with no indigenous population. Only the Pope, the resident cardinals, the highest dicasteries of the Curia, the diplomats, and the few officials needed for administrating the departments of the small state are citizens of the Vatican. Among them there are no artists. On the other hand, the Holy See has representatives all over the world, and takes an active part in the cultural life of all the countries in which it has a presence. Any artistic language, even that of countries with very different cultures, can be the language of the Church, so long as it has the courage to engage with spiritual matters. For this reason, the Pontifical Commission for the Cultural Patrimony of the Church is interested in inviting a select group of international artists to exhibit their work in the Pavilion of the Holy See. These are artists who quite clearly symbolize the religious spirit of the times, and who above all are capable of expressing themselves in variety of different ways and of working in very different media. In a number of interviews, Monsignore Gianfranco Ravasi has already mentioned names like Bill Viola, Jannis Kounellis, and Anish Kapoor, just to give some idea of the standard and the kind of work we would hope to show.

Could the Holy See's participation in the Venice Biennale of 2011 also be a reaction to changes in our society?

I wouldn't so much describe it as "a reaction to changes in our society" as an opportunity to open up a dialogue, to discuss and reflect on the important themes of our time. The theme of the sacred and the search for God has always held a central position in human life. In the past, art has exemplified this fact through works of unparalleled perfection. I am convinced that the spiritual growth of all human beings, especially in the particular case of artists here, can and will surprise us with new masterpieces and new and expressive proposals for future artworks.

How can contemporary art convey the essential content of religious faith?

There's no simple answer to this, because neither faith nor the sacred possess any specific visible form, and cannot always be directly represented. However, an artwork can convey its religious nature through its overall effect; sometimes through its iconography, other times through the emotions it inspires, although these can also be aroused by the handling of the material in an abstract work. Abstract works can also be religious. It depends on the disposition and intuitive understanding of the particular artist, and his relationship to the supernatural. Many find they can access this very easily, almost quite naturally, since they've had the advantage of a religious upbringing and education; for others, by contrast, it is a long journey through different levels of consciousness, which culminates in the search for God and for the supernatural.

What role does religiously inspired art play in our global society?

I would distinguish between works commissioned for places of worship, which serve specific liturgical purposes—since it is important that these emphasize their meaning, and since they almost always symbolize a holy subject—and works of a religious character in the broader sense of the term, which have come out of the artist's own personal search and need. You could count several abstract works among the latter kind of work, including, for example, a simple piece of canvas by Lucio Fontana. Once you recognize it as an attempt "to grasp the glimmer of perfection," then it assumes a spiritual value.

By broadening the notion of the religious, the artwork, in whatever form it takes and in whatever materials it is made, becomes a legible work, one that is capable of "making visible the invisible" beyond the realm of the visible—as Paul VI so felicitously put it—and thus enabling the viewer to perceive the divine nature of things.

For many centuries, the Church was an important patron for artists, craftsmen, and architects. Recently, Gerhard Richter was commissioned to design a window for Cologne Cathedral. What is significant about this, both for the patron and the artist? How did this process come about?

After long years of disengagement, the episcopal conferences and bishops of the Church have clearly signaled their desire to resume a dialogue with contemporary artists.

The case of Cologne Cathedral, which is not a unique case, is one of the most highly symbolic instances of this new approach. The incorporation of a window designed by Gerhard Richter—one of the best-known contemporary German artists—into the interior of an exceptional Gothic building, rich in ancient works of art, has inspired an open and lively discussion. I personally consider it a work of the highest artistic value, one that respects the atmosphere of the building while avoiding the easy solution of simply imitating something old. It also seems extremely important to me that we give people a chance to try out new solutions without always criticizing them. Incorporating contemporary works of art into an existing and often ancient building is an undertaking of the utmost delicacy and complexity. But if you think about it, it has been one of the most common practices in places of worship from ancient times down until the present day. Let us not forget how each of our beautiful churches is the result of centuries of accumulating works of art, and of instances of redesigning and reinterpreting its structure. I think there is not a single place of worship that has not been altered, enriched, and restored many countless times. The final outcome depends on the quality of the particular alteration and the taste and sensibility of the patron and the artist.

What's always important in such instances is to approach the issues with subtlety and sophistication, and take every aspect into account—theological, architectural, artistic, and, if necessary, considerations of town planning as well. Then, if you're working on an old building, you also need to weigh up how the changes you make will affect what already exists, without forgetting what kind of context

you're working in, and without ignoring the particular kind of sensibility you've already acquired in the process of preserving and restoring historic buildings and monuments.

Could the non-commercial aspect of these commissions end up influencing whether artists decide to accept them?

It depends what you mean by commercial. If you're talking about the artist's fee and making sure they're properly remunerated for the work of art they make, then it seems to me perfectly normal that they should receive this, as it has been over the course of many centuries. Nevertheless, in these days of economic crisis, we see that in many cases artists are offering their work for free, which I happen to think adds to the value of the work. The fact that the artist makes the artwork for his own pleasure and that of everyone else, without seeking any kind of payment or profit, emphasizes that his involvement is genuine and not self-interested.

The Catholic Church has a long tradition of collecting art, and is the most important custodian of art in the world. What are the challenges posed by owning such an enormous amount of art, such as the problem of conservation? How are these resources used to teach others knowledge of history?

This question concerns the most highly technical aspect of administering the artistic heritage of the Holy See. The Pontifical Commission for the Cultural Patrimony of the Church is the central advisory body for a variety of questions concerning preserving and evaluating the largest and most comprehensive cultural heritage in the world. The individual bishops' conferences as well as the different dioceses are implementing, in conformity with local legal guidelines, the central regulations. In recent years important outcomes have been achieved. A detailed inventory of its possessions has been produced, which has led to an indispensable archiving of the treasures of the various diocesan museums that have been established all over the world. In the Vatican Museums the situation is somewhat different, since it comprises one of the oldest and most important collections in the world, which is served by a series of excellent specialists. This is a structure that, to put it briefly, already works in accordance with clearly defined, internationally ratified guidelines.

ROBERT STORR

Robert Storr

Robert Storr—since 2006 the dean of the Yale Art School—is one of the most influential and leading figures in the global art world. He studied history and French at Swarthmore College, painting at the Boston Museum School, and ultimately received an M.F.A. in art from the Art Institute of Chicago. He was hired as a curator of painting and sculpture at the Museum of Modern Art in New York in 1990 and was serving as senior curator by the time he stepped down. In 2007, he directed the Venice Biennale. In addition he has taught classes in both studio art and art history at numerous institutions such as the Institute of Fine Arts at New York University, the Rhode Island School of Design, Temple University's Tyler School of Art, and the University of Pennsylvania. Over the years, Robert Storr has written frequently for such publications as *Art in America, Artforum, Parkett, Art Press,* and other magazines; he has two bimonthly columns that appear regularly in *Art Press* and *Frieze.*

"Money talks, but it does not have a lot to say."

What made you decide to become the dean of Yale Art School, after being a curator, critic, author, and artist?

There are many factors but the principle one was that I thought it would be interesting to go back to the beginning of the process. As a curator one deals with emerging, mature, and sometimes mid-to-late-career artists, but it is very exciting to deal with people as they are just coming into their own as artists. I began teaching art thirty years ago—studio practice, art criticism, and art history—which I continued during my time as a curator at MoMA, so it is a perfectly natural environment for me. I left MoMA for a variety of reasons, and I was not eager to go right back to the same situation with another museum. It is a combination of opportunity and a sort of desire to change the mix. I still write catalogues and organize shows around the world. I am always engaged on multiple levels, and I balance what I do for a living with my other interests or whatever is the next step. For this period of my life it seemed to me working with younger artists would be exciting and fresh. In many museums the job of a curator is increasingly a matter of servicing the taste of high-end donors, and this has never been my preoccupation. I work very well with patrons and donors, and I have very good relations with very wealthy people who have a serious interest in art. But that is very different than being a personal shopper for somebody who is not really interested in what you know and only wants you to help them do what they are already determined to do, or get what they are determined to get! One of my aims at Yale is to make this school more international. I'd like to open it up to a greatest possible variety of countries and cultures with regard to both faculty and students—to have an interactive, cosmopolitan exchange with the wider world.

How do you prepare the students for today's art world, especially for the art market?

It is not our job at all to prepare students for the art market. Individual faculty members may counsel students about the opportunities that come to them, or may give them advice out of their own experience, but we concentrate on the work they do. We talk about the work without the market being a factor on top of it. Suppose students go into a group critique with their peers and with established artists who are there only to discuss their work as art: if they then feel somehow that in the background lurk figures representing a gallery, a collector, a museum, or a company, it's possible the words that their contemporaries, their professors, or visiting artists say to them may be discounted or read differently. It is very important that young artists who wish to go to school have time to focus

on the creative activity itself without second-guessing their careers. Only after students have come into their own creatively should they ask practical questions about how to enter the professional or commercial world. In art school students should still have the opportunity to experiment and evolve with their work and to take the risk to move on and outgrow their initial successes and failures, which is always painful in the beginning but also a chance and challenge to grow. Being an artist is very difficult, as everybody knows, but most of the stories we hear are the success stories. What you don't hear are more complicated stories. For example, stories about artists with really serious reputations, artists admired by other artists and curators, who nonetheless make almost no money or very little money relative to their equally famous peers. Or perhaps they make it for several years and then suddenly they are no longer fashionable. That happened to Bruce Nauman, for example. He had a major retrospective in 1972 but after that had a very up-and-down life until the early eighties. America at that time was focusing on Pop Art and Minimalism and the conceptual work done by him and many others had relatively less support in the U.S. It had more support in Germany, Switzerland, or the Netherlands. I am not saying that art and commerce never meet. That would be nonsense. But you have to be realistic about the risks and realistic about the costs to the creative process of having that happen too soon or in the wrong way. There are artists like John Baldessari or Gerhard Richter who at an early stage of their career destroyed their formative work, because they felt it was not good enough—there have been other first-rate artists who have done this. Still others have let their juvenilia circulate and then regretted it. Creativity, self-criticality, and courage do not always come in the same proportions. For all those reasons, art schools should not be in the business of career management or career promotion. They should not be moralistic about it, but realistic.

How important are art schools today?

They are important everywhere. There are very few contemporary artists who have not spent some considerable time in art schools. Not all of them get degrees. In America it is more common to get degrees, partly because here one of the sources of income is to teach. Nowadays, it is virtually impossible to get a full-time or even a good part-time job without a degree. For many artists, taking such jobs has been a basic way to survive, especially in hard times similar to the present. For example, Brooklyn College used to be a very well-known art school because within a span of a few years Louise Bourgeois, Philip Pearlstein, Ad Reinhardt, Mark Rothko, and Lee Bontecou all taught there. Their faculty positions paid for the rent and materials. Some people teach because they like the engagement with younger people; Baldessari is good example of that, or Wayne Thiebaud—and then of course there was Joseph Beuys. The school environment is potentially a very important anchor for sustaining a community, for providing young artists some ballast and some background and to keep older artists in touch with new ideas. As a teacher you give something and you can receive something in return—it is an exchange. For all these reasons, schools can be incredibly dynamic organisms. This might be less true, though, in big art-market towns like New York, where the market

is so strong that the time commitment and complications of maintaining a career are likely to make teaching very difficult for busy artists.

Which role or purpose does art have today?

It has as many purposes as it has makers and viewers, I suppose. But I subscribe to the belief that art does not fundamentally have other reasons for being beside the fact of its existence and the ways it manifests its own intrinsic logic. Which is not the same as saying: art is for art's sake. However, to say that art has any sort of "a priori" cultural agenda is very problematic to me. There are cases where this has existed, such as in Russia, Holland, or Germany in the nineteen-tens, twenties, and thirties, when there were numerous avant-garde movements and a widespread sense of social or political mission among artists. And there are artists who believe that a social or political dimension is essential to their practice; take Hans Haacke, or Leon Golub and Nancy Spero. But you cannot say that this is true of art categorically. Robert Ryman believes that painting exists in order that we may have things to look at that will enlighten us, not in order to fulfill a public purpose. Gerhard Richter believes that painting is a way of posing certain questions, but he does not answer them, and maybe they are fundamentally unanswerable. If the question involves politics that does not necessarily mean that the work takes a position on politics. Félix González-Torres really did think that art had work to do in the world, and he chose some very subtle ways of accomplishing that. It depends on where the artist is coming from generationally, culturally, and intellectually. Felix was a refugee from communism in Cuba, Gerhard was a refugee from communism in East Germany, but they had very different approaches while neither fell into crude anti-communism. Certain artists have made extraordinary works that would not have existed had they not held certain strong ideas, while others have made equally significant works out of their equally strong doubt about similar ideas. By making those works, the concepts their activity addresses become significant, meaningful, and challenging. There is a wonderful statement that de Kooning made, to the effect that most art is not made because of big ideas—how big an idea is it that you paint a Romanian blouse? He was talking about Matisse. In many cases the most profound works are made about a discovery that begins with a simple intuition, and the intuition becomes complicated and more articulate as the artist proceeds to articulate it in forms and materials. Then suddenly even the artist can see that there was something they did not recognize, which was implicit in their work. But most artists who set out to try and solve the big problems of history and consciousness don't get very far.

Do critics still have an importance today in the global art world?

Critics have an importance in the art world. The question is what kind of importance and if they have power, which kind of power. Some voices are strong in some places, but not necessarily everywhere. I am thinking of the kind of criticism that has come out of *October* magazine, which is very powerful in universities and in a few museums that do historical or thematic kinds of exhibitions.

But it is of no consequence whatsoever in the world of collecting. It is too often unreadable, and in any case many of the collectors are not the kinds of people who read that sort of thing—they would rather read art-historical books, memoirs, catalogues, et cetera. Clement Greenberg was a very important critic in America in the fifties and sixties; he was one of the people responsible for making the reputation of Jackson Pollock and others. He was a good polemicist and a good writer, but he had exceedingly dogmatic ideas and he imposed them on a situation that was more pluralistic than he wanted it to be. He was also very damaging to some artists and very restrictive to certain kinds of understanding about art. In a way much critical discourse today is the legacy of that dogmatism. There are other critics who serve the market, who operate as pilot fish or tipsters. I think they have derivative power because almost none of the tipsters actually range very far afield from where the dealers have already been, so they help the process along and "grease the rails," but I do not think there is any tipster critic now who has real power. Nevertheless some critics of that kind are very clever. Often what they do is provide the smart remark that people can use at a party, or supply some sort of capsule formula that everybody can refer to. It is not as if they have no talent or no ideas. But most of them do not have any vision at all, because they lack real conviction, real passion, and as soon as fashion moves on, they move.

What does an exhibition of contemporary art need to be good? What are some criteria according to you?

First of all there are many types of exhibitions. There are different genres, different scales, different opportunities for making exhibitions, and good ones have a lot to do with how well the curator understands the situation they are in—the cultural situation, the historical moment, the physical realities, et cetera. A good exhibition in Istanbul in 2004 might not be such a good exhibition in Los Angeles in 2004—and then again it might be. It depends how you judge all these factors and how you pull together works of art that are actually more interesting than your premise. Too many exhibitions now have very complicated premises but then turn out to have not such complicated work. What you really want is a simple, provocative, open-ended premise and then work that opens it up and develops multiple perspectives on that unifying concept. What you don't want—at least what I don't want and most of the serious public doesn't want either—is a "walk-in" seminar paper.

I think a lot of exhibitions are driven by a desire on the part of the organizer to sound important, to make intellectual claims that cannot be sustained. After all, very few curators qualify as serious thinkers by the standards of the academic disciplines from which they draw their ideas and information. They may read a lot of books—or pretend to have read them!—and they maybe are able to quote a lot of authors who are in vogue, but it does not make them original minds. Yet they may have interesting intuitions, they may have good inquisitive eyes—they would be much better off using their eyes and their intuitions than trying to build a big thesis-based show and then making something that does not work. We must never forget that an exhibition is a form. It is not a formless thing: it is

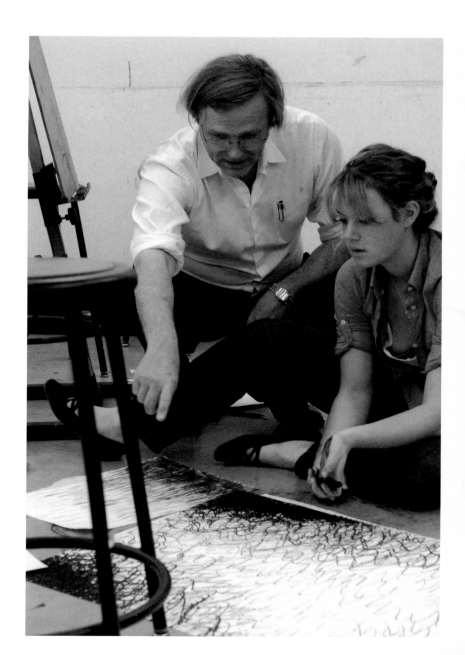

a form and there are many variations of the most common varieties of that form. One of the primary considerations in thinking about how to give an exhibition its proper form is how much can a viewer actually absorb? How many works do you show? How are they laid out? How many miles do you have to walk? Many bad exhibitions nowadays are good exhibitions that got out of control! Like some of the Documentas that ballooned out of proportion. They become incoherent as a whole, and the relation of object to object gets lost. It becomes punitive to the art because the viewer is thinking only about how he or she can survive the marathon. They are not looking with full concentration as they might and are just waiting for the end of it to come—like a movie that goes on too long. Bad exhibitions are characterized by too many things to look at, too many ideas—or too few—masquerading as an impenetrably complex discourse, as well as by excessive didacticism, incoherent installation. Those are the negatives. What is left over are many different opportunities for making many types of good shows!

There are more biennials, triennials, and more art shows than ever before. Did art just become a big global party?

The party part is another issue. The global question is more interesting, especially if you consider, as I do, that while the word "global" may apply to the commercial relations among interconnected markets, it does not describe the movement of ideas or the networks of the imagination. Local art worlds used to be small, and there used to be a relatively small number of them overall. And, of course, there was never just one center for all of them. It was never just an issue of Paris and then New York and then maybe Cologne or London—it was always much bigger, more far-flung, and more diverse than that. But now we have something that is incomparably bigger—and that is good. Take Latin America, which has been producing exciting art since the early teens of the twentieth century, which is roughly speaking the same time that Modernism hit North America; Rio, São Paulo, Buenos Aires, and Caracas have had very important art for a very long time. However, relatively little of that art was shown on the international circuit until recently. The gradual growth of the art system has nurtured and given outlets for active scenes that existed without those outlets. They have become more active, and more people have access to them than ever before. It is good that as developing countries come into their own economic power and cultural consciousness, they take an important place in this. Many of the new biennials are in such countries: China, Korea, and so on. I think well-made biennials in places where there are no big gallery systems, no big museum systems, or maybe not any real art infrastructure at all are very, very important and I think there should be more of that. The difficulties come if each of these biennials becomes a variation on the last one and fails to actually carve out an identity that is clear. The Havana Biennials have been interesting because they focused on developing countries that were left out of the international system, and that is a key point. Or the Asia–Pacific Triennial in Brisbane focuses on that part of the world. Part of the task that is

ahead for people promoting such projects is to understand that although you may want an international show, that does not and should not mean the same thing everywhere.

What do you think of the new cooperative interest between museums such as MoMA or the Metropolitan Museum of Art with Berlin, lending their collections. Is that a new way of financing a museum?

These are very complicated issues, and I am still trying to figure out what the limits should be. It is clear to me, though, that there have to be limits. Take the simpler problems. From the conservation point of view alone, the risks are extremely high. There are certain paintings that just cannot be moved. For example, at MoMA, we never loaned Warhol's *Gold Marilyn* because it is so fragile, so thinly painted, so brittle, that it just can't travel without being damaged. This came as a surprise to some people—indeed we were often challenged when we said "no" to requests—because the picture is not very old, whereas there are other older ones, even more valuable works that we could loan. A lot of these judgments start at the level of "doctors and patients." If your conservation team says this painting can be moved twice more in its life or never again in its life, then the decision institutionally, curatorially, is about sticking to your guns and saying, well never, or if it is twice, then it can only go to the most important shows that come up in the next thirty, forty, or fifty years!

Another issue is not so much medical or ethical; it is the question of where and in what context works have yet to be seen, or need to be seen the most? If you have limited options, where will their presence be of greatest concern or consequence? I think loaning valuable works to the Guggenheim Las Vegas is nuts. Art exhibitions in casinos out there are sideshows to the main attraction, which is gambling. Not that there is nobody intelligent who can look at pictures in Las Vegas, it is just that there are not enough people who go to Las Vegas for that purpose to make the city the best choice if you have a limited number of options. I think that museums owe it to both the artists and the public not be stingy about loaning in situations where the presence of important works will have a real impact. Moreover, it is fair to charge some kind of fee. And within reason, whole exhibitions can be sent as packages to places from which comparatively few people will be able to make the trip to the source—Treasures from the Hermitage or Treasures from the MoMA, et cetera—but it is not a good thing just to rent individual works or clusters of works as an income stream. Reciprocal lending used to be and should remain the way that museums maintain relationships with each other, with little or no money changing hands because in the long run everybody benefits. If one institution starts to gouge or monetized their collection as a road show, it throws the whole equilibrium off, making it harder if not impossible to obtain works when a genuine aesthetic or historical need for them is greatest. If a museum does not own the work it shows—for example, if its collection in substantial measure remains under the control of a patron who lends but does not give, like Eli Broad at LACMA—then that museum will not have much loan clout or lending capital on its side of the ledger to counterbalance loans that it may seek elsewhere for its programs. But if an institution

starts tacking on excessive surcharges or effectively installs taxi meters on its crates, the kind of relationships that should exist among museums gradually, indeed rapidly, break down. I am not an idealist in a starry-eyed kind of way, but I am a sufficiently idealistic person to think that much is lost if we become careless about sustaining these relations. Failing do to that will almost certainly have major consequences down the line in terms of the quality of exhibitions that museums will be able to mount, and so in terms of the quality of work that the public will see. It's bad business and in every other way short-sighted for museums to try to plug a hole in their budget by circulating their collections like video rentals. Great museums large and small take the long view!

How do museums, art fairs, and the art market interact?

Museums are there for the general public. They are there to make selections on behalf of the general public. People who do not have money to buy art, or people who do not have access to art education in a broad sense but who are interested in the visual arts, can come and find out what is going on in their world. Museums are like public libraries, and they should be the place where you can see a wide variety of works that are of interest, of seriousness, of quality—but are not necessarily the most sought after by the market or by fashion-conscious collectors. If you want to see a really interesting work by somebody who is no longer in vogue, you should be able to find it in the museum. Museums should collect fairly broadly and audaciously, but they should not collect simply according to the trends. A smart museum person pays close attention to the market, in part so that he or she can figure out how it might be possible to acquire works that are affordable before everybody else wants them and they are no longer affordable. This holds true for older work as well as newer work, work that has fallen out of favor for a while and is being rediscovered.

Nowadays, I don't think that any museum has the power that the Museum of Modern Art once had, when an acquisition by MoMA was considered a green light for everybody else. This is not true anymore. I think that MoMA has missed out on many aspects of contemporary art, or waited until too late and paid dearly for its lack of daring and decisiveness. But it is also true that many things it has done right have not been followed. It is a much more open field now, and in a way that is good. There is a famous, somewhat cynical but somewhat true remark by Bill Lieberman, former curator at MoMA and at the Metropolitan Museum, to the effect that good museum curators don't collect art, they collect collectors. And it is certainly true that because of his friendship with certain collectors, he was able to get great works of art for both museums. This is definitely one strategy, and every good curator does that to some degree. But just following the taste of wealthy patrons is not the answer. Curators must have a vision of their own and the skill to persuade patrons to consider their perspective and ultimately support their vision.

So much has changed since Bill's heyday. Now people in senior positions have to be both good curators and good managers. Still, some curators are very unrealistic about it; they expect to get the backing of patrons but refuse to engage with them. Worse, though, are those who are nothing

more than agents for collectors. Curators must be able to make their own judgments regardless of art-world consensus and based on their independent understanding of the institutional situation as a whole and of the state of art at the moment; they must try to build alliances with collectors who can help them do what they need to do for the museum. But an institutionally based curator should never work for a collector! Curators work for museums on behalf of the public. I've made it very clear to all of the collectors I've worked with that I will help them to get the best work by this or that artist on the condition that they give it to a museum. One of the real problems now in the curatorial world is that not enough curators actually stick to this rule, which means that the ones who are scrupulous about it are at a decided disadvantage, while suffering from the cynical view held by many that all curators are just hired hands of plutocrats. But the museum field as a whole will suffer as a result of this, everywhere!

There are of course a lot of critics who assume all museums are corrupt or all patron-curator relationships are corrupt. According to them "institutional critique" will tell us how to live after capitalism is over, but in the meantime institutions are all alike in being equally expedient and compliant in relation to the power of money and nothing can be done about that. This is nonsense! The question is how to live in this environment and act in ways both ethical and efficacious. That's not always easy and you cannot always win, but anyone with museum responsibilities should use every means at their disposal that will help them to steer a reasonably steady, reasonably straight course. You can't just wait for the revolution to make things right. You also have to know how to compromise and how far to go and when to stop. You have to know how to remain cordial with people who treat you as a professional—even when they do not do what you asked of them. The relationship of a curator to the patron has to be candid and respectful on both sides!

How important is the relationship between money and art?

It is usually important to certain kinds of art and not very important to others. That may seems like an uninteresting answer, but it is true. Although to my knowledge there are no undiscovered geniuses out there—no Van Goghs—there are certainly artists who are terribly undervalued by the market but who nonetheless make really important art. Then there are others that everybody knows about and everybody collects or wants to collect. Take Damien Hirst, or Murakami, or even an artist like Lucian Freud. Their financial standing has little to do with the importance of their work as art. Freud is a forceful but very conservative painter who has contributed something significant to figurative painting, but he is not in the same league as Bacon, and Bacon is not in the same league as Picasso—just to speak of traditions to which they are in some ways allied. But why he costs so much money now has more to do with how certain people want to spend their money than it has to do with the long-term aesthetic or even art-historical judgments.

These extremely high prices are in very narrow segments of the art market. The art market is experiencing a series of bubbles: there were bubbles in the sixties that went to the recession of the

seventies. Now inflation is global. There is a bubble in the transatlantic art market—not long ago that bubble looked like it might blow, but suddenly the Chinese art market emerged and bolstered the galleries and the auction houses. And suddenly the billionaires in Russia decided they wanted to buy art and that propped up the market some more. Then not so suddenly, but gradually in the same context, the Indian economy started to explode, and there was more money to support the collecting of certain people there. Then add the exponential oil boom of the Emirates and the growth in Brazil, which has had a long-standing art world but now is beginning to have a new generation of wealthy people.

At some point, though, somebody has to buy what you want to sell! Of course, in the background of all this furious circulation of art as a commodity or of art as a fashion item, there is the question of real collectors who are not intending to sell, who are intending to buy and hold and give. But we know that most of these transactions involve people who will buy and sell. Who is going to buy a $100 million Bacon? Three people—four, five? There is a lot of work by Bacon out there, and if every Bacon becomes a $100 million Bacon, nobody can or will buy them all. The dealers and the auctioneers are clever people, and they try to control or at least channel irrational exuberance, but irrationality is by nature irrational and at some point you have to pay the piper. I certainly cannot make a prediction about how long this meteoric rise in the market will last; it is unprecedented, but it is not infinite. There is certainly not a sheik or an oligarch for every work of art that is going to come on the market. Nor will an underdeveloped art market emerge somewhere in the world every six months or every two years! Nobody is thinking hard enough about what happens when the air starts to leak out of the balloon, but it just defies reason to think that a leak won't start soon. Bubbles are always the creation of people who rationalize irrational things. The first casualties of the inflated art market will not be the very expensive works of art, it will be the mid- and lower-market artists whose income will suddenly flatten because nobody will want to buy their works. They won't look like the next escalating artists because there is not going to be room for more escalation. All the focus will be on maintaining values in those areas where investments have already been made very heavily. So you may find that Murakami and Hirst and some others of the younger people are unaffected, but there may be other artists who are pretty famous whose rise stops abruptly, or whose values actually deflate dramatically. We have seen this already in history. And if things get bad enough, even Hirst and Murakami will come down hard.

The desire to spend time with or even to own a work of art and to look at it is a perfectly valid thing. In that sense good collectors may be forerunners of shifts in popular taste. But, once again, good collectors do not buy to flip; they buy to hold and to behold. The market we are talking about is mostly about buying and flipping within a five-year period, or a six-month period. That market is completely a bubble at this point, and it is boring. Still worse, it is dangerous to art and the serious discussion of art! There is an American expression, "Money talks." That's true, it does. But with respect to art-as-art, it doesn't have a lot to say! If you are discussing a work of art, the least interesting thing you

can tell me or anyone else is that it costs $50 million or a $100 million. The next least important thing you can say is that Bacon was a homosexual and a raging alcoholic, or that Freud is the grandson of Sigmund Freud or that Balthus liked young girls. The important question about their work should be, "What makes it compelling and complex as art?"

MARC-OLIVIER WAHLER

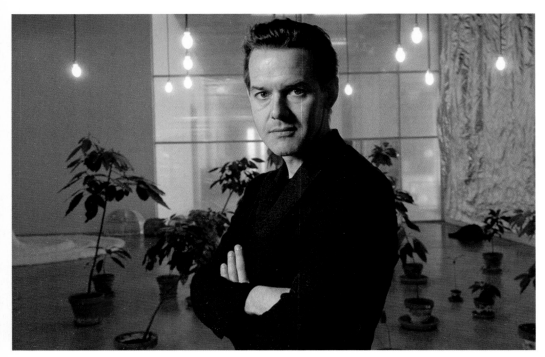

Marc-Olivier Wahler

Mens sana in corpore sano: no better way of summing up Marc-Olivier Wahler, born in 1964 in Neuchâtel, Switzerland, and raised in a family whose supreme values were manual labor and the liberation of the mind through sport. It was not until his teens that Marc-Olivier Wahler began to take a real interest in art; since then his thinking has been shaped by a wide range of studies, notably the French art history tradition and English-language philosophy. He sees this diversity of ideas and cultural/intellectual perspectives as a protection against the worst danger of all: ossification. Following this personal path, he became joint founder of the Neuchâtel Art Centre in 1995, and was subsequently appointed to the Swiss Institute of Contemporary Art in New York. Since 2006, he has been director of the Palais de Tokyo in Paris, a museum that follows new strategies. Wahler writes frequently, not just on contemporary art, but also on subjects as diverse as quantum physics and Mike Tyson.

"It's the margins that keep the lines in place."
—Jean-Luc Godard

In your opinion, what are the current criteria for a good contemporary art exhibition?

When I was living in Neuchâtel, my idea of contemporary art was the Abstract Expressionism of the fifties. Gérard Schneider was a major influence for me at the time. I was fifteen when I discovered this kind of art and it just blew me away. I'd gone to see one of Schneider's exhibitions in Zurich and by chance, in a state of exhaustion, I stopped off in a gallery plunged into total darkness; I sat down and a totally incredible world appeared before me—the world of James Turrell. Later I met Olivier Mosset; I'd seen a number of his exhibitions and he would later initiate me into contemporary art. When I saw his red monochromes show, I couldn't get it out of my head for a week: there was nothing to actually "see," but maybe that was the thing that made the transition to contemporary art happen for me. So I think that the best kind of exhibition is the one that starts to work on you once you've left.

Contemporary art's a mental and kinesthetic experience, but above all it's a way of keeping spiritually healthy. Olivier Mosset once said to me, "If you succeed in seeing a work as a work, then the world can stay as it is." There's something incredible about this, because if you can see a work—a monochrome, for example—for what it really is, that means you don't have to go looking for a story or interpret some set of symptoms or other. We have to be able to shake off all the cultural filters, the ones coming from advertising and propaganda and so on. If you can achieve that, the world can really stay as it is—set free of those filters. And I think that's great!

"Keeping spiritually healthy"—is that the message of your recent *Carte Blanche for Jeremy Deller* exhibition?

That's absolutely the message, in that Deller offers the public not artifacts but originals that have already been useful in some way. They belong to history and are symptomatic of periods like those Russia went through in the twenties and the United Kingdom in the seventies. Take the objects relating to electronic music, for instance: they can be approached from an aesthetic point of view—or not—without undermining their usefulness or the function they once performed. In the twenties, there were specialists out looking for new, revolutionary ways of playing and experimenting with music. It's up to us to put the results into context, but here the artist offers us the different possibility of going to the roots of things; he does this by facilitating the most appropriate, most receptive reading of the work while ensuring its autonomy at the same time.

This isn't the Umberto Eco principle of the open-ended work where anything can happen, however: here the work stays autonomous and independent. At the same time, as for any work of art, it can't be apprehended immediately: the viewer has to put in an effort. Let's compare a work of art to a house: you've got Victorian-style houses with a door, a romantic flight of stairs, and so on—readily intelligible houses. But today the work of art has to be seen as a slightly more frustrating kind of house (even if the internal structure—kitchen, living room, et cetera—stays the same), with the possibility of entering by a different door each day. So you try out different paths; that's what contemporary art is about, and that's what interests me. I call it the schizophrenia quotient: the higher the quotient, the denser and more effective the work, and the greater the range of interpretations. This is what sets the work of art apart from the everyday object, which brings us back to the ontology of the work of art and what was going on in analytical philosophy up to Arthur Danto, when the question was no longer "why" but "when" art existed.

And from there to all those questions philosophers have been obsessed with: why, for example, at some given moment is an everyday object transfigured into an aesthetic one? And in respect of this process of transfiguration, interpretation is fundamental. The everyday object doesn't automatically generate different interpretations: a chair is a chair, it's something useful and you sit on it. But a chair becomes a work of art when you start to interpret it differently. So the process of transfiguration gets under way when more than one interpretation is made possible. And there can be a host of interpretations without any loss of autonomy for the work, which in fact gains in density and effectiveness.

Five Billion Years, **your first exhibition at the Palais de Tokyo in 2006, signaled the geographical expansion of art. What's your feeling about the globalization—the deterritorialization—art is undergoing now?**

The main point of the *Five Billion Years* exhibition related to Einstein's observation that there is no fixed point in space. As we know, five billion years ago the expansion of the universe, which had been slowing down since the Big Bang, was abruptly and inexorably accelerated by a cosmic upheaval. And ever since, the universe has been in a state of constant expansion. No getting round it, there's no fixed point anymore. Einstein made this clear already almost a century ago, and now it's an integral part of artists' work. Contemporary art revolves around this idea of time—of a before, during, and after—and the idea of shattering the fixed-point categories on the timeline. Art institutions, on the other hand, continue to labor under the illusion that a fixed point is still possible somewhere, but at the Palais de Tokyo we're trying to work with the notion of an endless shift. Globalization's the symptom: endless shift means no fixed point and no center. There's no center and no periphery, because the terms imply fixed points. Art is possible everywhere and has begun accelerating inexorably.

Today we talk about globalization because frontiers have opened up and there's a constant stream of information. In art, though, this is nothing new, because there's no fixed point and the endless shift has always been the order of the day. An artist who locks himself into a category—an "ism"—is

static and necrotic. The thing artists are interested in, and I'm fascinated by, is the notion of freedom. Take John Armleder for example: no categories and no limits. But when he makes something, it's something that stays autonomous and purely personal and is like nothing else at all.

This mystery by which the artist, keeping his intervention to a minimum, manages to come up with kinds of UFOs that don't fit with the definitions, is itself beyond any possible definition. Which brings us back to the schizophrenia quotient. The artists who interest me, whether poets or painters, are the ones who, like mathematicians and physicists for over a century now, have given up selective logic—"this/that," "black/white"—in favor of additional logic: "this" *and* "that," and "that" again. Today, if you want to survive, this logic is the only way to go. Selective logic imposes choices on us: something has to be either Western art or Oriental art. No! Obviously art doesn't work this way.

What connection do you see between exhibitions and the art market?

The Palais de Tokyo has quite an important role to play. The function of this kind of art center is to present works that don't have a direct relationship with the market. We usher in new artists while also working with artists whose works won't necessarily be market-oriented. This is very important for us. We have no illusions, though: we know that one way or another they'll end up being co-opted by the market. It's a question of survival: the market is so powerful that artists are naturally inclined to produce works for it; the temptation is always there, but that's not what the artists are really about and the Palais de Tokyo is there for when they genuinely want to make things that are unique. Think of Herzog & de Meuron: they've come up with incredible projects and all of a sudden they do the Saint-Jacques stadium in Basel. They took some flak for that, with people asking them why such great architects should work on a football stadium; and their reply was, there's haute couture and there's ready-to-wear. That's an ever-present reality in the art world, the danger being that the market is very much about ready-to-wear and quantity output. But if there's no place for haute couture the entire system goes lopsided. So at the Palais de Tokyo we're a sort of quality label—we guarantee the artists. Take Fabien Giraud and Raphaël Siboni, for example: they're aged twenty-five, they have no gallery, and we've helped them produce a work at a cost of €150,000. Obviously there's an enormous risk, but it had to be taken; and if we didn't, who would? Not the galleries, because the financial risk is too high. I understand that. And it's not their role, anyway, it's ours.

Is art becoming more and more of an event?

Since 2000, the art world rationale has indeed shifted from exhibition to event. This explains the exponential increase in biennials and fairs. The emphasis on the event means artists have to keep up, otherwise they fall by the wayside; and for better or for worse this obviously has a partial influence on output. You have to sift out the good stuff, but the situation's a very dangerous one because you can see that art institutions have fallen under its sway, too; this is even the case with museums that should be concentrating on their collections, because big events are a great PR tool and a great way

of raising money. So everybody needs big events, even if only for economic reasons, but the fact is that for lots of institutions this is happening to the detriment of their thinking about exhibitions. The decision at the Palais de Tokyo has been to think in terms of real exhibitions and a different kind of tempo: exhibitions lasting three and a half months, six weeks, one month or just one night (every Thursday there's a talk, performance, concert, et cetera). So there are four different tempos, like four different chapters.

You yourself are known for your skill in finding patrons: for example, it's thanks to you that Maja Hoffmann has become one of the Palais's most generous backers. How do you see the interaction between museums, patrons, and the art market?
Patronage is the focal point of the battle. Hundred-percent public sector backing is a French tradition and one that has worked very well. But there are other traditions, too. Simply put, private support is a necessity now. And new legislation, notably the Aillagon Law, means that things have really changed here over the last four or five years. Since 2006, backing from business has increased fourfold and the mechanisms that have been set up have turned out to be highly efficient. As far as corporate support goes, at the Palais de Tokyo we're keeping a close eye on all the fundraising instruments: the art world saw the financial crisis coming two years ago and that's why we've been working on a system of patronage by private individuals, along Anglo-American lines. Right now we're setting up the Tokyo Art Club, an exclusive English-style club where artists can rub shoulders with corporate and private patrons. We've got a system of interaction between the business and art worlds that's going to generate real synergy in France and internationally. The Palais de Tokyo's going to be a mind-boggling platform for artistic experiences and production.

How does the Palais de Tokyo compare with other art centers around the world?
In France, the Palais de Tokyo is the art center flagship. Internationally speaking, it's not up to me to say, but you can get an idea from the coverage in the *New York Times*, the *Financial Times*, and the *Guardian*, which have real clout. What I've noticed is that whenever an art center's being set up, I'm asked for an opinion. And what's for sure is that the Palais de Tokyo has become a model—at least in France—for its responsiveness, its internal organization, and its economic structure, whence the importance of supporting it. Economically, we're fifty-five percent independent, which is something new in this country and something other art centers can take inspiration from. We're there to help them, especially in France where this kind of experience is not so common. We're there to show them that given the right tools you can get this economic model working. In international terms, when I was working at the Swiss Institute, it was running on seventy percent private sponsorship; before that, in Switzerland, it had been one hundred percent private. None of this is new to me, then, but funding is always a struggle: after 9/11 in the United States we lost forty percent of our budget and we had to stay right on the case to get through the year, otherwise we would have had to shut

The Third Mind: Carte blanche à Ugo Rondinone (2007–08), exhibition view, with Sarah Lucas's *Car Park* from 1997

down. It's this responsiveness that's got the Palais de Tokyo through all these crises, and this is because Jérôme Sans and Nicolas Bourriaud had set up a sufficiently flexible economic structure.

In the July 2008 issue of *Technikart* you were asked, "Are there too many biennials?" You replied that now every exhibition was like a biennial, even going so far as to compare them to football matches in terms of the "big-event" or "fast-food" thinking behind them. What do you think biennials actually mean now on the art scene?

We still need biennials. If all of a sudden someone discovers contemporary art thanks to a biennial in Katmandu, that's great, I'm delighted. Except that my feeling is that this isn't the way biennial organizers see things. The idea now is much more that of some self-serving event: the biennial has become a career tool for the curator, and this to the detriment of what the public sees. Imagine a curator who does three biennials a year, one in Japan, one in Canada, and one in Brazil. How does he go about it? Maybe he'll visit two or three times, draw up a list of artists and then come back for setting-up a few days before the opening. And what do you get? Maybe not a bad exhibition, but an exhibition

with no soul. A real exhibition needs the soul of its curator—and its artists, who also won't have had the time to come along and think about the space.

The outcome is biennials that look like contemporary art fairs. There's a damaging standardization going on. Today's biennials are coproduced by galleries because nobody has the money to produce large-scale works, so you've got the whole market system driving things: the big-event system for self-promotion by artists, gallerists, and curators. That's what's happening in most cases, even if there are still biennials that are exceptions to the rule. Venice, of course. And Documenta, which is more than a biennial: it's a true exhibition, with the curator thinking things through for five years. He has the time! I'm not saying the biennial model doesn't work, it's just that the people involved are often involved in countless other projects and that's a problem. You can be the World Exhibitions Champion, but if you don't have the time you can only do things in a half-baked way.

What are the jobs a museum director has to take on these days? Art protector, expert, event manager?

My job is almost that of an old-style curator, in the sense that the director of a museum used to be an art expert who took care of exhibitions while providing intellectual collateral. The difference being that in those days the curator didn't have to worry about management. This new function forces us to go looking for funds and run our teams at the same time—two different things.

In 2007 in the United States there was a big debate about the museum director's role. Some people said there should be both a curator and a manager. I don't agree with that: in practice it means distortion of the program, because the person who decides on the "final cut" is the one who holds the purse strings. I'm completely behind the second school of thought, which says you can't have a financial director *and* an artistic director. The reality is that today you can't separate the two. Maybe it's more difficult to find the right person, I don't know, but whatever the case, the director has to be a curator and the curator has to be the manager. That's vital! When I came to the Palais de Tokyo, I set up a new team with an assistant director who looks after areas like the media and patronage, and a new woman administrator. We're a kind of basic triumvirate in management terms. But in the final analysis there has to be someone to take responsibility and in my opinion that can't be two people. If things don't work out, someone has to take the consequences. And that's me.

Do you still think artists can create something unique in this globalized world?

There's a split in art right now. There's market art, which has become a sure thing, something you can invest in and speculate on. This is the image most people have, because this is what interests the media. When you read the papers the focus is always on a work that's broken a record in the salesrooms or the carryings-on of some artist. That's the big-event rationale, that's what gets artists into the celebrity press. But it's all only surface froth, because there are also artists who are working and thinking and producing things which, for a while at least, beat the market logic and truly keep

you "spiritually healthy." There are artists and works that maybe represent the last outpost before the advance of the TV culture that tells us, I know what you like, I know it even before you do, and I'm going to give it to you right now. Contemporary art is a kind of intellectual bastion that puts that kind of thinking into perspective. It can happen that the TV/spectacle rationale shows this froth up as exactly what most artists reject, even though it's inevitable and there's no beating it. At the same time the Palais de Tokyo is under an obligation to stand surety for the alternative approach and for spiritual health.

Why are there so many art foundations now? What part do they play?

There are people who pay part of their income tax by setting up foundations. This means they can have closer control over the use of the taxes by distributing them directly to artists and creative activity. The state might have done this anyway, but in any case foundation people decide to put their money into a public interest body (such as the Palais de Tokyo). It's a more considered, more personalized way of paying your taxes, an approach that's both financial and intellectual.

What do you think of the "Bilbao syndrome": the dramatic redevelopment of an otherwise ordinary site?

Bilbao's an example of how to create not a museum but an event, using an extraordinary building backed up by the whole big-event rationale. I see Bilbao as a kind of showroom for American art. When I went there, it blew me away: that magnificent cathedral presenting American artists, and straightaway you're saying, "Wow, fantastic!" Then you come to the European section, which has been deliberately made tiny and cramped, and the presentation is a disaster and you say, "Hey, European art's hopeless." You can't call it a truly expert museum: they've created a very special kind of event and it works—it's an amazing propaganda tool for American art. It would be interesting to know what their real agenda is.

And the latest cooperative venture: the Louvre and the Guggenheim in Abu Dhabi?

It's corporate thinking at work. Every company is condemned to expansion, that's the way things are. Capitalization means the fixed points necrose. A business like the Louvre or the Guggenheim has to keep active, expand, create events; so they open branches elsewhere.

In an interview, your predecessors spoke of the Palais de Tokyo as a brand, a label that could be exported internationally. Where might you envisage another Palais? There have been rumors of Edinburgh or Buenos Aires . . .

It's something we're doing in a humorously detached spirit. We set up the "Chalets de Tokyo" because a chalet is a place you go to when you have the time, or that you lend to friends. The Chalets mean we can put on micro-exhibitions in Naples or a big exhibition in Buenos Aires. There's no rule,

no model—the Chalets are for trying out things we can't always do here. The Palais de Tokyo has an incredible media impact: our newsletter goes out to fifty-five thousand subscribers and the big media keep tabs on us, so we might as well pass on the benefits to curators and artists who are a long way from having that kind of access. The Palais de Tokyo travels, too: for example, we put on an exhibition at the International UFO Museum in Roswell, New Mexico. In Naples, there are lots of artists and curators, but it's very hard for the curators to find an international audience. So we've set up a sort of international organization of curators we have a special relationship with and work differently with them. It's not a colonialist approach: we work with local and international artists by creating cells that lead to the creation of new spaces. The only model that interests us is art.

GALLERIES

CLAUDIA CELLINI The Third Line, Dubai

DONG JO CHANG The Columns/The White Gallery, Seoul

ARNE GLIMCHER PaceWildenstein, New York/Beijing

JOHN GOOD Gagosian Gallery, New York

MARAT GUELMAN Marat Guelman Gallery, Moscow

MOHAMED ABDUL LATIF KANOO Ghaf Art Gallery, Abu Dhabi

PEARL LAM Contrasts Gallery, Shanghai/Beijing

GERD HARRY LYBKE Galerie Eigen + Art, Leipzig/Berlin

CLAUDIA CELLINI The Third Line, Dubai

Claudia Cellini at The Third Line in front of a painting by Farhad Moshiri

Dubai has been synonymous with superlative economic growth for some time. Now it is in the spotlight again with its aim to join the global competition for the most successful future art market. One of the experts of the still very young Dubai art scene is American Claudia Cellini, co-owner of the gallery space The Third Line. When she and the Iranian Sunny Rahbar opened their art space in 2005, together with Omar Ghobash from the United Arab Emirates, they were the pioneers in the just-emerging art market of the Emirates. In their warehouse, they feature cutting-edge exhibitions with artists from across the Middle East as well as realizing a concept that goes far beyond the traditional program of a gallery.

"Dubai is an international city, but our primary focus is building a rapport with the local community."

Why did you choose Dubai for opening a gallery?

Because I think Dubai has a great potential to serve as a base for an art scene, an art movement—to effect a change in the way people have come to understand the contemporary development and identity of the whole region. There is a special situation here in the Gulf: Dubai seems to be an area where there is a certain amount of freedom, a lot of activity, and a special economic force which is helping this process to advance. People here are using their money in interesting ways—some purely commercial and some for perhaps more righteous ventures. But whatever it is, when there are funds available, they can be used to develop the arts. That was one reason I came to Dubai.

In terms of supporting the art scene, this can be turned into an advantage compared to Beirut or Cairo, which have beautiful, rich art scenes but little income base to support the artists to get out beyond the city or that country. In places such as Cairo or Beirut, there is the local audience and then a collaboration with international institutions such as the Ford Foundation, Goethe Institut, Alliance Française, and so on. There is very little interactivity regionally. At this point in time, Dubai is definitely showing signs of developing an art market, where you sell and buy art. This is a very important development for artists from the region—a much closer financial base for their work. This I think is just the first step in what a place like Dubai can offer.

What kind of art do you represent in your gallery?

We show contemporary art relevant to the region—predominately artists born and bred in the region or part of the region's diaspora. Up until recently, artists lacked professional representation within the region. This is a problem within the Gulf, in terms of not supporting the arts and developing them in the best or most fruitful manner.

How important are the galleries for the emerging art scene in the Emirates?

As there is still little support for the artists from the local governments, the galleries are vital—but even once the government begins developing programs of support for the artists and the art scene, the role of the gallery is instrumental to an artist's professional development. A gallery brings in new artists, creates discourse on a more mature artist's career, and helps grow an audience for varying aspects of the art scene. A gallery cultivates language and familiarity around an artist's work or specific movements. Within the entire region, there is still the misunderstanding that all the gallery

does is tack on a commission to an artist's work. We find we spend a lot of time educating people on the role of the gallery for an artist's career.

You follow a special gallery concept . . .

Audience development is perhaps one area you could single out. An audience rapport was one of our biggest concerns in opening our space. In our gallery shows, we try to go beyond the boundaries of what might be commercially viable and show art that hasn't been shown before to our audience base. We also try to afford our artists a more complex platform—allowing them a chance through their exhibitions to reach a higher level professionally.

Along with traditional gallery exhibitions, The Third Line runs regular non-profit programs to build a varied audience. We host film projects and periodic art talks; we have an Arabic and English-language literature group that discusses novels published by Arab writers. We hold the international forum Pecha Kucha every three months. According to the principles of Pecha Kucha, which comes from Japan, you get six minutes and forty seconds and no more than twenty slides to present a creative idea to a rowdy audience. It's a very successful project, and we are proud to be the first in the Middle East producing such programming. We want to connect to people living in Dubai and to people in the region who want to stay in the region.

Is there a real interest in contemporary Arabic art in the Emirates?

The first time we held Pecha Kucha, we had over four hundred people packed in the gallery! So the interest in contemporary art is increasing rapidly—the need for art is there. Ten years ago there was very little in the way of contemporary art programming. But now there is not only a huge boost in art but also a strong effort to make increasingly complex work. Although there is very little institutionalized support for the artists, the government realizes more and more that they need to invest in culture and take a great responsibility. We have clients from different parts of the world, but we are not really focused on the international market just yet. We are really trying to build up a local audience and local market.

Due to globalization, gallery owners are networking all over the world. Do you plan to open other gallery spaces?

We just opened a second space in Doha. As of yet we are not thinking about the West beyond the important art fairs. It's not that we don't want to go to the West—we have discussed representation in New York and London. But we think we want to stay in this region and stick to our work here. We want to be based locally, think locally, communicate locally. That is one of the major issues for the Middle Eastern art scene. We need the local language, local thought about local culture. Usually English is always the language to analyze the local art production, but it should be the other way

round. The art should analyze us. So being based here now is important. At a certain point we may go global later.

What possibilities exist for artists to get an appropriate education in the Emirates so far?

Most of the local educational possibilities are based in the Emirate of Sharjah: there are universities, artist-in-residence programs, art societies, museums, the Sharjah Biennial. But more and more institutions are coming up also in Dubai and Abu Dhabi: art schools, art forums, further museums. The issue of censorship exists in the United Arab Emirates, but it is not the major obstacle to artistic practice and production as might be found elsewhere in the region.

If it is such a global population here, is it possible at all to create any authentic art for this specific Arab region?

Maybe yes, maybe no. Is there an authentic Western art? Look at the music. Jazz and hip-hop are considered to be Western music, but in fact there are African influences, African roots. I think we shouldn't make the distinction between Western art and Eastern art. Therefore I wouldn't say the geography is so important: everything is global now. The artist wants to speak more to a culture or a circumstance than to a location, to reach an audience beyond geographical boundaries.

As it is only quite recently that universities have offered art degrees here, it is difficult to say right now what the local art production can potentially become. So far, not many people have gone through a local art education. Most of the artists my age had to go away to Lebanon, Cairo, Europe, or the United States to study.

What are the most important venues for the art scene here?

The Sharjah Biennial is very good, not only for the Emirates but also for the region. Especially since the 2005 biennial, which was directed by Jack Persekian and HH Sheika Hoor al Qasimi, they are really making a step forward each time. For this year's ninth biennial, for instance, they are putting up grant proposals so artists can apply for grants to produce special art for the biennial. And in between biennials, they are also increasing programs that bring in international artists to work in Sharjah. Then there are the auctions and Art Dubai. Both have also become essential for this young art scene. Art Dubai is a magnifying glass on the global market for the regional art scene. There are more and more people coming in from all over the world, an increasing number of international gallery spaces participating. Through their presence, the art fair has fueled a certain dialogue. We are excited by the international market, which will help us to sustain, and which will give us help with bigger and better projects for our artists, because that is what it is all about.

Do women play a role for the development of an art scene in the Emirates?

Yes, indeed. There is a special link between art and its support by women in the Emirates. Members of the royal families in particular are increasingly playing a role in the arts. Several of them attended university for art and are building careers in this field. We have women's colleges and universities, and when you visit the academies here in the Emirates, you'll find an unusually high percentage of female art students. Women in general play an important role in the Emirates.

What do you think about Saadiyat Island, the gigantic museum plan in Abu Dhabi? Will it help to establish the art scene?

We hear a lot about the names, the buildings, increasingly the people who will run them, but we don't hear very much about their program plans. Will they collaborate with the local galleries, artists, the local community? There are obviously some entities that are involved, but nobody knows to what extent. In my opinion, I think the material, collections, or programs should dictate the building structure and not the other way around. But am I glad it is all happening?—absolutely.

How much and in what aspect is the Middle East art market affected by the current financial crisis?

I think everyone has been affected by the crisis; many people do look at these emerging markets as still hopeful and prosperous, however. The global art market is very interconnected. Dubai will always be a leader in the region. We do believe that the current turn of events is in part a natural correction. Over the last two years there has been tremendous growth because of the boom in the art market, but this growth brought with it many speculators. What will remain after this crisis will be only those groups and individuals who really believe in their art, the artists, and the region—and if this happens, it can only be a good thing for the future of the Middle Eastern art scene.

DONG JO CHANG The Columns/The White Gallery, Seoul

Dong Jo Chang in front of a work by Chun Kwang-Young

Dong Jo Chang was born into a collector's family. He received two M.A.
degrees from New York University for special education and rehabilitation
counseling in 1984 and 1986. From 1984 to 1999, he lived in New York,
working first as a counselor for psychiatric patients and then in 1991 becoming
an independent curator of art, building up an exchange between New York
and Seoul for museum and gallery exhibitions. In 1994, he opened up a
gallery in New York, exhibiting artists such as George Segal, Arman, Jesús
Rafael Soto, Wenda Gu, and Bill Thompson. In 1999, he moved back to Seoul
and opened up a gallery there. Today he owns The Columns and its sister
space, The White Gallery, both located in Seoul and focusing on Korean and
international contemporary art.

"In today's global market it is no longer important in which country you are based."

How did you become involved in the art world?

My father was a collector of traditional Korean and modern Korean art, so I grew up living with art in our house. He was the first board member at the National Museum of Contemporary Art in Seoul. This was in the seventies, around the time South Korea started to have an art market. After the Korean War, my father began to collect art, becoming the patron for many artists at the time. He brought me to some of the galleries showing Korean modern art, many of which are still around today. He also took me to visit artists' studios, which was quite an unusual experience for me as a ten year old. Much of that had a great impact on me when I decided to become a gallery owner many years later. I remember, very vividly, how the Gallery Hyundai operated; the owner showed my father some works of art and went on to explain them to him. At that time there were no Western works in galleries, only Korean art.

When was Western art introduced to South Korea?

Western modern and contemporary art was introduced to South Korea just before the Olympics in 1988. A few of the newer galleries traveled to New York and Paris and brought over works by Pop artists and European contemporaries. During the Olympics, the Korean government commissioned monumental sculptures from international artists for display in Olympic Park. I also recall a group exhibition of Pop Art and Trans Avant-Garde around that time at the Ho-Am Museum, which is now called the Leeum Museum and is owned by Samsung. It was then that the tax law in South Korea was changed in order to bring foreign art into the country: there was no import tax on art and this law still exists today. The Olympics opened up the country in many ways and started the economic boom in South Korea. Eventually, however, there was a collapse of our currency because of massive inflation as Korea expanded rather rapidly. The late nineties saw very few sales in the Korean art market. During the years of the IMF, 1996 to 1998, many galleries had to close their businesses.

What is your professional background? When did you start your gallery?

I have a very diverse background. In the late eighties, I lived in New York and worked at a psychiatric treatment center as a counselor after graduate school. I also studied fine art appraisal at NYU, and in 1991 I became an independent curator and dealer, coordinating exhibitions between Korea and New York. One of the first shows I did was a collaboration with the Gallery Hyundai and the Seomi Gallery showcasing five projects by Christo. I also organized exhibitions of artists such as Soto and Arman for various other galleries. I began to work as a liaison between international and Korean museums

and galleries. In 1995, I began coordinating an exhibition of Italian contemporary art from the eighties to early nineties for the National Museum of Contemporary Art in Korea. In 2004, I served as a commissioner at the Gwangju Biennale and have since participated in many international-level exhibitions commissioning and curating art.

I opened the Inkhan Gallery in SoHo in 1994, a time that was rather tough for the New York art scene. In the same way, I went back to Korea in 1999, which was also an economically difficult period. But I am driven by an ultimate goal that guides all of the work I do. There was a gallery across the street from mine in SoHo that was owned by the legendary American dealer Leo Castelli. Since the opening of his gallery in 1957, he had literally written the history of Pop Art. He was the one who had shifted the world focus in art to New York, which until then had been centered in Europe. After the war, there was a desperate need to find a new perspective to embrace and to portray a different world. People wanted to get out of depression and needed to feel the new air. Robert Rauschenberg, Jasper Johns, Andy Warhol, and Roy Lichtenstein to name a few were the ones that brought changes to the art scene and moved it to the next level. These artists were true geniuses in their respective ways, but it was Leo Castelli who made it happen. His influence became dominant and he not only staged his artists to the international level, but also proved to the world the greatness of American art. That influence is still strong to this day, and I believe it will continue to be so. One man's belief made all this possible and I can't but admire him. Now, it is my dream to stage my Korean artists on the international platform and let the world see and appreciate the greatness in their works.

Which artists are you exhibiting?

I own two galleries in Seoul. My program consists of thirty percent Korean artists (Chun Kwang-Young, Kwon Yeo-Hyun, and various other young artists) and seventy percent international artists (Daniele Buetti, Dionisio González, Markus Linnenbrink, Michael Wesely). My program has also included other international artists such as Thomas Eller, who is now the director of the Temporäre Kunsthalle Berlin, and Fred Tomaselli, who has gained considerable international acclaim. Both were shown at the inaugural Busan Biennale in South Korea in 1998, when I was the commissioner.

What is the Korean artist's scene today and what was it before? Are Korean artists under pressure to make art?

The past fifty years constitutes Korea's modern art period. A very painful part of Korean history is attached to this art. It was very difficult for Koreans after the Korean War, so some of this modern art is sentimental and born of this hardship as a non-verbal reflection of that time. The late fifties and the sixties were the most pressing years for Korean artists and some of them have expressed this experience in their works. Today these works have a high value, but only in Korea.

In the years leading up to 2007, there had been an increase in the global demand for Korean contemporary art. Dealers pressured certain artists to produce more art and, along with speculative buyers

and art investors, fueled the art market bubble, causing problems for the future. Though this bubble inflated prices around the world, the current global depression is shifting the focus of art collectors from blue chip artists to the younger contemporary artists, particularly in Asia. The Asian art market is quite strong and continues to grow. Sales at Christie's and Sotheby's in Hong Kong demonstrate the selling power of Chinese and Japanese artists and the potential of Indian artists. Yet for all their auction records, Korea has the largest art market. The Korean International Art Fair (KIAF) had over two hundred galleries participate last year, and Korean artists like Lee Bul, Kim Soo-Ja, and Seo Do-Ho are gaining international fame through exhibitions and auctions outside Korea.

The problem facing Korean artists today is that most of them are relatively unknown to the rest of the world. It has only been a few years since the debut of Korean contemporary art to the global art scene and their reputations need to develop. However, artists like Chun Kwang-Young are paving the way by exhibiting at internationally renowned institutions like the Aldrich Museum, the Mori Art Center, and in 2010, the National Art Museum of China, Beijing. Korean contemporary artists will gain more recognition from the world as they develop their art internationally.

How did the Korean art market develop in the past years?

The presence of auction houses is very new to Korea. The major international auction houses are represented here as well as auction houses owned by galleries. In the past two to three years, many of these auction houses posted record prices in contemporary art. The mass media in Korea put out a lot of press about these prices, and some people came to the idea that art could function as an asset. When the broader public heard that a Korean artist sold for $4 million, they became interested in it and many people started to buy art on all different scales. They realized that it could be an asset and that it could make them money for future investments. Many are easy manipulated by the media and are raising money to buy and sell art like stocks. But, especially in new art markets, this sort of purchasing can become very tricky. For example, with Chinese art, Vietnamese art, Indian art, and so on, these "collectors" buy because they believe in high auction results. However, there is a difference between buying art for personal reasons and buying art as speculative investments. One of the fallouts of this type of purchasing behavior is that young artists become "auction stars," garnering high prices early on in their careers: prices for their works climb unimaginably high because of buyers driven by auction results. Eventually the prices reach a point where collectors cease to buy. But again, these are international developments echoing in Korea.

The Columns Gallery, works by Imi Knoebel, Jean-Pierre Raynaud,
Chun Kwang-Young, and Robert Indiana (from left)

What is the collector's scene in Korea? What was it before and what is it today?

The collector's scene is currently in the midst of change. There is a new generation of collectors in Korea, most of whom are CEOs of big corporations. Almost all of them have been educated abroad, so they've been exposed to Western culture and are very at ease with relating themselves to contemporary art. Many of them are collecting not only to assert their ideals and styles but also to incorporate the potential of art into their business. Using art as a status symbol has always been one of its functions, but recently that has become a "global desire." Their fathers, the former CEOs, were collecting modern Korean art and now the second generation is following suit, collecting international contemporary art as well. Some of them are corporate-minded and display their works in their company buildings to enrich their public persona. They incorporate art into their foundations and build private museums for their own enjoyment. But this also adds to their image and the company's image. Moreover, auction results are accessible on the Internet and they can see in a matter of seconds which work is selling and for how much. The younger generation buys artworks not only for pleasure, but also as a possible future investment. And, since there is no tax on art and no inheritance tax on Western works, art acquisition is highly encouraged.

There are, however, many collectors who are even more art knowledgeable than dealers because they are more traveled and have tremendously diverse networks. Instead of purchasing imported works from Korean galleries, they will go abroad and buy artwork directly from auctions and galleries in the West. Galleries in Korea are limited as to who they can represent and who they can exhibit, but many galleries in the United States and in Europe work directly with world-renowned artists whose works these serious collectors are interested in. In effect, these Korean collectors are building up very international and high-quality collections.

The pool of collectors in Korea is also becoming more diverse. In the past there were a few key collectors who dominated the art market. But since 2005, the Korean art market has become more accessible and more varied as art became more popular. Now anyone can purchase art because it is easy to find art that is agreeable and affordable.

How do you advise the younger generation of collectors in Korea?

Most of the collectors are running global businesses and most of them are already collecting Korean or Western contemporary art. There is no standard by which they purchase. They simply buy what they like. Some have more experience than others and they know what they want. So I cater to their preferences and show them works that they would enjoy. I also provide them with information about exhibitions and galleries in other countries because they are frequently on international business trips. At the moment, I am curating some of their collections and certain works of art have to go into private collections or private museums. As a gallery owner, I believe it is extremely important where artworks are placed. A particular piece has to be at the right place at the right time. This is not just

for business, this is my life. I receive a certain satisfaction from exhibiting art in settings where they would be most appreciated.

The way of life in Korea has changed rapidly within the past twenty years. It has become Western-ized and there are big apartment buildings everywhere, with some traditional Korean elements still retained. Lifestyle-oriented collectors change their interior style entirely after two to three years and then want new works for their new homes. For many Koreans, art is purely decorative.

Do art fairs play an important role for you?

Yes, they do. After fifteen years of visiting art fairs as a guest, one builds up an international network which is very useful for dealing in an international market. I know how the art market functions in Europe, in the United States, and in Asia. Now, I am an exhibitor in art fairs such as Art Cologne, Art Hong Kong, and of course the Korean art fair, KIAF. I participate in art fairs not only to sell artwork but also to present ourselves to other participants in the market and build up our reputation and credibility in a global world. I'm from Korea but my intention is to develop a truly international gallery, not simply a Korean gallery. In today's global market it is no longer important in which country you are based. It has become very global, very quickly, and with the Internet you can do business wher-ever you want: you can send any piece of information anywhere within a matter of seconds.

Is it possible for a South Korean gallery to exhibit North Korean contemporary artists?

To preface, I do not sense the existence of any real North Korean art. They produce what we would call propaganda, and their artworks are traditional only because they have never been influenced by Western culture. As they have no freedom of expression, all you sense is that it is art from North Korea. In 2007, Andreas Gursky was invited as an artist to photograph the "Mass Games," which are essentially a demonstration of North Korea's power: fifty thousand people making a painting by changing color cards. Cultural events like this are similar to military performances which are used for North Korean propaganda. Even though a Western artist was invited to document the Mass Games, I doubt that he would ever be allowed to show his photos of Western culture in North Korea.

The Korean National Museum of Art is documenting the history of Korean photography, and they are particularly interested in North Korean photographers. But, it would be very difficult to obtain their work in South Korea. The medium is just beginning to develop in North Korea and there is no real cultural exchange to facilitate or predicate such an exhibition. Before the Kim Dae-Jung government of the nineties, there was absolutely no cultural interaction between North and South Korea. Because both countries were ruled by military powers until the late eighties, the governmental animosity precluded any exchange. Even after South Korea opened up under President Kim, North Korean art was only presented as commercial goods via China. South Korean art has never been exhibited in North Korea, and our only exposure to North Korean art was a few years ago at a small commercial exhibition. One of the biggest obstacles is that the North Korean government controls art, using it as

propaganda; so there is no desire to exhibit the contemporary art of South Korean artists. Perhaps by exhibiting North Korean artists here, we could begin to heal the cultural divide. That would be a big step ahead for this divided country.

ARNE GLIMCHER PaceWildenstein, New York/Beijing

Arne Glimcher with Zhang Huan's *Giant No. 3* from 2008

Arne Glimcher, born in Duluth, Minnesota, is one of the art world's most powerful dealers. He was educated at Massachusetts College of Art and Boston University. In 1960, he founded The Pace Gallery in Boston and three years later moved that gallery to New York City. In 1993, Pace merged with Wildenstein & Co., forming PaceWildenstein, an organization with the potential to show works of art from the Renaissance to the present. Today, Arne Glimcher serves as the Chairman of PaceWildenstein. In August 2008, he opened a gallery in Beijing. Since 1986, he is also a director and producer of films in the United States, and in 2007, he received the Distinguished Alumni Award from MassArt. In 2003, he was awarded the Légion d'Honneur by the president of France.

"The artist is the center of the art world. Without the artist you have no art."

What made you decide to open up a gallery in Beijing and not in Moscow or the Emirates, which are also emerging markets?

I have never been to Moscow, and I am not acquainted with an art community there yet, and I know of none in the Emirates. I love to be where artists are, and the newest art is coming from China, just like the new art in the eighties and nineties was coming from Germany.

Art flourishes after conflicts; for example, it was after World War II that Abstract Expressionism evolved. In China, the Cultural Revolution destroyed everything, even the ancient art. It left a tabula rasa upon which art could reinvent itself. There are a few really good artists who have already emerged, and a new generation of artists is coming up in China. Today there is very little excuse for realism in the Western world, as we have gone through realism and into abstraction. Most realist artists today synthesize things that have been done before. But in China there is no history of abstraction, and they begin with this kind of incredibly sincere art of figuration. There is less cynicism than there is in England or America. It is all built on a base of passion and not on commerce, although commerce is developed around them. China's artists have developed like the Abstract Expressionists, who also had no one interested in their works when they started out. Then art became an incendiary commodity in the world in general and collecting became a global phenomenon.

What do you ascribe this global phenomenon to?

Money, just a lot of money. Houses, cars, jewels, or furs are not a big deal; art is a big deal, because it is part of the culture. It is a commodity you can't create in any other way but with talent. More people are globally educated to understand it, and more people suddenly realize that the spoils of war since ancient times have been art. Art has had a value that has existed from the time of the Stone Age. Every country that has been leveled—whether it was by the Mongols or Hitler—has lost its art. Art is a lasting commodity because it extends the perception of the public. It is a tool that society uses; it is very important, yet in itself it has nothing to do with money or publicity. As Ad Reinhardt said: Art is art, and everything else is everything else.

Can art be a non-verbal tool?

Absolutely. Art is very important and almost a science. If you look at scientific discoveries—particularly in the field of visual perception—over the last hundred years and compare them with the evolvement of art over the same period, there is an absolute parallel. You can't distinguish the experiments of Edgar John Rubin, the Danish psychologist, from the collages by Jean Arp, they are identical.

Rubin tested visual perception with an image of two identical, black profiles facing each other on a white background, forming the shape of a vase between them. Jasper Johns used this image of two profiles turning into a vase, just as Salvador Dalí had used it, without really being aware of Rubin. Jasper Johns was, however, aware of Dalí.

How do you feel about the cult of the art star?

I think Leonardo da Vinci was an art star, Titian was an art star, Michelangelo was an art star, and Jackson Pollock was an art star. The artist is the center of the art world. Without the artist you have no art! Today the media is just bigger than it was before. Anything that is involved with so much money is something of interest to the media. Art and money are related today. But art itself has nothing to do with money. As Agnes Martin said, and I quote: If you go into the studio thinking of Picasso you paint Picasso, if you go into the studio and you think money, you paint money. I think a lot of people today paint money.

Will you be introducing European and American contemporary artists to China?

We will be showing American masters and younger artists. The art world in China is not ready yet for Western art, but Beijing is a crossroads for Hong Kong, Macao, Korea, and Taiwan: everybody comes there to see art. We wanted to have a geographical position in Asia, and we wanted it to be where the artists are actually living. Right now, more is sold to Hong Kong than to mainland China, but that will change. New York is a great art market because the artists live there, just like Berlin and London. Beijing will become the same.

How important are the geographical and cultural circumstances artists are working in?

Zhang Huan lived in New York for nine years, and then he moved back to Beijing. He started a whole new section in Beijing, called SoHo. Then he decided to be a little bit out of the center and moved to Shanghai. Artists create the center, they don't go to the center. If you look back, the Abstract Expressionists were all in New York and they made it the center. They took the center away from Paris. In today's world, art is much more synthetic than revolutionary. There are some artists who make work that could have been made anywhere. It is a different time now, and for most of today's art, this is not the greatest time in the history of art—but ironically, it is maybe the greatest market.

Contemporary art has become tremendously expensive today. What is your opinion about this as a gallery owner who is dealing in Old Masters, Modern, and contemporary art?

The Old Masters were contemporary artists in their time; they had patrons. Titian's studio lined up six Mary Magdalenes that had been commissioned by churches—his assistants worked on them and he would finish them. Rubens had a dog painter, a flower painter, a sky painter, and a hand painter . . . There is really not so much difference, except that now the amount of money in the marketplace is

The exterior of Pace Beijing

enormous. Today young artists are making a lot of money. That's good, but record prices in auctions can be dangerous for them. When Andy Warhol is more expensive than Pablo Picasso, there is something wrong with the market. Art becomes fashion, and to some people it is preferable to see a Warhol in an apartment rather than a Cubist Picasso. People pay ridiculous prices for fashionable art—money means nothing. This is also an effect of globalization: you have a totally international market.

There is an enormous increase in art fairs around the world. Is it still worth it to sell works in the gallery?

Yes, clients still come to our galleries in New York and now in China, too. I don't like art fairs, and I think they are bad for art and for the artists. We only do four art fairs a year. Many dealers get their artists to make paintings for the art fairs, but this is not the way you make art. You make art because you want to! Also, people are going to galleries less, because they think they can see more at the art fairs. They can't! They just see one work—but you can't understand an artist's oeuvre by seeing one work, you need to see the work in context. I know where I want to place the works, and this

Encounters, Pace Beijing, 2008, exhibition view with works by Zhang Xiaogang, Yue Minjun, Andy Warhol, and Wang Guangyi (from left)

has nothing to do with being elitist—I have to protect my artists in a way. They are sold to collectors who are significant in the art world, who have important collections, or who are associated with museums. Many works in Zhang Huan's show went to museums, and there was great demand for the work.

What are the consequences for you as a gallery owner of the fact that art is ever more treated as a commodity or an investment?

You have to be careful to whom you are selling a work. I know the people who flip art, and I don't sell to them. If some new collectors come in and I feel that they are very sincere, I might give them a work. If a famous collector who flips art work comes in, I won't give him anything. The new buyers come from everywhere—they are hedge fund owners, they are in real estate, they are business people, or they come from the fashion world; they are from all over. I think some of them are sincere. Art is very beautiful to live with, and it is a privilege of wealthy people. There are investors who say, "I am taking a position in these five artists." This is not the way a sincere collector speaks. I would rather hear, "This is a fantastic work, and I'd love to live with it."

Is this an effect of globalization?

The effect of globalization is just the natural consequence of the media and the Internet. If you go to Shanghai today, it is a gorgeous international city. When I went to Shanghai twenty years ago, it was a spectacular, exotic place. It is difficult for a country with billions of people and so many disasters to evolve. The same with Russia, you have incredible poverty and incredible oligarchs. Abu Dhabi and Dubai with its huge buildings—it is just hotter there but no different than New York. This all has to do with the world evolving, and art is part of it. But Western culture is still desirable, and America is still the biggest power for a while.

JOHN GOOD Gagosian Gallery, New York

John Good in his office in New York, in the background
a work by David Smith from 1963

John Good moved to New York in 1979 after graduating from the University
of California at Santa Cruz. He began his career at Leo Castelli Gallery,
worked as an assistant for Helen Frankenthaler, and then was appointed
director of the Leo Castelli Gallery at Greene Street. In 1985 he started the
John Good Gallery, where he showed a roster of international and New York
artists dedicated mostly to abstract painting, including Fiona Rae, Juan Usle,
and many others. The gallery closed in 1995 and Good spent the next few
years freelancing. He curated a group exhibition entitled *The Prophecy of
Pop* at the New Orleans Contemporary Art Center. He also organized *The
Art Exchange Show,* an alternative art fair that ran for several years. In 1999

he joined the Gagosian Gallery where he manages the estates of Alberto Giacometti and David Smith as well as the contemporary artists Mark Tansey and Richard Phillips. Director of the Gagosian Gallery in New York, John Good is also part of the global empire of the gallery. Gagosian is represented all around the world and has opened its latest gallery in Rome. This slightly unexpected decision has been taken because of the fondness of Larry Gagosian for the city of Rome, a place with a great history and tradition of art. Larry Gagosian wishes to take care of his artists by exhibiting their art in the "eternal city," a place few artists can resist and where collectors can be easily approached.

"For artists to be important, they have to appeal to their own culture, their own tribe, and then hope to be universal."

What is the status of contemporary art compared to Modern art? Where is it going and what is the importance now of both art forms? How does the gallery deal with both departments?

In one of our galleries in New York, we are expanding into the fourth floor to develop a program devoted to Modernism, to complement our efforts on behalf of contemporary and postwar artists. We will work with the greats—Picasso, Giacometti, Beckmann, and others with whom the gallery already has a relationship. We now represent the Giacometti Foundation in Paris; it makes sense to develop our commitment to this part of the market. In the last decade, the market has been stronger in contemporary art than Modern because there are fewer Modern masterpieces in private hands and the big money goes after the greatest examples. The best Impressionist and Modern art often goes into public collections, and there just aren't enough masterpieces to trade. "B" and "C" material doesn't help to build a strong market. Postwar art has become, in the last ten years, the place where you can still buy masterpieces. Great examples by Rothko, Pollock, or David Smith allow us to build a market with exhibitions and catalogues, something we do very well. Art created from the eighties to the present—artists like Richard Prince, Murakami, and Damien Hirst—give us lots of "A" paintings to work with. While there are plenty of Warhols around, there are increasingly few masterpieces and the prices are in the tens of millions of dollars; the market needs great works at lower prices than that. In a price range of $500,000 to $10 million, people are trading the "contemporary masters," as

John Good visiting Richard Phillips's studio

we might want to call them. That is all part of a new market that will probably get its severest test in the next couple of years.

Do you think that modern artists like Picasso or Rothko are better to collect than contemporary artists today, such as Subodh Gupta or Richard Prince for example?

I see artists who have a potential to be seen as masters, but I don't think that anybody who has a brain can determine now who is a contemporary master.

Gupta is a wonderful artist whom I've liked from the beginning, but there are plenty of artists who looked great for four or five years and are completely forgotten now. If you can afford it, it is great to build the foundation of a collection with the most influential Modernists, postwar artists, contemporary masters, and the art of the present. That's a nice way to collect art and to have fun and be involved with today's culture. It's also a very effective way to spread your risk; we all know that art isn't free and we're paying real money for it. Some parts of the market are riskier than others; contemporary has always been riskier than Modern and postwar. I think there are very few young contemporary artists who don't at least relate to Andy Warhol. You can see a trajectory from Duchamp to Warhol to Koons to Prince to Damien Hirst. And if you were to collect, I think what would be a really smart thing to do is to get a Duchamp, because of his influence on artists like Warhol and Prince. From a market point of view, Duchamp is relatively inexpensive; he's certainly undervalued for his importance.

What is your point of view on artists working with big companies? Do you think it is good for artists with big names?

It could be greed! Murakami is the one who has done it in the most interesting way. He seemed to start it all and allowed other artists to do the same. If your art is better than your handbag, then you are okay. But if your career has been made by the corporations and the handbags, you've got a big problem. Richard Prince is in a confident enough position to do fine with it, and furthermore, I am actually in favor of that kind of limited approach to the mass market. We like our little rarefied art world, but it is important to get more people involved.

From a pure marketing strategy, it is a smart way to reach a high net-worth individual, but in a bigger sense, art should get out beyond the art world. I like people to see art in fashion magazines or on television or in store windows and say: "What is that?" It gets them to think. Keith Haring in the eighties wasn't doing it in a commercial way; he was just getting his work out on the subways and stations, tagging anything he could find. A lot of people thought that was a cynical attempt to mass market his work; I don't believe it was at all! I think it was a very generous act, and I think that what these artists are doing with Louis Vuitton, for example, could be construed in the same way.

How do you consider the relationship between money and art? Are there more investors who treat art like a commodity?

I appreciate the fact that we live in a market economy. The relationship of money to art is fairly simple; there are many levels of the art market. You don't have to be rich to be an art collector, you can actually collect at a fairly low end; you can collect things for hundreds of dollars. The risk is higher: they may be worth zero, but the things that you've collected for a thousand dollars could also be worth zero. There get to be levels where once an artist reaches a certain point the market becomes more stable, but markets are cyclical. We have been in a long period of expansion, and this isn't going to go on forever. Throughout any period, there are collectors who primarily want to decorate their walls, those who really get excited by art, and a range of people in between. We have clearly been in an expanding phase up to now, and there is more of a variety of collector types: more young collectors, more middle-range collectors, and more speculators. Some people approach collecting mostly from a market point of view. They understand how markets work and they'll say, "If I believe in this artist then I should take a position, just like I should take a position in a company I believe in." They'll buy ten works by that artist and then maybe they'll sell a few. In the old days, people would collect in depth because they wanted to understand an artist's range of work. If you buy several works from the same artist, you can live with the work and then say, "These are the five best, I'm going to keep them and sell the other five." Until now, the market has been much more fluid than it used to be; people buy and sell more than in the past. It was often looked down upon to sell; one was supposed to buy with the notion of a kind of *noblesse oblige,* with the rich collector taking care of the poor artist. Now the situation is more balanced. Everybody is a participant and if an artist is charging a very high

price on the primary market, the collector may think twice; at a certain level, you want to protect an investment and be careful how it is sold. Dealers always appreciate being offered something back if the collector wants to sell it.

Do you think that contemporary art from up-and-coming countries such as China, India, or Russia will establish itself?

I cannot answer that question with any degree of intelligence; I can only speculate. I think that those countries have finally understood that there was a modern movement and they are trying to catch up quickly. To the extent that they support their own galleries, their own artists, and their own auctions, they will create something that is not just a market phenomenon globally but they will also be supporting their own culture.

The local market actually helps the global market. For artists to be important, they have to appeal to their own culture, their own tribe, and then hope to be universal. Artists who are great transcend their own culture. If something is beautiful and it references its own culture and a more universal humanity, then it has a chance to be significant.

Why are there more and more art fairs around the world? Is it still useful for a gallery like Gagosian, which is already everywhere, to participate in those?

We don't need art fairs as much as art fairs need us. We are very targeted in the art fairs that we attend. We participate in very few: we are present at Art Basel, Art Basel Miami, and Frieze, above all to market the gallery and show people what we have. The Gagosian strategy has long been to show the international community what our gallery is all about. Many galleries in smaller cities do important shows that don't get seen. They develop their inventory and it is not sold locally. Theoretically, with the globalization of art they wouldn't need to go to these art fairs because we would know about them anyway. Though we are increasingly interconnected through technology, we still need to put the paintings, sculptures, videos, or whatever in front of people's eyes. Personal contact is very important for all galleries. We started off participating in art fairs primarily for marketing, but they have become a very powerful marketplace.

The events and parties had an unexpected effect: people love going to parties, and the parties have now become a place where people share ideas about artists and galleries. The social aspect of the art world has become more pronounced. I think that for smart collectors, however, they take it all with a very big grain of salt. There is something seductive about good parties, but ultimately, are we here for socializing or to look at great art? The glamour attracts new collectors and we need them. They are the sign of an expanding art market. And when the inevitable correction occurs, you will see fewer parties.

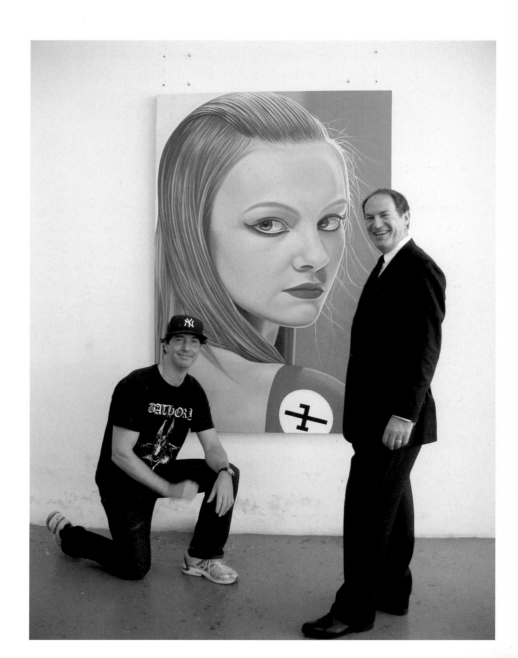

Concerning "correction," do you think there is too much trash around and that the art today is less good or that is there too much of it? What will be corrected?

Demand will be corrected; supply is fairly constant. There are perhaps more creative people pursuing fine art who otherwise would be going into TV or film right now because there is a real art market. But it is still very difficult for an artist to make a living. It is inevitable that there will be a contraction. Maybe it will happen gradually, but it will happen. The last time it occurred was in the early nineties. There was an auction where many things had been bought in (i.e., they did not sell) and everybody in the sales room looked at each other and said, "Uh-oh!" It took five years to recover; it affected Impressionists and Modern and contemporary art. In all markets, there is a flight to quality when the market starts contracting. It's the middle of the market that gets hurt the most, because the young artists are happy to sell their work at a survival level. They just want to make things and get somebody to buy them. Warhol prices have their ups and downs, as do Picasso prices, but their value is established. No market goes in a straight line.

Once an artist is in several museum collections and regularly reaches a million dollars at auction, their career and market are solid. Right now a lot of artists are getting hundreds of thousands of dollars for their works. Some have hot markets, but they cannot all sustain such price levels. You can't have fifty new great artists! In the sixties, a huge number of great artists emerged: Pop artists, Minimal artists, Conceptual artists. The seventies didn't produce a whole lot of great artists; and the eighties and nineties are maybe too close to our time to tell. Not everybody from the current generation of artists will make it. Despite all the technology and despite the globalization, this still is a very personal business. It's all about relationships, people trusting you. Collectors have a relationship with the art, but they also have a relationship with the dealers. I call people I like to work with and say, "Hey, look at this great new sculpture we just got in!" If I email somebody I don't know, and say, "Hey, look at this great thing," it is not the same.

So the role of the gallery for you is still very important. Who plays the key role in the art market? Is it the gallery, the artists themselves, the auctioneers?

The auction houses perform a very important role in the art market by providing instant and transparent liquidity. If you are a collector and you need to sell quickly and the market is expanding, the auctions are very tempting. If you have a relationship with a gallery and you wish to be discrete, a gallery can often get a higher price. Ten percent of what is sold at auction gets the big news and the big prices; the other ninety percent is not "A" material and does not get "A" prices. The "B" works do well at auction in an up market, but a gallery will perform better in a down market. Sophisticated people, real collectors, know that you can't read too much into auctions because they are only the most visible side of the market. Ultimately, the galleries are the key to the development of artists and their careers; the auction houses are a barometer, but the galleries build and sustain the market, in good times and bad.

How do you choose artists and why do you represent so many artists? How long is your commitment with artists?

In terms of the greatest artists of the twentieth century and now the twenty-first, you can't have too many. We would never apologize for having Picasso, Giacometti, Twombly, de Kooning, Ruscha, Warhol, and other great artists. Our commitment to newer artists and emerging artists is a recent development. It is important to show new work and surprise people. The danger is the "Gagosian market factor," in which as soon as we are rumored to be taking on an artist, their prices go crazy. A commitment is mutual; it's kind of like a marriage. There are "divorces" between artists and dealers but most of our relationships are very stable.

MARAT GUELMAN Marat Guelman Gallery, Moscow

Marat Guelman

Founded in 1990 in Moscow, the Marat Guelman Gallery is one of the first
gallery spaces in post-Soviet Russia to show contemporary art. Marat
Guelman himself is a key figure in the progressive art scene. Nearly all
Russia's art stars, including political troublemakers such as Oleg Kulik,
The Blue Noses, and AES+F, originally come from his gallery. He works
tirelessly to promote Russian art, not only through the provocative shows he
curates for his gallery, for biennials, and for museums, but also through his
work as a curator building up museum collections like the Pinchuk collection
in Kiev or that of the first public museum for contemporary art in Perm,
Ukraine. His strategy is to establish the status of Russia's contemporary art

not only in the international art market, but also to widen the audience for such art throughout Russia.

"We were the curators for Russian contemporary art because there was nothing."

You were one of the first gallery owners in post-Soviet Russia. How did you start?

I began to collect in 1987. Until then, in the Soviet Union you had to work at one place; otherwise you could be put in prison. Everybody had to have a concrete job. My profession then was communication. In 1986, they cancelled this law: I was a free person. It was the time of change between socialism and capitalism where you were allowed to make a profit, but you were not allowed to keep it—you had to spend it. So I decided to collect art, as I had always loved art. I was brought up with it. My father is a famous playwright in Russia, and he always ran in artistic circles.

My career in the art market then was only due to coincidence, through "mistakes," as I call it. Before I opened my first gallery in 1990, there was no art market in Russia, zero. I lived in Georgia and had organized an exhibition with Russian artists for a Moldavian museum. It was quite successful, and I decided to leave the south and go to Moscow. But to collect art from artists in Moscow was too expensive, at least for me. I then found interesting art in the south of Russia, and I organized a show *The South Russian Wave,* my first mistake. It was mentioned by all international curators because, until then, people thought Russian art was conceptual, and this was the first time that somebody showed interesting art that was absolutely different from that. Leonid Bazhanov, who is a very important Russian art historian, came up to me and said: "Marat, you must open a gallery," and that was the moment I became a professional person in art. Although I was not convinced at all: there was no art market, I had no experience, no money. But he insisted and said: "You just have to care about the artists and make exhibitions. I bring you a lot of foreign collectors." Finally, my wife, Julia, and I decided to take the risk and open a gallery—another mistake, because Bazhanov has not sent any collector to the gallery so far . . . So if I am asked about my success, I always say: if God wants for the mistake to be your success, then you go for it. Success means taking the chance; you just have to make it happen.

How has the art market changed since its beginnings, and what is your strategy?

Today the art market in Moscow looks like one in a normal capital, but it is not. The art market is still very small. We have all the usual art types but only very few of each. Russia is a special country.

Mentally, the Russians need one person: one politician, one poet, one terrorist. So in the nineties, they also only needed one gallery owner—Marat Guelman. It was not the normal type of gallery. All sorts of art activities went on there. We were named gallery, but we weren't; we were an art center. The best client was Marat Guelman himself, so more or less we worked for nothing. We were producers; we pushed all the artists who are well known today with our exhibitions. We were the curators for Russian contemporary art because there was nothing. Now art institutions, museums, and foundations are coming. We still assist at museum exhibitions, but apart from that, the gallery has turned to become more or less a normal gallery. We get around two thousand portfolios a year from artists who are based all over Russia. They hear that with Marat Guelman, you can become famous and they dream of that. We are working very carefully with our artists. We have special shows with young unknown artists, and we often work together with other gallery spaces. We try to build up their career slowly but steadily. Of course, art needs a market, but business has to rank below it. Art has to be the main topic and then comes the money.

How important is the gallery for the artist here in Russia?

Everywhere the artist is part of a cultural machinery that works with expertise, shows examples, and makes selections. People want to have examples—this is art, this is literature, this is poetry. You give examples, and then you have a filter to find the talents. In Russia, this cultural machinery works differently. The art schools only teach in a very traditional Soviet-style fashion, and there is hardly any filter. So the gallery owner becomes the expert: he is the one who puts the artist into his status, makes him an artist. Therefore we have a very close partnership between the artist and the gallery owner. He is more like a father to the artist, he is the head of the art community. My gallery is more like a family in that way: for example, Oleg Kulik, who works with us and is very influential to other young artists, naturally brings us new talents. He would never only be concerned about his own art, he cares for others—and for us.

Where is the Russian art scene today?

People think the Russian art scene must be in Moscow or in Saint Petersburg. But this is only part of the truth. Seventy percent of the artists in Moscow come from other parts of Russia—from Novosibirsk to Yekaterinburg to Tbilisi. They all come to Moscow because it is the capital, the place to come, the place to find a gallery. Due to that migration, you have interesting infusions from everywhere in this place, and there is definitely a special Moscow art scene, just as there is also in Saint Petersburg, which is very different from any art scene in the provinces.

For example, here in Moscow we had the big battle between the conformists and non-conformists, thus between the official art and the unofficial art. The artists built up a mental wall; they were going wild with each other. But when we had the exhibition in Kiev and we named it *Very Good, Very Bad,*

it worked out wonderfully. People were very peaceful there. We have to bring the different art scenes together. I am just now following such a project with artists from different places.

What are your criteria to choose your artists?

I think the system of criteria has collapsed; there is not a good or a bad anymore. Each modernism has tried to find a new system of criteria and a new discourse, until it has ended up being destroyed in its turn. Now you can do it this way or that way, and it is more a question of context. Apart from being talented, the artist must stay in the modern context, that is, the context of contemporary visual art language, the context of art history, the context of the society and its specific issues. And the artist must have a clear personal strategy from one exhibition to the next—he must have a vision. Only then I can see if he is ready to really play a role as an artist.

What do you think about the problem of identity versus globalization in art?

Now if you look at the new Chinese art, it is a collective identity. Russian art in the beginning was a little bit the same, for example Sots Art: national identity against personal identity. Art means diversity; all the artists are different. They should develop a sensitivity for their individual strategy. But we have a problem. We want to develop a new civilization and save the tradition at the same time. This makes it very difficult for the artists to find their own identity and stick to it.

Is there something specific in Russian art?

Russian art is very narrative, as Russia has a long tradition for literature. Artists often integrate texts and comments into their work. And then there is this special self-irony. When you go to international exhibitions, you will find it only in Russian art. American art is social, erotic, formal. If Russian art is good, this self-irony can be understood by anybody, not only by the Russian people. It depends on the context. Take the trend close to Arte Povera in Russian art. There is a special relationship between art and beauty that differs from the Italian Arte Povera. In Italy, people have everything to eat, they are on a diet because they care about their weight, their beauty. In Russia, Arte Povera derives from the fact that people are poor; they are dreaming of food. Formally it is close to beauty, but with respect to the content, its meaning is the opposite. Superficially they are both doing the same—Arte Povera—but the outcome is different as a result of their differing intentions.

What do you think about the big price increases for contemporary Russian art?

Prices for Russian art are still very low in comparison to Western art; take, for example, the prices for Oleg Kulik, who has absolutely the same position as Jeff Koons or Mark Rothko in America. Even Ilya Kabakov is cheap in comparison to Rothko, whose paintings are sold for more than ten times as much. In my opinion, the market for Russian contemporary art will grow within the next years. The Russians will discover their own talents, instead of buying at auction the artists who are known by

everybody. I already have many more Russian collectors among my clients now. If you compare them to the Western collectors, they are very young and successful educated people. Now they have to develop their knowledge, their taste, and believe in it. In the nineties it was different: a lot of political people with a very autocratic way of deciding and not much knowledge.

What do you think about the relationship between art and money?

Money is blood for art; art needs money. But the huge amount of money that has been invested in art has changed the art market. Because of the great demand, there is a lot of bad art on the market now. And the successful artists have to be young nowadays. So we have art from artists who might have a very quick career but have exhibitions in the wrong galleries, who are not in the right community. Money is not everything. Of course you can buy a piece of art by those artists—even for big money—but you can't buy the community, the heart of the artist.

What do you think of the growing star cult in art?

In Russia, this is not like in other countries because still ninety-nine percent of the people hate contemporary art! So we could only call our well-known artists "negative stars." They make ugly pictures—and for this negative energy they even get a lot of money!

You are one of the founders of the Moscow Art Fair. What importance do art fairs have for the Russian art market?

The Moscow Art Fair was founded with my support in 1996. Especially for Russian gallery owners, the art fairs are very important. Here in Russia, government and country are identical. Our government has no idea about the cultural poverty. They want to decide who is an artist and who is not; they want to control everything, and this is not the way art can be developed in our country. So foreign activities are important, as there is no control the way there is here. As a consequence, Russian contemporary art is very successful outside Russia: for example, Kabakov became famous not in Russia, but in the United States. Russian art needs to be international, to be present at international art venues. I go to nine art fairs a year, which often is not very practical but we need to do it. And due to globalization, the biennials are also very important—especially Venice, Istanbul, and China.

Today, art is often linked to spectacular events.

There are hundreds of ways to use art: you can transport drugs inside sculptures; you get diplomas; you make a beautiful decoration; you use it for political reasons. This is all not about art, it is only the way you use art and the money for art. In this relation, of course, you can link it to spectacular events. But I think if people decide that this is the mission of art, it will be dangerous.

Gallery owners are networking more and more internationally with new locations around the globe. Why did you open a new gallery space in Kiev instead of New York?

Most of the artists in my gallery are trying to develop art in the region of Kiev, and we found Victor Pinchuk to work together with. He is one of my most important clients—very well educated—and I pushed him into art. He has a very good collection in the Ukraine now, which he shows in his new museum, and it gives the public the opportunity of understanding contemporary art. This is what I am aiming for.

But of course New York is very important for my activities. For me, New York is communication. Everything internationally is still linked to New York. I have some works in the Chelsea Art Museum now, and we have a lot of partner galleries there. If I had my own gallery space there, I would come into conflict with them.

Art and politics. You are also a political advisor and you represent very provocative artists like The Blue Noses, AES+F, Oleg Kulik. Do you have to be specially political as a gallery owner to become successful in Russia?

Yes, I am political for the money, for the success. It is my form of artistic creativity, my brand. It is some sort of compensation to be creative by promoting provocative artists like Kulik or The Blue Noses, and there is a change in attitude now. In the beginning there was a mental wall. People asked me why I worked with such political artists, getting involved in "the dirty politics." Now the same people congratulate me, they adore me for that. And even more: some of those former critics are my clients now, they began to collect this art. In this way they make a double investment—one into art and one into the social aspect of political art. And by starting to get involved with this kind of political art, they start to develop themselves.

Concerning the artists: art is always the demonstration field for freedom, so political statements in art are essential in this country, which is still struggling with censorship, with political and personal freedom. When we talk about freedom, I mean the total freedom that artists need for their work. They can't be half-free. The artists are the ones who prove this with their work.

What about the censorship in Russia?

There are certain persons who think some artworks are politically incorrect or even dangerous, as happened in Paris recently with our exhibition *Russia 2*. Instantly the public interest of the exhibition was huge, so the effect was quite the opposite. The brutal offense on my gallery here in Moscow, including the physical attack of my person, was something different. In those days there was an anti-Georgian campaign, and we showed an exhibition by a Georgian-born artist. We wanted to show that we wanted to be part of the global world and not nationalist. For the nationalists, contemporary art is dangerous because they think it separates people from Russia. So showing this kind of art, I had to

be a personal danger for them. It was the "Russian" answer to a Georgian gallery owner in Moscow. I was on the list, together with persons like George Bush!

You had a very spectacular exhibition *Art and Death*—a synonym for the "McDonaldizing" tendency in art through globalization?
No, I wouldn't go that far. The exhibition was not about the general death of art, but it wanted to make clear the high price an artist has to pay when becoming successful. We are talking here about serious art, not art as decoration. For artists who really make an effort to that in their work, art is a question of life. They pay with their blood—it is a personal sacrifice.

Do you think the role of the gallery owner will change in the long term?
The auction houses are a real danger, because it is just a huge machinery with hundreds of people who make business with art. The gallery system gives a certain stability to the artist and to the market. But the way artworks are being exchanged is evolving. You have more artists who sell directly; you have museum projects with site-specific works . . . Maybe the gallery owner will be an outmoded mode within the next twenty years; there will be other agents—maybe we have to change our format.

Especially in Russia a growing number of collectors have started to open up museums for contemporary art. Is the collector-museum the future model there?
Everybody hears the names Victor Pinchuk and Igor Markin: both are very much involved in this with their museums in Ukraine and Moscow. Those museums are very important for us, because until now we have had no public museums at all that have the tradition for collecting contemporary art. The first museum for contemporary art will be opened in Perm—in the very east of Europe!—with very spectacular Russian architecture. I am involved in it as the curator for the collection. To see good contemporary art we need private support, private museums. And it is even better if they are not only in Moscow. There is a vast need for education in the provinces.

How much and in what aspects is the Russian art market affected by the current financial crisis?
We don't have the worst situation imaginable. No art institution has closed because of the crisis. And strictly speaking, this is understandable. For instance, nobody needs a restaurant that is not for profit. But a cultural institution that is not for profit is normal, because it is formed for other aims—by enthusiasts, by people who love art.
Big museums sustained losses because of sponsors refusing to finance large international exchange projects. For instance, the Pushkin Museum cancelled practically all imported exhibitions. The other victims of the crisis are young artists, those who are just declaring themselves. It's clear that it's hard to begin a career in conditions of crisis.

Marat Guelman in front of *Homeless Adolescents. Moscow. Mark.9.37* by Dmitry Vrubel and Victoria Timofeeva

What does it mean for the artists and their art?

The answer to this question is simple in Russia: the role of the state is growing. The state is maecenas, the state is collector.

What do you think art is heading for in the future?

I don't know, it is difficult to make predictions. Through digital art, the old art system has truly changed. The question here will be the decision between the gallery owner and the artist regarding the number of editions to still fulfill the criteria of uniqueness. The Internet seems to gain more importance in art; maybe one day we will have a mass art with millions of creators all over the globe.

MOHAMED ABDUL LATIF KANOO

Ghaf Art Gallery, Abu Dhabi

Mohamed Abdul Latif Kanoo in front of his work *NYC Taxis*

Mohamed Kanoo's ancestors were the founders of one of the biggest Pan-Arab trading companies, the Kanoo Group based in Bahrain. Living and working in Abu Dhabi, he and his wife are key figures in the local community and generous supporters of the arts. Being an artist himself, Mohamed Kanoo is especially interested in the formation of an art scene in Abu Dhabi. Not only that, he passionately supports the spectacular Saadiyat Island Project with the largest-ever-built museum complex including a Louvre and Guggenheim; he also gave a personal response to it from the private sector by opening along with another artist, Jalal Luqman, the first art gallery in Abu Dhabi, the Ghaf Art Gallery, sparking the new contemporary art movement in the capital of the Emirates.

"We do not worry about the oil as we have a lot to come. The question is what to do with it."

Where do you see the position of the Gulf region in the art world?

The Arab world has always been the crossroads between the East and the West. If you look back eight hundred years, the Arab world was the place where everybody who wanted to trade used to come. Today, with globalization we don't have borders anymore. How does this apply to art in the Arab world? We should take contemporary art in China as an example. A few short years ago, what was Chinese contemporary art? A very small number of galleries and artists. This quickly evolved into an energetic, creative, international contemporary art movement. I see us about ten to fifteen years behind the Chinese. We have the same creative potential as other countries and cultures, especially given our very rich culture over the millennia. Now it is the question of how you focus it, how you train it, how you present it, how you polish it. For this we need education. But it is equally important to have projects like the Saadiyat, globally experienced people like Tom Krens, and cooperation with many educational institutions such as Columbia University or the Sorbonne.

What is your role?

I like to encourage people to get involved in art. I try to excite them. As a businessman from a hundred-and-twenty-year-old family company, my primary instinct is to try to make money. We have done this for generations (I am from the fourth generation myself). But I always think: What are you giving back to your culture? I want people to start to get involved in culture and see what they are able to contribute. Maybe you like poetry, or art. Maybe you love music. How can we encourage young people to become professional artists? What is needed to make this possible? Certainly a basic education is necessary, but also encouragement and support from government, maybe with funding for exhibitions locally and abroad. However, success will breed success, and ultimately the best artists will succeed as they have elsewhere in the world. Art can have an additional financial value in that the works may appreciate in value in the future. We have a lot of catching up to do yet.

Why is it only now that Abu Dhabi is focusing on culture and art? Has there been any tradition for it in the Emirates?

As recently as a few decades ago, people had very hard lives. Survival would always take top priority given our very harsh environment. We didn't have basic things like hospitals or schools. When you

start from such a very austere basis, you have to focus on the things that need development, like hospitals, schools, security, infrastructure. Once the basics are in place, you may begin to consider other "luxuries" like culture and art. But despite not having a long tradition of art in the Emirates, we are part of the Middle East region which has one of the oldest historic and cultural traditions—if you only think of Islamic art and its many influences on other cultures.

Our Arab culture is not a visual-based culture, it is an audio-based culture as a result of our very, very rich language. That is why poetry and literature remain so important for us. Our religion is founded in the beauty of the Arab language. We have the task to bridge between the Islamic tradition, with its old verbal culture, and the visual culture of today. The key for this is education, just as it is the key for any cultural evolution. And therefore the museums are very important. In the past, we didn't have access to museums in which visual art is shown. Anyone who wanted to see a painting would have to travel abroad. Now, however, we are in an enviable situation where we can focus more fully on the educational and cultural evolution of this nation. This is why, in my view, it is the right moment for these types of iconic projects, such as the Louvre and Guggenheim.

What is the vision of the Saadiyat Island Project?

We are now giving the young generation the opportunity to experience international culture and learn about the history of art and its place in human civilization. The cultural experience is going be very important, and we are realizing this project for the world, not only for ourselves! We want to attract people from all over the world to learn about our own rich culture. I look forward to the day when we can visit an important work of art in the morning at one of the great new museums and then listen to an international opera star at Zaha Hadid's beautiful Performing Arts Centre in the evening. And of course we want to promote Arab artists so there will always be something new, something exciting and busy here in Abu Dhabi. And this will encourage people to get involved with art. It is going to be really exciting, far more than the buildings. We will soon have the hardware sorted, now we need the software!

Don't you think that for a local population of fifteen thousand, the Saadiyat Island Project is quite oversized in terms of dimension and the number of star architects?

We have no time for long developments. We have the great challenge right here, right now, and we like to think in the long term. We plan big and include the future into our plans. That is why the project is unique, the architecture outstanding. Even if Hadid's Performing Arts Centre is a very ambitious design and nearly impossible to realize due its technical challenges—for example concerning the acoustics—we will invest the money to solve any such problems.

There is a lot of criticism about the "Western import" of art with the Guggenheim and Louvre cooperation. Why don't you plan a cultural center for Arabic art?

This is a question of importing the "best practice," and this happens to now be the West. However, we must consider that our world has become globalized. Borders are being removed, especially cultural ones. Contemporary Arab art must continue to evolve, to improve, to take a place in our common human heritage. It is interesting that successful Arab art obviously means being successful in the West! But now having these museums here gives our people the opportunity to learn, and then they will be able to interpret this art in their own way. And don't forget: we have a global village here, eighty percent of the population in the Emirates comes from around the world.

Why did you open a gallery?

Being an artist myself, I decided together with a friend (another artist) that we needed to have our space to exhibit. Then we realized that there are a lot of artists who live here but have no possibility to show their artworks. We decided that these artists had to have a space with a certain personal and intellectual atmosphere to feel comfortable, to exhibit. So we found a charming old villa and fixed it up. We have had solo and group exhibitions, and we have even had shows for students to encourage them into the arts. For the development of a sustainable art market, you need local galleries. Meanwhile, there are several other galleries that have followed us. We are very proud that our small gallery will be part of this exciting art scene.

The Gulf region is surrounded by a politically tense atmosphere. Can art be the tool for peace in this part of the Middle East?

In my view, culture (and art) is by far the most cost-effective and interesting method for communicating between people. When we have the ability to communicate, we find that it becomes difficult to have conflict. Tolerance is a trademark of the founder of the United Arab Emirates, Sheikh Zayed. He insisted that we remain very tolerant of the visitors who have come to the UAE to work, to help build the country. Tolerance is an important ingredient in the successful rooting of culture.

Does religion still influence the art here?

Yes, it does. There is nothing in the Holy Koran that prohibits art. In fact, there is a saying from the Prophet that "God is beautiful, He loves beauty." Any prohibition that may exist does so within each of us; it is self-realized. But the envelope keeps expanding. Once again, tolerance is key.

Is art heading for globalization or is there a specific art like an "Emirati art" here?

What is specific? Is a Rothko specific? The moment you open up to the world, uncorrupted indigenous art will always be accused of being compromised. The moment you can travel somewhere you will become influenced. Artists today are always influencing each other, as we are all influenced

by each other. The whole of humankind absorbs different things from different people at different levels. So there is already a globalization of art. But the way the artists combine their own culture with the influences they got from other cultures makes something totally new and authentic. You will have proof of being authentic if you are able to compete on an international level—a Shirin Neshat with an Andreas Gursky. Both are photographers on a level where they can compete.

How much and in what aspects is the young Middle Eastern art market affected by the current financial crisis?

The Middle Eastern art market has suffered considerably by the current financial crisis, probably more so than other more "traditional" art markets. With very few collectors, private or corporate, to sell to, the market has clearly shown how shallow it really is. This is most unfortunate as the market for Middle Eastern art was on the ascendant prior to this.

Art in the Middle East region has the perception of it being purely a luxury and as such is one of the first things to be sacrificed as budgetary belts become increasingly tightened. We have yet to experience art as an alternative investment to the more traditional jewelry and more recently stocks and shares.

Regional economies have had a unique converging of negative economic factors which include very low oil prices, drastic falls in regional stock markets, a real estate market in freefall. Add to this increasingly complex and at times contradictory legal framework changes, exceedingly concessionary labor and employment sectors, and the results are drastically weakened traditional family companies with greatly reduced spending and investment capabilities. However, with an improvement in any of the above factors, we would see a quick reversal of fortunes and a return to luxury expenditures which may include art.

What does this new situation mean for the realization of big cultural projects such as Saadiyat Island?

The exciting Saadiyat project will continue to move ahead—although in phases. The first phase includes the Guggenheim (designed by Frank Gehry) and the Louvre (designed by Jean Nouvel) projects. The second phase would be the Performing Arts Centre (designed by Zaha Hadid) and the Maritime Museum (designed by Tadeo Ando). Slotting in between the first and second phases would be the Sheikh Zayed National Museum (designed by Sir Norman Foster). Lastly would be the Biennial canal pavilions, even though the canal itself will probably be built as part of the early infrastructural development of the project during the first phase. Naturally, some of the phases may experience some delays in implementation, but I expect these may be more technical rather than financial.

One must remember the extremely positive international reaction that the project received on its launch. This reaction has added great impetus to the cultural vision of respect and tolerance and politically continues to be of critical importance today and into the future.

Mohamed Kanoo with his work *Untitled*, 2009

Pearl Lam

Pearl Lam was born in Hong Kong, to the family of a tycoon real estate developer. She studied law and accounting management in London before being forced to return to Hong Kong after her graduation in order to fulfill her familial duties by joining her parents' company. She had, however, always been attracted by beautiful things and passionate about contemporary art and design; her tasks in the family business left her feeling bored, so she decided to concentrate on art. With her glamorous, larger-than-life person- ality, she quickly became one of the biggest international collectors. In her three galleries in Shanghai and Beijing, she shows contemporary Chinese art as well as cutting-edge design work.

"The whole point is how people perceive China or how China perceives other countries."

China has the reputation of being quite conservative. What is your opinion?

China is not conservative; it is run by millennia-old philosophy. Our culture was founded in 550 B.C., and today the same things are still very important: Confucianism, Taoism, and Buddhism—this is ingrained in our culture. Today's Chinese culture is different in that we are more expressive. In my generation or my friends' generations, we would never say to our mothers, "I love you," nor would we kiss our fathers. We don't do things like this. But the current generation—all my friends—kiss their sons and daughters and say "I love you." It is incredible! It is changing because we all studied abroad and have seen things done differently than in our country—for example the expression of affection. However, this does not occur in China. The children are spoiled with attention from the parents and both sets of grandparents, yet it is not the same kind of affection one can experience outside China. No parents or grandparents would ever say "I love you" to their children.

How did you come into the art world and become a gallerist?

I am from Hong Kong. I was asked to return home and work on a project in China. Before I went back, I met many designers while decorating my student flat in London to make it sophisticated. Then and there, I decided to open a gallery in Hong Kong. It was a challenge because why would a Chinese family ever want their children in the art world? As my father would say, "Art is for you to spend money on . . . you can collect it and have fun, but it is not a proper and respectable job." And my parents thought it was even worse to have a gallery. They were furious and reprimanded me for such a ludicrous idea. They said that they didn't send me away for so many years of study to have me return to become a shopkeeper. For years, they were trying to hold me back; they tried to distract me by giving me different missions so I couldn't focus on my gallery.

Nonetheless my intention of opening a design gallery was not straight and proper, as the gallery was my excuse to travel abroad regularly, limiting any chances of me being stuck in Hong Kong or China. The noble idea I had was to introduce handmade and limited edition works in Hong Kong, where people had only been exposed to Milan industrial furniture. I expanded the idea by inviting these designers to China to manufacture and produce new works. Honestly, I didn't have the faintest idea about manufacturing but I thought I was helping the designers, since there was a recession in the U.K. in 1993.

What has fed your passion for collecting?

I'm a shopaholic. I have always liked to collect beautiful things. I would spend any pocket money I had on glass bottles I would find at markets. I still have them in my London flat.

How did you start collecting Chinese art and furniture?

A Chinese artist was taking me around all these different artists' studios and we were meeting, talking, and listening to them. They didn't have any galleries. But going to artists' homes and seeing what they do has always fascinated me. I started buying and collecting their things. Then I had another idea and thought that it was stupid to limit myself to design with my gallery—why shouldn't I try art and do it the same way as I did with furniture.

I used to hate Chinese furniture because I had always associated this with my grandparents and great-grandparents—really old-fashioned. But I collected French antique furniture. My attitude changed after I did more research and saw different kinds of pieces. Now I like Chinese furniture, especially Shanghai Deco. I see how Ming furniture has influenced Corbusier. I am eclectic, so I am interested in all different styles of art and design. I had curated a show in France in 1998 and was working with Drouot using French antiques, South American collectibles, Picassos, and contemporary works. It was a reflection of my eclectic taste—antiques mixed with contemporary designs.

Who were the first artists you decided to work with?

My gallery's first exhibition took place in January 1993. The artists were Tom Dixon, Mark Brazier-Jones, Scott Cunningham, Nick Allen, and Patrice Butler. Patrice became the gallery's art director until 1996. I created a "mobile" gallery concept, where exhibitions moved to different venues—private residences and so on.

What is your gallery concept?

My intention has been to find a new gallery model that does not follow the model of Western galleries like in the U.S. and in Europe. The gallery or the museum structure is a Western concept—traditionally, we didn't have galleries or museums in China. Art was previously only for self-cultivation. Today, we need to explore how to combine traditions with commercialism. With information technology and globalization, we can reach all parts of the world. The Internet is becoming more important and we are seeing more mobile exhibitions.

My initial idea when I began the gallery in Hong Kong was to show the public how art and design go hand-in-hand. I didn't even know that there was something called eclecticism. I had no idea, but it was just my frame of mind. I believe that in Hong Kong it was very different—people didn't understand art, but if you tried to mix everything and arouse people's interest, they would want to learn more about art and art history.

One day, the French general consul discovered my gallery and was very impressed by my concept. He asked me whether I could do the same thing with French designers. His proposal was to demolish his residence and for me to redecorate it with French design to promote French artists and culture. I accepted and on his invitation went to France. This is how I started my relationship with that country.

In 2003, the cultural attaché in Hong Kong said to me there's a Chinese year in France and a French year in China, and they really wanted me to think about a good exhibition concept. They didn't have any strong concepts, so they wanted me to come up with something. So I came up with an exhibition that would take two hundred square meters, treating the French influence in Chinese art, but when it actually opened it was two thousand square meters! Then I went to France and was staying there, trying to explore that topic. At the end of 2003, I set up an office in Shanghai just to work on the catalogue and started curating the show.

What nationality are your clients: are they from China or from foreign countries? What differences do you see between the two types of collectors?

I think the Chinese have a different way of appreciating art—we look at art in different ways. There are a few Chinese collectors who collect Chinese contemporary art, but the rest are all private museums. If you look inside a typical Chinese public museum, they have exhibition space, but not permanent collections. You have four or five people who have collections and that's it. The people who are buying a lot of Chinese contemporary art are the Chinese who live abroad. People in Hong Kong, Singapore, Taiwan—even the Koreans are buying. Chinese in America—they are all buying. These collectors are Western-educated.

The Chinese in China are not buying. What they do buy is ink brush, calligraphy, and sometimes realist paintings. Ink brush collectors won't collect Basquiat because they don't have the same educational background as the people in the West. There are some Chinese art collectors who collect Chinese contemporary art, but you wouldn't have met them. They are very, very private—very different from all these other collectors. And when they are businessmen, they are buying contemporary Chinese art as an investment. They are not cultivating a collection. They are only buying because they think they can make money because of the internal Chinese auction market, not because of the international auction market.

We don't sell to museums in China. They don't have any money. We have to donate to museums. I sell to the Chinese around the world—that's how I began.

Gallery owners are networking through new locations all around the globe. Why? And why are you only based in China in this globalized world?

In my opinion, one doesn't need all these new locations: when you have an art fair, you are able to meet people from all over the world. You also have globalization and the Internet, which enables

Zhang Huan, *Wind*, 2007, private collection Pearl Lam

people to see different works. It is a novelty to have a gallery or art that is far away—people make an effort to see it. Art and design should be treasures to discover—they don't have to be too accessible.

You should be gaining an understanding of Chinese culture—that's why you buy Chinese contemporary art. My gallery deals with cross-cultural and cross-disciplinary work, and I have never followed the model of the Western market. So I am trying to discover what should be the model of a Chinese gallery. The gallery itself is a very Western phenomenon.

What is the role and function of an artist today in China?

Traditionally for the Chinese, art itself is only for self-cultivation. It is not to be sold. We don't even have so-called artists—we have *literati*; we have culture that rules China because artists traditionally worked for the king, the Mandarins, or officials.

Of course, globalization started to accelerate in the twenty-first century. The Western influence really pushed artists in one direction. First, I think artists are really thinking about money. The Western

tradition for artists since the Renaissance is that they are second-rate citizens, and they have to sell their work to make money. They are not allowed to stay around the nobility because they are like tradesmen—they painted the Catholic churches to make a living. For those artists, art was a tool to make a living. The Chinese are different—traditionally for us, to create art is to meditate and to make oneself a better human being. That's why when you look at China, we have very great antiquities because our *literati*, who are the people who painted and became government officials, used culture to rule China. That is why we have a very, very rich culture and great antiquities.

Today, artists are moving toward the Western side. Western theory has influenced the entire world. Chinese artists have always needed to be famous in the West before they return to China. To please Western curators, they forget their own Chinese theory of art to cater more to Western audiences. Besides Western art theory, there is no written theory of art from any other country, although Gao Minglu is working on a Chinese theory of contemporary art. With that, the West will gain more understanding of Chinese contemporary art.

What are your next projects?

Initially my idea was to explore the emerging art market through the three oldest civilizations: India, Iran, and China. But I think the Indian sensibility is too difficult for China. I really like Middle Eastern art because there is a very strong international language, and poetry and calligraphy. I think it is beautiful. I am showing some Pakistani artists as well. Pakistani art is very interesting.

This fall, I am mounting a contemporary group ink brush exhibition. I am showing some ink brush by Wang Tiande, André Kneib, and Zhang Hao at the Hong Kong art fair as well. I'm also continuing to invite international designers to create new works in China.

How do you explain the record prices for the emerging markets at auction?

These are Western investments. We are talking about the art market. For the first time, art is not only for the elite, it has reached the middle classes. When something reaches the middle class, it becomes popular; it becomes a commodity. Formerly, art was only for the elite classes and it possessed a spirituality, but as soon as the middle class is touched by art and spirituality, a new world is born. All this is not about globalization but the fact that art has now reached the middle classes. With the economic crisis those new collectors will buy much less, and prices will probably come down.

Do you have partners you work with all over the world, or are you all by yourself?

I pick people who do things I like. Choosing who your partners are, who you want to work with, is very important. I strongly believe that if people want to have Chinese contemporary art, in order for me to cultivate those people they have to learn about our culture. I have an artist-in-residency program, and I invite international artists to come and stay in China and create works linked to China.

Does art today have to be linked to spectacular events to be more effective?

Art, like any other venture, is about marketing and branding. If you want massive attention, you need to do a big event. That is why art fairs bring people in.

What are the effects of globalization on art?

Today, everything, including the emerging market, is judged by Western perspectives and standards. Because of this Western perspective—you call it globalization; globalization is actually promoting a uniform culture. The worst of all this is that for a civilization like China, Iran, or India, contemporary art does not mean rebelling against tradition. It is not like Western contemporary art, which is rebelling against tradition and is formulating something new. Chinese, Iranian, and Indian contemporary art is about evolution, evolving from our traditions. Western contemporary art is always about the conceptual—psychology and philosophy. In China, our philosophy dates from 550 B.C. and we have no psychology. What are we going to do? We don't have conceptual art, so our Chinese art is evolving from our traditions. All these Western standards try to tell us what is good and what is not good . . . Westerners don't understand when they look at Chinese art how to relate to our culture. It is easy to say that Western art is about philosophy. I spoke to some Chinese artists and they said to me— especially those who have been abroad: "We use the Western philosophy." I said to them, "Really? How much do you know about Western philosophy? People study philosophy for years to learn it. You can't just tell me that. That's bullshit!" This whole thing is what the West decided to do. Today, what I see about the emerging market is that it's all run by the Western contemporary so-called art experts. Then they call themselves contemporary Chinese art experts. All they know is fifty to hundred years of our history. We are different! We don't have a Dark Age. Our civilization continues, and how can one not look at the past in order to understand what we are doing today?

What are the characteristics of Chinese art and artists today?

The world now is very simple—art becomes a commodity, and if we define art as what we used to define as communication, then we have a big problem. Chinese contemporary art should teach us about contemporary culture—what we are and what it is all about—but it is not doing this. Today the artists are representatively doing the white face, the laughing face—they do not think about their culture, they think about money and how they can please the Western collectors.

I wouldn't say every one, but the majority of them are like that because there's no point for them to teach us about contemporary culture. But today, if you define art as communication, it is especially important for it to reflect what we are today. So we should not have all these cynical political paintings around. This is completely mad! And also ban the West, because the Westerners want to see paintings that create dialogues. So when they see something that looks like pop and politics, they understand because they didn't even make an effort to try to learn about our culture.

In your opinion, who is the artist who has most respected your culture?

Zhang Huan. You know, the ash paintings. I just love him! The other person is Shao Fan, who is doing Taoism—he is taking Taoism and pushing it to tell people: "Hey, look back at this!" He's not afraid of not selling his work.

Will there be a serious correction due to the crisis?

Of course there will be a correction! It's ridiculous! The pricing was not realistic.

Among the Chinese contemporary artists, who will have the importance of a Damien Hirst?

I think it is still very early, but I can tell you I think Zhang Huan will be number one in the world. He is fantastic! He is doing ten to twenty different works all at the same time, all different series of works. Producing one thing over and over is one thing, like Damien Hirst's butterfly paintings. But he does more than that—his creativity is truly amazing. I have never seen another artist like him. The great thing is that if you have big galleries like Pace involved, the artwork will reach important collectors, and marketing will reach different museums as well. It is good for Zhang Huan to have such good credentials. Even if there will be a huge correction, I don't think it will touch him because most of the things he has been auctioning are his performance art. This worked very well, and most of his new work is not on the auction market.

Do you think that Western art, through the explosion of new ways of communication like the Internet, can influence Chinese artists?

No, because the Chinese are no good at reading even an English newspaper. Many of the artists cannot read English. When they see paintings, they only see the surface but they don't understand the concept. The whole thing is quite superficial. People in the West never understand that the Chinese see Velázquez and are inspired—but it is just the appearance of the painting that they see. We have to remember that this is very Asian. We still look simply at visuals because we don't know what conceptualism is. Aesthetics are very important!

Do you collect European art yourself?

Yes, I have one or two pieces. I collect what I like, very different from the West. In the West, they always say that if you are a good gallerist you are not a collector.

Do you think globalization is a good thing for art?

Everything is based on a Western theory of art. Until the Chinese theory of art is clarified, the world will have a uniform, Western language, not an international one like people think, which is boring. Globalization in trade is very good, but when we talk about globalization in art and culture, it is very bad. What we should try to do today is maintain art's integrity: Chinese contemporary art should

be Chinese, Iranian art should be Iranian, and Japanese art should be Japanese. Western curators judge us from a Western perspective—there will be no more differences. The reaction against globalization is to remain different, to celebrate those differences. Currently, Western contemporary art dominates the contemporary art market. Unfortunately, Chinese artists who became successful in America left China, because up to now we never had a structured art market.

Do you think the Chinese market has a potential to grow?

I think it will come in its own time. Collecting is in the Chinese blood; they collect all sorts of things, but they don't collect contemporary paintings because they don't consider it to be a collectors' item yet. How are we going to bridge that gap? It is very important for us, because we are really different from the West. What I am worried about today is that this Western domination might kill us, could kill who we are. It is not about money; it is about our respecting who we are and our differences. I think that is the urgent question. There are a lot of people who don't know how to go to galleries—they go to auctions. Then they are buying. This middle class is different; we are in the twenty-first century and for them art has become a commodity. We have to accept this whether people like it or not.

GERD HARRY LYBKE Galerie Eigen + Art, Leipzig/Berlin

Gerd Harry Lybke

Gerd Harry Lybke was born in Leipzig. After graduating from high school and finishing a training as an electrical engineer at the Kirov works, his first ambition was to become a cosmonaut, but the prospect of having to move to Moscow put him off. In 1983, he happened to take a job as a life model at the Hochschule für Grafik und Buchkunst in Leipzig. The same year he opened a gallery, where he exhibited works made by friends. Today Gerd Harry "Judy" Lybke's Galerie Eigen + Art, based in Leipzig and Berlin, holds a highly prestigious position in the international art scene. His discovery of the artist Neo Rauch opened up one of the most successful periods in German postwar art and has turned Leipzig into an internationally renowned cultural center, attracting many up-and-coming young artists.

"It's the artists who make a gallery. Anyone who doesn't understand that will pretty quickly find themselves losing out on the global market."

How did the Leipzig School achieve its great international success?

The notion of a "Leipzig School" is really only a media label for the present situation; it isn't an idea that developed out of the scene itself. The notion of a "Leipzig School" goes back to 1961, and has simply been carried over to the present day. It really has nothing to do with what these days is generally considered a particular style of painting.

The breakthrough for this kind of painting meant first and foremost a revival of painting itself. Because between 1990 and 2000, photography and video art were enjoying the height of their success. Painting had virtually ceased to exist; most of the art schools weren't even teaching it anymore. Instead they had "media classes." Even art students who had originally enrolled to do painting ended up working exclusively with the new media. Back then, painting just wasn't sexy anymore and you couldn't get a girlfriend with a paintbrush in your hand. It was photography and video that were in. But even at the time, people felt this vacuum on the art scene, they just couldn't really put their finger on what it was. That changed very abruptly when artists like Neo Rauch broke into this vacuum and opened the door again for painting internationally.

In this situation, Leipzig, where Neo Rauch came from, was the only art school where no one was telling their students that painting was dead, and this was thanks to one professor in particular: Arno Rink, who was Rauch's teacher. Perhaps he didn't keep it from them deliberately or consciously. In Leipzig students continued to paint out of a certain sense of defiance. There was a very close relationship between teachers and students here, which was different from the other art schools, particularly those in the West. Over there, they were inviting in art stars to teach the future "stars." And they didn't want to be told what they should be doing. In Leipzig, by contrast, students received a proper coaching from their professor, even after Rink left. Interestingly enough, increasing numbers of students started coming here from the West as a result, among them Matthias Weischer, David Schnell, and Tim Eitel, all the later representatives of this school.

Neo Rauch is the key figure in this group of artists. What makes his art so unusual?

His kind of painting was new. It wasn't interested in becoming international in the sense of following processes of globalization and worldwide homogenization; rather it defined precisely the difference.

That was the sign of a new approach. These were artists who had understood that the world wasn't being driven by processes of homogenization, but rather that globalization meant the heterogeneous and the different working together like hinges. If you are French you are a Frenchman, and if you are German you are a German. And when Neo Rauch quite deliberately said, "I'm a German, an East German artist from Leipzig," this amounted to a new beginning in Germany after 1945.

Neo Rauch offers what is in effect a screen onto which anyone can project their thoughts—in other words, painting. He addresses the issue of painting's rediscovery of its own origins. The more specific and biographical his works are, the more precisely they refer to the place where they were made, the more universally relevant they become, because everyone can read them in their own individual way. For example, the people in Israeli museums say, "Finally, someone who is making works about the problems in our country," or Americans say, "Finally, someone who is continuing the tradition of Hopper." Although Rauch also quite deliberately emerges from his work as a German artist from Leipzig, they see connections with things they know from their own experience.

So his pictures are connected to our collective unconscious, and this is something everyone seems to feel about them. In his pictures, past, present, and future converge; a futuristic age is collaged together with an archaic one, both of which feel familiar to us. Rauch lets all these things fuse together in his pictures. His work has inspired a critical self-examination in both artists and public and a new way of looking at things.

To what extent does this new way of seeing have anything to do with the division of Germany, and with Rauch's origins in the former GDR, which was largely cut off from the West?

It has nothing to do with it. Many people in the art world abroad, both artists and collectors, were often completely unaware that an East German state even existed. When I opened a temporary gallery in New York back in 1993, I tried quite deliberately to draw attention to the fact that I came from East Germany. No one understood me. "You come from eastern Germany? Hey, I come from eastern America." It was clear that people simply didn't know about the division of Germany after the war. And in the end it really doesn't matter where you grew up. What actually matters is what kind of family you grew up in. For Rauch, too, this is the crucial starting point for his work. It's no accident that for him present, past, and future are all mixed up together, because that is how his life has been. His parents died in a train accident when he was still very young. So he grew up with his grandparents. And this meant he experienced the past as the present, but as a present that only concerned him and his visual knowledge of the future in his own futuristic world. In addition to this, though, there was also another parallel world: how would things have worked out if his parents had lived? None of this has anything to do with the history of the GDR. And Rauch was also far too young to really be affected by East German socialism. Understanding his work in these kind of terms is purely hypothetical and verges on the idiotic. It shows yet again how little people really examine the background and biography of an artist.

The success of your gallery is closely related to Rauch's success. How did this happen?

I met Rauch in 1982. He was studying painting at the Hochschule für Grafik und Buchkunst in Leipzig under professor Arno Rink. He later became Rink's assistant and eventually even succeeded him as professor, occupying the post from 2005 to 2008.

In 1995 and 1996, my gallery showed an exhibition of Rauch's pictures at a stand at the Armory Show in New York. Roberta Smith, the leading art critic at the *New York Times,* wrote a long article about Rauch and a seventy by fifty centimeter painting of his. The next day a lot of visitors were looking at this picture with great amazement and seemed to feel that this painting anticipated something important, that it filled the vacuum I mentioned earlier. This vacuum needed to be filled, just as every age needs its heroes. And in 1995 there were really no other painters apart from Rauch. That didn't change until 2000. Today there exists a kind of painting that no longer needs to be referred to another context in order to be understood or to make sense to other cultures. It exists in its own right and can only be traced back to the artist. If this kind of painting comes onto the market, it gets gobbled up immediately.

You were also the first person to exhibit Rauch's pupils.

At first, all Rauch's pupils set up their own gallery together, the Produzentengalerie Liga. One of the students took over running it. When she left the gallery to concentrate more on her own work, a former colleague of mine, Christian Ehrentraut, took it over. I knew all the artists and wanted the new gallery to do well. So I sent all my collectors there. I told them, "You're hungry. There's something interesting here." When the Produzentengalerie closed down, Ehrentraut took some of the artists for his own gallery, and the others came to me.

You are among the most successful gallery owners operating in the market. What is the secret of your success?

The gallery is a team of people who work here, each of whom have their own specialist area. They work extremely efficiently and always have as their main focus the artist and his work. Without this team, which is the gallery's motor, there would be nothing. I run the business side of things, and everything we do is part of a strategy. I run my gallery like any other business, which means that I sell successful products, artworks by the successful artists of tomorrow. To do this, I keep an eye on how an artist develops over the course of five or six years before I work with him, or he with me. I've known all the artists I work with for a long time, have visited them in their studios, and have followed the development of their work. It's important that you don't try to control what artists do, because the quality of their work is directly judged by the degree to which it is considered properly theirs, and also by how well they are able to recover from setbacks and continue developing. An artist must have the courage and the space to make mistakes. Even works from weak periods are important as stages within a wider course of development. I am completely open with the artists I represent, as

they are with me. That is the only way the gallery has been able to become what it is today, and that is the only way that you can get collectors coming in the door on their own initiative. As a gallery owner, I must be in constant "motion round the artist." It's the artists who make a gallery. Anyone who doesn't understand that will pretty quickly find themselves losing out on the global market. And that's precisely what a lot of people do: they're only interested in the product and try to sell it to any collector they can.

Like any businessman, I have to think about the future, because otherwise you get pushed aside; you become less and less relevant. But I would like to have a hand in writing the history of art and become immortal through what I've done. That's why I'm becoming less interested in my own generation of gallery owners and more interested in the younger generation following them.

Why don't you work with partner galleries?

I represent our artists exclusively, which means that the artists only have one gallery, mine, and perhaps one other. So far we've managed to work successfully with galleries like Hauser & Wirth, Irit Mayer Sommer, PaceWildenstein, and David Zwirner. If we don't find the right second gallery for these artists then we wait. Because if an artist has the wrong gallery, then whatever happens it will only be about selling this artist's work, and not about his art. And it is precisely the latter that is crucial if you're going to attract good collectors. I'm only really interested in these, and above all the museums and *Kunstvereine* (arts societies). Unlike most galleries, I tend to avoid collaborating; I generally prefer to fight my own ground.

You have opened your gallery in an unusually large number of places, though often for only short periods of time. Why?

Whenever I've made money at art fairs, I've used it to open a temporary gallery somewhere in the world; that is, a gallery set up on the basis that it will only last until that money is used up. This forced me to ask the question, where in the world can you find interesting art? In 1990, it was Japan. So I went there while all the owners of contemporary German art galleries were going to Cologne. No one had any use for me in Cologne, but Tokyo was uncharted territory. For this, I took half my profits from the Frankfurt art fair and gave them to the artists; with another part I had catalogues printed and sent all over the world, and with the rest I opened my temporary gallery in Japan. I learnt a great deal there and formed many close friendships with artists. Economically it wasn't an easy time, because in 1990 and 1991 the country was really on its back. After the three months were up, I went home. In 1991, Paris was the place to be, so I opened my next temporary gallery there; in 1992, it was Berlin; in 1993, New York; in 1994 and 1995, it was London. Since 1996, it's been Berlin and Leipzig again, but I was already represented there, so I've stayed in both places until today. Along with the large international fairs like Frieze in London, Art Basel in Basel and Miami Beach, and the Armory

Show in New York, they mean I can cover all the places that are important in the international art market.

How important to you are the new markets?

We'll have to see. Russia could be interesting to me, because there's a certain basic understanding of European art there. That's something that's almost completely lacking in new markets like Dubai, even though they're building enormous museums. The Chinese may also end up finding a place for European artists in their museums. But at the moment they seem to be much more interested in their own artists. If I were to go there with some of our work, then I would be very lucky if I could sell any of it on its own merits, and then only if I were really giving it away. And when I think of all those endless new exhibition buildings that are being put up in all these countries, or are going to be put up, then I wouldn't have enough works to sell to them anyway, and nor would I want to. At the end of the day, there is a limited supply of top-quality work, and you have to think carefully about who you give it to. That's an important part of my strategy and one that I always discuss with artists.

How has the art market been changed by globalization?

The art market has changed completely, because the number of clients buying at the top end has expanded from fifteen important decision-makers to several thousand. They are the ones now deciding what good art is. It's like during the rock 'n' roll era. Back then you had to be a Beatles fan or know who the Stones were. These days you need to know certain clients' names, and need to like them and to have seen certain exhibitions in order to be able to join the conversation. These days, art is a way of becoming accepted by the society of one's own generation. Young people between twenty and forty identify themselves with contemporary visual art. They find they can project their own thoughts and feelings onto it. In Leipzig we have four hundred visitors coming on the weekend. And this despite the fact that our gallery is located in an old cotton mill on the edge of the city. But we also have something to offer at this location: a group of international galleries from New York, London, Chicago, Mexico. And the rents are very reasonable. Here you can rent a space for a whole year for the price of two dinners with a group of collectors.

Do you think that art is heading for total globalization?

No, absolutely not. On the contrary, it's heading for total individualization, which are the hinges that make true globalization possible. These days, I'd like to learn all about Mexico from someone from Mexico; I'd like to share some of his knowledge, hear something about his personal experiences, and not from someone or other who comes from somewhere or other and lives somewhere or other. The more individual and authentic an experience is, the more it can feel relevant to other people across the world.

How important do you think art fairs are?

Any market is always important. Personally I don't see art fairs merely as events that you can sell things at; for me they're not simply places for selling. They're more like places for looking at stars. If you look directly at a star, then you see it out of focus. You need to look a little bit to one side of it. So you *can* go to the fairs, pay money, and show your goods. But then you become mere filler, you become uninteresting. That's why you need to be very clear about which fairs you go to, and why. Let's start with the Berlin fair: this fair is closely linked to the city of Berlin and reflects its liveliness. People use this fair as an excuse for going to Berlin. So I generally put on themed exhibitions there, for example, on the theme of sculpture. I invite a variety of interesting artists to do them. For me it's really about finding themes that are interesting, ones that you'd like to know more about, and which the collectors are, or will be, curious about. By contrast, at London's Frieze I always do one-man exhibitions, because this fair is so big and colorful. You can either use a single concise work to get across a very specific statement, or show the different aspects of an artist's work and thus offer a deeper insight into his entire oeuvre.

I also do one-man shows at the Armory Show in New York. Here my target groups are museums, curators, and critics. And here you really do need to show many different aspects of the artist's work, and accompany it by a high-quality catalogue, which you'll have already sent out to the interested parties. The most important thing here is the level on which you communicate with people, and for that reason there's sometimes up to six of us on the stand at the fair, so we can communicate a great deal. And in Basel? Sometimes I borrow a picture from a museum that I've sold them earlier, so I can show the kind of quality I have.

Are you benefiting from the new trend in the market that is increasingly turning art into a commodity or an investment?

This trend has no relevance for my gallery business. To work this way, I'd have to have available an enormous supply of works, a huge surplus of goods. But things are different for me; I have a seller's rather than a buyer's market. That means that if I have twenty works by an artist, then I'll have about six hundred people interested in buying them. And among this six hundred there are at least ten buyers with big collections; in other words, there are also museums. This means that I will have no problem passing on these works to people who are not only interested in them, but whom I would ideally like to sell them to. The potential buyers among the initial six hundred people who are interested only in reselling the works speculatively stand so far to back in this queue that they really have no chance of getting anything. This kind of person is better off buying at auctions, just as long as they don't care how much they pay. And that seems to me quite right, since this way they end up supporting the market.

What will be the influence of the financial crisis on the global art market?

Every crisis is a sign that the forces that have been in play up until then have lost their relevance and that power and influence will now pass to others, usually the next generation. In a crisis, this happens very radically, without any consultation or a period of transition. This is something we experienced in 1989, when the GDR collapsed and the Federal Republic assumed its present form. Anyone capable of keeping pace with the new, or who is even just starting up, has an opportunity to benefit from the redistribution of the market. We were and are ready for it.

AUCTION HOUSES & ART FAIRS

LISA DENNISON Sotheby's, New York

LOURDES FERNÁNDEZ ARCO, Madrid

SIMON DE PURY Phillips de Pury & Company, New York

MARC SPIEGLER Art Basel/Art Basel Miami Beach

LISA DENNISON Sotheby's, New York

Lisa Dennison

Lisa Dennison studied art history and French at Wellesley College. She received an M.A. degree in art history from Brown University in 1978. She worked at the Guggenheim Museum as a summer intern in 1973, followed by internships at the Fogg Art Museum, Harvard University, and the Museum of Fine Arts, Boston, before joining the Guggenheim Museum in 1978 as a curatorial assistant. She served in multiple curatorial capacities at the Guggenheim, becoming deputy director and chief curator for the network of museums, including Bilbao, Las Vegas, Venice, and Berlin. In 2005, she was appointed director of the New York museum. In 2007, she joined Sotheby's as Chairman, North and South America.

"Building bridges across culture through art is very important."

You changed your position from a not-for-profit institution, the Guggenheim Museum New York, to a global for-profit company, Sotheby's. What was the challenge for you personally to pursue this step?

There are some striking similarities in my experience at both places, and one has specifically to do with the nature of the museum industry. Museums have become more like commercial institutions in order to survive in today's increasingly competitive art world. They have had to create more of an entertainment factor to gain audience share. "Audience" means individuals who buy tickets for admission; these revenues support operations. "Audience" also means sponsors who want to associate themselves, associate their brands, with your museum, your brand. The pool of collectors and individuals who will become your board members or your patrons want to align themselves with a place that has the most exciting programs, the best collections, superb architecture, and financial solvency. Because the group of museum visitors, collectors, patrons, and sponsors is a relatively small one, there is a lot of competition for this audience. As a museum, you are competing for that share of the market, and you are also competing against other leisure-time activities. You have to give your audience an experience that is very rich and unique, and often this means that you have to be entertaining at the same time. You cannot be an elite ivory tower institution which makes people feel inadequate from the moment they walk through the door—as if the experience will be beyond their intellect. But if you don't give them a significant and interesting intellectual experience, that will be off-putting as well. Today, you have to create a "user-friendly" environment. As a museum this means creating an environment that can be a communal place for socializing, as well as learning.

If museums have moved more toward a commercial realm, then it could be said that auction houses and galleries have moved in the other direction. Auction houses have display spaces that compete with museums. Their installations are "curated," and their catalogues are full of scholarship. Galleries are also concerned with scholarship. They produce catalogue raisonnés; they work with the estates of artists; and they create exhibitions that are museum-worthy. The boundaries are becoming increasingly porous between all these institutions. I came from a museum that had a global network and was thinking about globalization at a very early stage. We were conscious of emerging markets—we had significant shows of Russian art, historical and contemporary Chinese art, and we were building a museum in the Middle East. Coming to Sotheby's, a global company also active in these emerging markets, was not so far from my experience at the Guggenheim. My job at Sotheby's is focused on business development and building relationships with our key clients. My expertise can

help in this regard. It is a much broader activity than it was at the Guggenheim. I have a reason to reach out to more people, and more people have a reason to reach out to me.

Who has the most important role in the art market today?

I think museums are in a difficult position today because they don't seem to have the power to speak with the same authority that they had in the past. More and more people are learning about art from galleries and auction houses. Museums need to build their permanent collections, but what we are seeing is a phenomenon where collectors don't want to gift their art in perpetuity to a museum that may put it in the basement storerooms. Collectors want their collections to be living, breathing entities—and this makes museums less relevant to them at this time. The collectors, auction houses, artists, and galleries all feed off each other in an important, synergistic dynamic. They depend on each other for their survival, and this now happens globally.

Another international phenomenon is the fact that collectors today are forming their own museums, so to speak, including Baron Ullens in Beijing, François Pinault in Venice, Victor Pinchuk in Kiev, Eli and Edythe Broad in Los Angeles, Mitchell Rales in Washington, Donald Fisher in San Francisco. This is an interesting development to me because it speaks of dissatisfaction with museums and the roles that these institutions play in today's society. It also speaks about the amount of contemporary art that there is in the world, and the fact that art can often no longer live comfortably in the boundaries of a home environment, but rather needs its own environment. It may be about sheer volume, scale, or the complicated demands of a particular installation. It also speaks of the collector's desire to be engaged with this art, to play a meaningful role in acquiring it, shaping its presentation—but it doesn't stop with just ownership anymore. We are seeing the same phenomenon we saw in the late nineteenth and early twentieth centuries when titans of industry like Carnegie, Mellon, Rockefeller, or Guggenheim helped to form a whole host of new museums, based on their private collections. But today we are seeing this on a worldwide basis, very globally. And what starts as the simple vanity of a private collector may quickly be institutionalized. They bring in curators, they have boards, governance, education programs—they are creating structures that in many cases will become the institutions of tomorrow.

The most powerful people today in the art world are really the collectors: this is where the power resides.

The borders of art are becoming ever more fluid, not only between countries but also within art forms. Is this a consequence of globalization?

Breaking down boundaries between art institutions parallels a similar phenomenon in the art world as a whole. Art, fashion, and design all meld together in today's world. Zaha Hadid's work—is it sculpture or is it furniture? Today's collectors want to expand the categories of what is considered art as well, like they did in the early twentieth century. I think there are artists who follow in a lineage

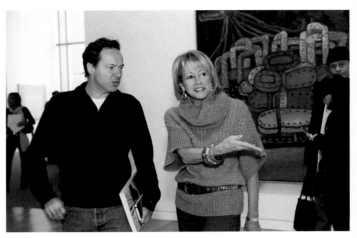

Lisa Dennison in the showroom of Sotheby's New York,
in the background a work by Philip Guston

of Duchamp in a much more conceptual way, challenging the conventions and definition of art. And there are other artists who share a more formal aesthetic and are coming from a different strand of thinking.

Building bridges across culture through art is very important. The humanitarian goals are not insignificant because art can breach great distances that politics often cannot.

What is the strategy of Sotheby's as a global public company to enter new markets?

Our strategy is to source globally but to sell locally. We have offices in forty countries but principle sales rooms in only a few cities: New York, London, Hong Kong, and Paris. We encourage our bidders not to think anymore about their local sales room, but about buying and selling globally. In the past it might have been unthinkable for an American who wanted to consign a work to even consider it could do better in Hong Kong, Paris, or London. We encourage a whole new way of thinking among our consigners and our buyers—that they will buy in multiple sales rooms and they will buy across categories. People who are serious collectors often run out of wall space very quickly. We may find that today's painting collector might really love mid-century furniture or jewelry. So we want collectors to think about cross-collecting categories and about buying and selling beyond their geographic boundary. That is why we bring our sales highlights to cities around the globe, including emerging markets. We bring our staff as well so that they can get to know to the communities.

Contemporary art has evolved in the past five to seven years tremendously. To what do you ascribe the increase of global interest and global sales in contemporary art versus Modern art and Old Masters?

If you add up the net sales for the year at an auction house of the auction market of Andy Warhol versus Pablo Picasso, you will see that Warhol has overtaken Picasso as the world's most actively traded artist—which is surprising to me. There is a lot of supply in contemporary art, and hence demand can be satisfied. Whereas in the Impressionist market, fewer people can participate because the supply is so limited. People love the engagement with the art of their time, partly because of all the social aspects of contemporary art, such as art fairs and the international festivals like biennials: it creates a lifestyle, an immersion in one's culture.

In Old Master art there is a much smaller community, partly because of supply, of course, and partly because of the knowledge base one needs to have in order to collect in this category. Today in art journals there is very little to read about Old Masters compared to contemporary art. Old Master art is much more grounded in study and scholarship than contemporary art, which virtually surrounds you everywhere you look.

What does it mean for a living artist to have works sold at auction in your opinion?

As we know, artists have always pushed the auction houses aside in a kind of negative way, yet I sense they are becoming closer to the auction houses recently. Artists today are sometimes consigning their works directly to auction. Or, if they find their work at auction, they are often very cooperative and helpful with installation and conservation issues, understanding that it benefits them and can benefit their market. Of course, their market doesn't always benefit, particularly if a work doesn't achieve the desired price level. In the new markets, such as China, it is even trickier because the underlying system of primary and secondary markets is not there. The meteoric rise in prices is very new and has happened by bypassing traditional systems.

Could "bypassing the system" change the rest of the art market?

Of course it could change. PaceWildenstein opened a gallery in Beijing, the first traditional Western gallery to do so, and this could have an impact. China is intending to open one thousand museums in the next ten years. I cannot predict the direction of change but there will definitely be a change.

Could art become the same everywhere then?

No, the nature of the creative process will insure that art will not be the same everywhere. Art is informed by local geographies, politics, and identity. However, as the world becomes smaller through technology and faster exchange of information, there is a danger that this could happen. It is like the mall phenomenon in the United States—Madison Avenue in New York, Rodeo Drive in Beverly Hills, or the Magnificent Mile in Chicago—they all have the same stores. It is as if no more individuality

exists. Even internationally—from the Faubourg St-Honoré in Paris to Bond Street in London to Orchard Road in Singapore—there are fewer and fewer little boutiques where you discover something new. The same can be said of hotels: you stay at the Four Seasons because you know that your room in Buenos Aires will look identical to your room in Shanghai or New York. Will the same happen with art? Probably not, because the creative process is so much about individuality. Individual genius will always break through the sort of neutralization or homogeneity that institutions will try to impose.

How will this happen in a global world—because of circumstances or selection?
No, I think the point about the market is that it is short term. You can have a very hot market and artists can become famous very quickly, but the question we have to ask is, "Will they be around in one hundred years?" I think what will be critical here are the museum exhibitions and the work that museum curators do to distinguish the quality of an artist's oeuvre. This is going to happen in a very different way from the market: it is going to happen in spite of the market!

In the past, estimates in auction have gone up more than ever in contemporary and Impressionist/Modern art and in both evening and day sales. How do you explain this?
There is a lot of liquidity in the world, and many people chose to buy art with their wealth. But art is not a necessity to most people, it is a luxury. The worldwide demand for art today is still strong, but there is no crystal ball to look into the future for the art market. Occasionally, we see work that broke all previous price barriers. There is the occasional work that pushed over $25 or $35 million or even $100 million, and this happened because the demand was there. The demand might have been a result of previous auction sales or of private sales. But this possibility is open for very rare and very top-quality pieces, of which there are only a few in the world. Then people might push the boundaries and pay the price for a once-in-a-lifetime opportunity. The higher prices in day sales were certainly a new phenomenon, but as you go through the day sales, most works were sold in the $300,000 to $400,000 range, rather than in the $1 million to $2 million category.
While art is widely considered to be an asset class today, there are some problems associated with this. The art market is illiquid and opaque, and it doesn't track against other indicators in any rational way. It is tricky. It seems that in times of currency devaluation, some investors are more comfortable diversifying their portfolios to include art because it has performed better than stocks, money markets, and in some cases real estate. On the other hand, it is illiquid and you can't necessarily sell it the way you can sell a stock and get your money out immediately. It doesn't pay dividends; there is a real cost of maintenance; it doesn't always appreciate in value. There are no long-term guarantees, because the art market will always have its peaks and valleys.

Is the art market secure itself in a crisis because it is global?

I think it is global and markets are diversifying and broadening, but in the end this is a community that is not that big, and one horrible weakness could create a crisis of confidence. And then some people may step back in their buying or selling activities. But art is about timelessness and passion, so I believe the market will always be there in some form or another.

Who are the new buyers?

There are new buyers every day. The market is broad and there are collectors everywhere: Russia, India, Asia, or the Middle East, as well Europe and North and South America. In 2007, there were six hundred new buyers who spent approximately $1 billion at Sotheby's. People come in to the market; people go out of the market. There seems to be a younger demographic of people who are interested in collecting art today. Museums help foster this with their "young collector" councils. Auction houses have mid-season sales of contemporary art at a lower price point.

How much and in what aspects are the "old markets" like America and Europe and the "new markets" like Asia, Russia, and the Middle East affected by the current economic situation?

The current economic crisis is global, so we feel the impact in all markets, old and new. However, we will need to go through several more selling cycles before we can make generalizations about where the strongest or weakest pockets of activity are. We continually see new buyers to the market, of all nationalities. And while this is not something that can be quantified, I somehow feel there is less speculation. In the Middle East, world-class collections are being created for national museums. I think this is a very powerful phenomenon that we are just beginning to understand.

LOURDES FERNÁNDEZ ARCO, Madrid

Lourdes Fernández

Lourdes Fernández is the director of Madrid's ARCO, one of the most im-
portant international fairs for contemporary art. After majoring in museology
and art history, she was successively a project director for the Musée
d'Orsay and head of the Department of Culture in her home city of San
Sebastián. From 1988 to 1994, she worked with Madrid's Marlborough
Gallery, followed by a spell with the Galería DV in San Sebastián, before
going on to ten years as director of Manifesta, the European Biennial
of Contemporary Art, also in San Sebastián. In the spring of 2006, while
overseeing a communication group's art collection in Madrid, she was
appointed director of ARCO, succeeding Rosina Gómez-Baeza, who had
been holding down the post for nineteen years.

"The market is very powerful, but art's above all that—art's the beginning and the end of everything."

For you, what makes ARCO different?

ARCO is part of IFEMA, a self-financing, not-for-profit consortium that organizes over seventy-five fairs a year in Madrid. ARCO's own profits go, for example, into financing all sorts of activities, including a series of conferences for artists and art specialists. One of the things that makes ARCO different is having had a guest country or region present each year since 2004–05, with Latin America and Mexico among them. I think receptivity to Latin America should be a major outreach sector for ARCO: we speak the same language and the Iberian Peninsula is obviously a way into Europe for those countries, with their fertile contemporary art scene.

What are ARCO's goals?

ARCO's first task is to make a name for itself on the art market. I'd like to get the message across about what's happening in contemporary art, both generally and in emerging countries in particular. It's very rewarding to keep in touch with what's going on abroad. Every fair needs its own personality, and for ARCO the key is the variety of its programming: the "Guest Country" feature, for instance, means we can show what's happening in a specific country and attract new collectors, new galleries, art critics, and museum directors with a special interest in that country. In three days, the guest program gives you a whole different idea of things. What the visitor sees—fifteen galleries representing two or three artists each—demands a preparation time of nearly two years. Recently, I was in Mumbai and New Delhi to choose curators for "Performing ARCO" and the other curated sections. The curators get in touch with the galleries and talk over the choice of artists with them. That way we can give a fuller view of the art situation in the different countries concerned.

Are some fairs better than others? And what, for you, is the basic role of a contemporary art fair today?

Basel, Basel Miami, Frieze, and ARCO are among the best. The FIAC has improved now, with the Carrousel du Louvre for the young galleries. I haven't been to Shanghai. In my opinion the true role of an art fair is presenting artists, creating a market, and getting things moving. Another goal is to communicate what's happening on the contemporary art scene. This explains why ARCO includes several programs and why I work with specialist curators. The "Expanded Box" program, for instance, which is devoted to artists working with new technologies, is curated by curators who are

specialists in that field. We also have the "Solo Project," a curated program for single-artist shows by galleries. Every year we work with curators from all over the world who really know what the artists are worth and which ones are likely to have interesting work to show. This brings us a substantial museum clientele. I think working this way helps to give the fair its distinctive personality, establish it as a platform for the market, and at the same time show what's currently taking place in art internationally.

How do you explain the proliferation of fairs around the world?

Looking back, I realized that the current proliferation of fairs worldwide is mainly the outcome of an economic scene that includes a more stable market, together with the globalization of the art world. Clients, galleries, collectors, and experts have much faster and more comprehensive access to information and greater mobility than before. The information comes through much more directly, there are lots of people looking to invest in contemporary art, and the market has really expanded. All these factors contribute to the multiplication of fairs, which above all hinges on globalization. Supply is going global too: an artist working anywhere at all can sell his work anywhere at all. There's been a complete change of roles. There's a greater sense of urgency, and everything's going much faster.

What's the future for the traditional gallery? Does it still have its place in a globalized world?

I continue to believe in the gallery as such: a fair remains a fair, by which I mean a programmed, rapid-fire event where galleries have to give an overview of the artists they're working with. The solo exhibition is something else entirely. I still firmly believe in the traditional gallery as a creative space where the artist shows his most recent work. The gallery doesn't exist just to make its artists work for fairs: it also has to make them work for themselves, make them advance. Artists don't work just to have a picture on show in Basel or at ARCO. There are people who say that the galleries pressure their artists to overproduce, but I don't think this is their fault. I remain very proud of the galleries, because I think it's more the market itself that generates this phenomenon. A lot of artists can't keep up, and if some of them are celebrities because they command very high prices, it's because there are very few of their works on the market.

How do you explain the record prices that have been achieved at auction for contemporary art?

It's basically the same for the market, a question of supply and demand. The greater the demand, the higher the price. To some extent this helps to consolidate the market and broaden demand: there are collectors in China now, and in India and Russia. It's not just Westerners buying any more. The very curious phenomenon represented by Christie's and Sotheby's has totally changed the market situation. Before they came along, the market took its cue from the galleries, like a kind of second market. Right now Christie's and Sotheby's might not be a primary market, but they're able to set certain

prices. Globalization is here, and I'm proud to say I believe in art. I think there's always something sublime about art. We're in the midst of globalization and the market is very powerful, but art's above all that—art's the beginning and the end of everything.

What's your view of the art/money nexus? Has the collector changed and become a speculator? And what's the impact on the fairs?

In my opinion art has always been an elite sector. It's always been part of the private sphere, even if in the old days the Church commissioned art and even if museums are free now and everyone can just walk in. Art is a luxury item. Even though it doesn't cost much for people who love art to visit museums and biennials and fairs, there's an ongoing attempt to "sacralize."

I think the traditional, old-style collector is still with us. Speculation only represents one facet of the market. The market is a very wide-ranging affair, and one part of it has become far too spoiled. I don't have the exact figures at hand, but there are statistics to show that the Chinese and the young were buying "like maniacs" at auction. They were speculating, but I never thought it was going to last—you're talking about another culture and another generation. Market consolidation is a real asset for the fairs. Speculation in the art sphere is surely going to bring the same disillusionment as in real estate. In recent years, speculation has almost overinflated art's status and the buyer's status with it: now you hear people say, "Personally, I'm investing in art."

SIMON DE PURY

Simon de Pury

Simon de Pury is the Chairman
and co-owner of the auction
house Phillips de Pury & Com-
pany. Founded in 1796, Phillips
de Pury is, after Christie's
and Sotheby's, the third-ranking
auction house in the world.
With offices in New York and London, the company focuses primarily on
contemporary art, and since 2007 it has launched a partnership with
the Saatchi Gallery in London. In autumn 2008, the Mercury Group, a Russian
luxury goods importer, became the majority shareholder—a move intended
to strengthen the company's reach and position in respect to the growing
Russian art market. Simon de Pury is a man of many talents: an artist in his
own right, he knows the art world inside out. The Swiss native was director
and curator of the Baron Thyssen-Bornemisza Collection in the late seven-
ties and early eighties, and today co-owner with Daniella Luxembourg of the
Zurich-based Galerie de Pury & Luxembourg.

"What I would like is to provide an unforgettable pleasure experience."

What made your auction house decide to specialize in contemporary art and fields like photography and design?

It has always been my dream to have my own auction house, but for me this is much more than just that, because it combines a number of different activities: auctions, private dealing, exhibitions, plus the gallery. We are also acting as consultants for art lovers who are in the process of building a collection. Each activity is separate and together they form a most unconventional auction house—a model that is different from the way things used to be.

When I became majority shareholder at Phillips in 2004, I decided that the only way to create something exciting was to specialize in a field with optimal potential for development—contemporary art. I think I made the right choice, as contemporary art has become the market's number one sector, just the way Old Masters dominated until the late fifties before being supplanted by the Impressionists and the Moderns. In my opinion contemporary art will continue to head up the market for the next twenty years, because it's a question of availability. Even with unlimited financial resources it is impossible to have the best collection of Old Masters: with just a few exceptions they are in museums and no longer available on the open market. The same goes for the Impressionists and the Moderns: whenever a top work comes onto the market, you have to spend $150 million or more, and there just aren't enough works of that caliber available. Contemporary art is the only field now where it is still possible to build up an outstanding collection.

In your opinion, who is the key player on the art market: the gallery, the museum, the auction house, or the collector? Would it be accurate to say the classical gallery has come to the end of the line?

I don't believe in compartmentalizing the art market. I am for breaking down all those boundaries. There is a comparison to make here with art forms in general: the medium comes second, what counts is the talent. The same applies in terms of how one approaches selling: why shouldn't an auctioneer be a good gallerist as well? These pigeonholes are totally archaic, and thanks to globalization they are on the way out. The explanation lies in the fact that artists from emerging countries have not been trained to work in the old system. An example of that is the gallery that prevents clients from putting their purchases up for auction: they are obliged to sell them back, privately, to the gallery. But we are supposedly living in a free world now, and one of the most basic rights is to be able to buy and sell whatever we like, as and when we like. Interestingly, the dealers who are most protectionist do themselves the most harm.

There are all sorts of ways to launch an artist. I think gallerists and dealers are vital here—without them the auction houses couldn't survive. Each actor on the scene has a part to play and is inextricably tied in with the others: for instance, the only way to justify a price is on the basis of the prices obtained at auction. But to really launch an artist today, there is nothing like a gallery that believes in that artist and works for him body and soul—even if the Internet means that there are all sorts of new ways for an artist to reach the public. The most consulted website in the world is the Saatchi Collection site, where thousands of artists show their work. Pretty soon, I think, we are going to see what has happened with music also happening in contemporary art, because the Internet is an alternative way—and a very democratic, interactive one—of making yourself known and getting started. The only museum where I have seen this democratic thing at work is at Igor Markin's in Moscow. On the way in you are given "For" and "Against" stickers to put next to the works. This very quickly gives you an idea of which pieces have triggered a violently negative or very positive reaction. Igor Markin is a collector who wants to see what impact his works have on the public. Apparently at his last exhibition, he had the prices of the works on full display, which normally is absolutely taboo.

As I see it, something else that is going to change is the métier of the dealer. Looking closely, you realize there is a gut-link between the value of a business and the person running it, and when the person dies the business is worthless. This makes me think there is going to be a structural shift resulting in multifunctional groups that combine the auction house and the gallery, that work directly with the artists and handle the cultural diffusion in a completely new way.

Once there were art patrons, now there are investors and investment funds. What are the advantages and disadvantages of the new collecting approaches?

Collecting is a highly creative activity. There is the old saying that a camel is a horse designed by a committee, and you can't build a great collection using a committee, even one made up of the top experts. There has to be one person in charge of the artistic choices.

What's the proportion of private sales at Phillips de Pury, and why is it that the guarantees paid to sellers are getting higher and higher? Do you guarantee minimum prices?

Private sales are on the rise because people want discretion, and it is important to be able to offer that in parallel with the actual auction house. The guarantee principle is something that has become much more prevalent over the last few years, because of the competition between different auction houses. This has led to substantial guarantees, which is a good thing for the seller: once the contract has been signed, you have to wait three or four months for the sale to take place, and it is not easy to predict what the current state of the market will be. All you can do is make forecasts. So the guarantee provides security. We give our clients impartial advice. If we criticize a work solely because it is being sold by a competitor, the client won't come back for advice again. The only thing that counts is developing a relationship of trust with the client over the long term.

Given the present context, do you see art as headed for total globalization?

I think the major change to the market over the last five years has been an opening-up leading to true globalization. Until not long ago, the market was dominated by American and European collectors; now it is open to collectors from all over the world who are buying artists from all over the world. This is reflected in the proliferation of contemporary art events like the big biennials, which are happening in places as diverse as Havana, Istanbul, or Lyon. Globalization is also the result of the new technologies, which have universalized market access and brought greater transparency at the same time. On the Phillips website, we keep track of visits by nationality: among the ten most active countries, only three—the United States, the UK, and Germany—are traditional customers, while the other seven include Turkey, Indonesia, and Brazil. This gives us an immediate idea of how the market is going to change, and it is fascinating. Another result of globalization is collector interest in art from China, India, Russia, Latin America, Africa, and the Gulf countries. These new collectors start out with jewelry, then they move on to contemporary art, beginning with their home countries and then broadening their scope.

Could you explain why photography seems to be the favorite medium for artists from the countries emerging onto the art scene?

The new technologies have made photography a global phenomenon. The proof is that every cell phone has a built-in camera, and every day billions of people are taking billions of photos. There's never been such a proliferation of images. The majority of artists have been brought up on TV or computer visuals, which explains why photography and video have become such major media.

Is it still appropriate to talk about works created with eternity in mind? And is the physical conservation of a work an issue for potential buyers?

There is something timeless about great art: it is remarkable because it is not tied to the period of its creation. What every artist wants is a place in history, a trajectory, a lasting impact. In that respect the physical nature of the work definitely counts: lots of artists use self-destructing materials, and it is true that for a collector a work has to be lasting. Thanks to institutions like the J. Paul Getty Museum, it has been shown that photographs can be made to last, even if they are fragile and don't stand up to prolonged exposure to light. But then again, the same can be said of watercolor.

What have the repercussions of globalization been for art?

Art changes fast and continuously. An artist faced with commercial success is also facing a fresh challenge. Some don't manage to cope and settle for working solely for the market, sometimes to the point of self-imitation; and then they lose all creativity and originality. Others keep blazing new trails in spite of success and lose nothing of their creativity. They are the real artists, and they will leave their mark in the long term. Damien Hirst is one, Jeff Koons is another. What makes them such

Contemporary art auction at Phillips de Pury & Company in London, February 2008,
works by Damien Hirst, Andy Warhol and Ilya Kabakov, among others

formidable figures is that their most recent works are at least as strong as the ones that made their reputations.

Does art merchandizing necessarily call for promo-style events?

I think celebration is something very important, and I have always tried to give it a place in my professional activities. When I was curator of the Baron Thyssen Collection in Lugano the opening parties were amazing. For a showing of works by Goya from private collections in Spain, we invited the top flamenco groups and we danced for two days! To mark the exhibition of Malcolm Forbes's Fabergé collection, we had a balloon made in the shape of the last imperial egg he had bought, and he and Baron Thyssen climbed aboard and overflew the Villa Favorita. At Phillips we try to create the same enthusiasm by having pop groups play after our sales. Recently, we had George Clinton & The P-Funk Allstars along and saw George dancing wildly with Cindy Sherman, and when Kid Creole & The Coconuts played, everyone danced madly around Damien Hirst's *Fish Tank*. That way we get a chance to enjoy ourselves and not take things too seriously, because all of us are incredibly busy and under pressure all the time. What I would like is to provide an unforgettable pleasure experience and have fun with the artists, the clients, and our friends.

What do you think of the art celebrity cult?

Media coverage is important for an artist. If we look at the twentieth century, nobody had a more photogenic gaze than Picasso; and no artist of the time used the media better than Andy Warhol—he sold for less than some of his contemporaries, but his media impact has continued well after his death and thanks to that he just keeps coming back. It is the same for more recent artists: Jeff Koons and Damien Hirst are known to the general public, not just to art lovers.

At present, even young artists appear in auction more and more often. What are the dangers of overproduction for an auction house?

The problem is more the opposite, in fact. Let's say an artist only produces thirty-five works a year. His gallery is going to make a strategic international choice of the collections those works could go into. But for the thirty-five works, there are maybe three hundred and fifty potential buyers. This is what sustains a market for that artist, and it explains the record prices you get when one of his works comes up for sale. But it cuts both ways, because when an artist's rating really takes off, you have to wait and see if things are going to stay that way.

There are also more and more pieces going on sale, and the quality is noticeably higher. This is exclusively due to the healthy state of the market. As soon as the market slows down, the catalogues get thinner and the quality falls off. In 1990, when the market adjusted, it wasn't the prices that dropped, but the supply—suddenly and dramatically—and auction house sales figures fell by fifty-seven percent overnight. We have to wait and see what will happen in the near future.

Obviously the market can't just develop vertically. Every year you have a quantity of works that end up in public collections and are thus lost to the market. So you find yourself with more buyers and fewer works, and in the long run this can only keep prices at a certain level. The trend is going to become more pronounced, because in the emerging countries there are hundreds of new museums springing up, and they have to be filled, and that is going to subtract major works from the market. This makes me very confident about the market's future, even if there are going to be temporary adjustments.

Already from one season to the next, you see certain artists on the rise, while others drop back or generate less interest. Others still are badly underestimated in artistic terms and they will come up for reassessment. But each artist has his own market, with its own overall pattern. Look at what happened in the nineties: some artists' prices fell and they never got over it, while others came back even stronger than before. You just can't generalize. Let's take the Chinese market, for instance: what is interesting is that it started out with collectors quite different from those who were buying American and European art. Some people saw a potential signaled by the country's economic power and invested in Chinese art with the hope that its stock would rise. At the beginning it was being bought by Western collectors.

Do you feel that art should be considered more and more as merchandise—as an investment?

As soon as a certain amount of money goes into the acquisition of a work of art, it is normal for the financial side to be taken into account. No one likes throwing his money away. Everyone hopes the market will confirm his choice, but if it doesn't happen, no problem, because you have bought a work you love. Let's not forget, either, that you don't need a lot of money to put together a good collection. Often you come across remarkable collections built up with limited resources, and very mediocre ones a lot of money has gone into. There is real justice in the market. People who buy with discernment, passion, and love often make the best investments, while those who are fixated on the investment angle can lose out badly, as one can experience these days.

At Phillips de Pury we see both kinds of collectors. Some hand us a given amount of money to buy art for them, and when they want to sell we are paid on the basis of the works' financial performance: an approach that is unambiguous and icily objective. But later, when we get back to them about selling because it seems to us the right moment, some of them refuse, because they have lived with their works and come to love them. They have got the collecting bug. That is the difference between art and every other kind of investment: the physical attachment you can develop for certain works. Art becomes a mistress. But the marvelous thing is that there are as many motives for collecting as there are collectors. Collecting is the most beautiful sickness in the world: it takes countless forms and it is absolutely incurable.

MARC SPIEGLER Art Basel/Art Basel Miami Beach

Marc Spiegler

Founded in 1970, Art Basel is the world's most important art fair for Modern and contemporary art. Since 2002, the fair has an American offshoot, Art Basel Miami Beach. Marc Spiegler took on the directorship of both fairs in 2008, together with Annette Schönholzer. French and American by birth, he worked for more than a decade as an art world journalist and columnist focusing on the international art market, writing for magazines such as *The Art Newspaper, Art + Auction,* and *New York Magazine.*

"Our first job is to get the art world to come here, and our second job is to create that contagious passion for art, which transforms itself into both buying and curatorial interest."

In the nineties, the biennials were the place for the art world to meet. Now it is the art fairs. What are the reasons for this shift?

I think people still certainly meet at the major biennials. In fact, it's harder than ever to get hotel rooms in Venice during the professional preview. But fairs have indeed become much more central to the broader art world. In the beginning of the nineties, the art market was very slow, but as the art market steadily grew in size, many new people entered the art world through the market. Just as important, the general concept of the art fairs changed completely, making them attractive to a broader cross-section of the art world. This was a moment when many people new to the art world first came to shows such as Art Basel, and then only later started going to biennials, when they became more involved in the art world.

Art Basel is one of the oldest and still the leading art fair in the world. What are the secrets to achieve this success in a growing global competition?

It's no secret: wherever you are operating today, if you want to be successful you have to meet the art world's expectations of a top international event. This requires more than having a great group of galleries offering high-quality pieces, although that is the fundamental factor. You also must have a VIP program and an intellectual-content program, like our Art Basel Conversations, Art Lobby, and Art Salon.

Many people now coming to our shows are not selling something directly and have no intention of buying anything—they come because the "whole art world" is there. And because they're there, the rest of the art world actually comes. Also, Art Basel has innovated to become a totally different event than a traditional art fair: The legendary curator Alanna Heiss of P.S.1 used to say that if she caught one of her curators at an art fair she would fire them. And now P.S.1 has collaborated with us at Art Positions for the last three years at Art Basel Miami Beach!

But Art Basel also has its global reputation because it has invested a lot of time and energy into building a worldwide network. We have VIP relations officers all over the world—we just added one in India, for example, and obviously we're looking in other parts of the world. We thus hope to make sure that the best collectors and the museums have been identified by us, that they're encouraged

to come, that they feel welcome at our events. So what our galleries do is very much spotlighted for those people. The proof for this model is that we always see a great number of new collectors coming to our shows—this year, they were not only those from new markets like Russia, India, and China, but also from Western Europe. We meet a new generation interested in art, which is exciting for our galleries.

Another reason for Art Basel's success is that in our halls you can trace the relationship between the older and younger works shown by the galleries of the different sections, covering eleven decades of artistic production. Working from youngest to oldest, you could start in a corner of Art Statements, go through Art Unlimited, cross the catwalk to go upstairs to the first floor of Art Galleries, and then end up downstairs with the Modern dealers. This aspect is crucial because the artists of today have a strong connection with their predecessors. So as you walk through the halls, the older work feels invigorated by the presence of the younger work, and the younger work is validated by the presence of the older work.

What do you think about the increasing number of parallel art fairs trying to profit from the success of the prestigious art fairs?

On the one hand, it's a compliment that we've created that density of art world audience—galleries desperately want to be present in some way. And the proliferation of parallel fairs doesn't really threaten us. From a tactical point, it was much more of a problem when there were three parallel fairs than when there are twenty or more. Because there is an art world type who is terribly afraid of having missed something—I'm one of them, to be honest. So if there are five or six such events in the city, those people will try to see all of them. But once there are twenty, it just becomes impossible, absurd even . . .

Also, every gallery has a support group of collectors who come during that week, and those people don't only go to that parallel event. They also come to Art Basel and Art Basel Miami Beach, where sometimes such collectors turn out to be very strong supporters of the younger, newer galleries present in Art Statements at Art Basel, or Art Positions and Art Nova at Art Basel Miami Beach.

Art Basel has extended to a second art fair in America, Art Basel Miami Beach. Why did you choose Miami, which is so much linked to parties, glamour, and celebrities? Does art need this platform?

What attracted Art Basel most to Miami Beach was its high density of great collectors and the proximity to Latin America. The two cities are radically different from each other in most regards, but both in Basel and in the Miami area you find private people who are very, very serious about art. They collect a lot of art, support major institutions, help artists publish catalogues, and so on. This was an aspect many people ignored about the Miami area, but without that support, Art Basel Miami Beach would never have been a success.

When Art Basel Miami Beach started, there was a decision to give it a more spectacular quality, partly to distinguish it from Art Basel and partly to draw people there at first. And, after all, it is Miami Beach, which is a party town every day of the year. We couldn't change that, even if we wanted to—which we don't, since we believe pleasure and art make excellent bedfellows.

But our focus at Art Basel Miami Beach remains on the art itself, on the artists and the galleries creating a really serious art show. In fact, we only organize three events at this fair: The Welcome Party, since people are traveling from all over the world and you want to give them a meeting point. Then the concert on the beach, which is our gift to the younger Miami Beach public, and finally a Goodbye Party, which is attended almost exclusively by our local supporters and our gallerists, who deserve a party after an intense week.

Has the presence of the galleries at art fairs lost importance in times of global communication?
Not really, because there's a limit to what you can do by telephone and email. Some things you need to see for yourself, with your own eyes. That is why the galleries always take the central position in our shows. If we don't deliver a great platform for them to show programs, then nothing else really matters. The galleries are our nucleus.

Art Basel 2009, in the foreground a sculpture by Mathieu Mercier/Galerie Mehdi Chouakri, Berlin

Also, it used to be that the only people who came to art fairs were dealers and private collectors. Now you see a great many more curators, museum directors, and artists. At Art Basel, they are able in a very quick time—because it's such an international fair—to get quite a strong overview of what's going on worldwide, and perhaps find the next young artist for their premiere solo show. An amazing number of artists have participated in Art Statements and found themselves inundated with offers for solo shows in various museums all over the world.

You see, part of how we measure our success is how well our galleries sell, but it's also how many new contacts they make and how many new shows come out of this week for their artists. When that works it's a very strong cycle, pulling together many different parts of the art world in support of the artist. And for this to function, human interaction is essential.

With Art Unlimited, Art Basel has created a special space for large installations. Do you see a reason for the oversized and spectacular formats in contemporary art?

Art Unlimited was developed because ten years ago, many Art Basel galleries had great artists whose most interesting work simply did not fit in a traditional fair booth. And after offering this new possibility, we found more artists and galleries becoming ambitious. And now there is an even greater market for such work, as there are so many more private collections with huge industrial spaces and private collectors eager to own pieces like those.

That said, I think the scale issue goes in both directions. Certain artists succeed when they go bigger, and others don't. You can't just pump your work up to make it twice as big, because sometimes it becomes half as interesting . . .

There is a tendency for curated gallery shows nowadays. What is the reason for that?

It's attractive to the gallerists, both intellectually and because a tightly curated show within their booths really helps to position their program within the art world. One of the most important missions a gallery has at our show—apart from selling work—is presenting themselves to potential new collectors, curators, museums, et cetera. When you have a booth that truly represents your thinking and your program, then you create that possibility for stepping out from the crowd and connecting with all of the gallery's potential audience.

Why did Art Basel spread its activities also to design?

Actually, Art Basel has embraced design much less than some of our colleagues. We think design will be ever more important. And we think the design market is synergistic with the art market in the sense that there is a lot of overlap between collectors—and there are even some of our galleries which now show both design and fine art. But Art Basel has deliberately chosen not to be involved in a direct way, which partly explains why our parent company, Messe Schweiz, owns half of Design Miami Basel and ten percent of Design Miami. We want Art Basel to keep its focus on art, so we steer design toward those two fairs.

There are collectors criticizing that the galleries are already sold out before or right after the opening . . .

I disagree with that completely. That's a common misperception which we've done a lot to fight against, because it's so rarely true. Also, more and more gallerists have become very resistant to the tactic of just sending around jpegs and selling the work by email before the fair. There are two reasons for that resistance. First off, most gallerists don't just want to sell art like a commodity. They want to have a real conversation with a collector and develop the kind of bond that leads to a longer kind of relationship.

Secondly, you don't make the effort of coming to Art Basel—shipping the work, storing the work, insuring the work, housing your staff, organizing the dinner for the collectors—in order to sell to the same people you already know. You don't need to leave your gallery to do that. Gallerists come to Art Basel and Art Basel Miami Beach to meet new collectors. And if you have nothing left to sell those new collectors, then it becomes very hard to build a rapport with them.

More and more art fairs are evolving around the globe. What do you think about this competition of art fairs?

If you look at the history of Art Basel and what made it successful, it's really the fact that time and time again the show has innovated. I think we were the first event to have a free-standing photography section, at a time when much debate raged in Europe regarding photography's place within the market. Prior to Art Unlimited there was a free-standing video section and Art Basel had experimen-

tations with digital art. Some of the experiments succeeded, some of them failed—but certainly you can't go forward without taking those risks.

We always ask ourselves: What's now developing in the art world that needs a place at Art Basel? Art Unlimited was a great example, because it became clear that if you only limited yourself to the art which would fit within a standard fair booth, you were eclipsing a really interesting part of what was emerging. In the same way, we introduced curated performance programs more recently, because many artists started to rediscover live art, either in the public space or an actual theater setting.

Why is contemporary art so popular today, and what are the criteria for its quality?

Nobody needs to own art. Art won't keep you warm. You can't breathe, drink, or eat art. The art market exists solely because people are passionate about art. For that to hold true, the art has to be compelling—it must connect strongly either with who we are now—the zeitgeist—or who we are fundamentally, an essential human aspect.

Without artists who can challenge us and inspire us in that way—who can create new perceptions and new modes of thinking—the art world would be uninteresting. So "fair art" that feels like it's only been manufactured to be sold, or the pseudo-ethnographic "biennial art" created for a particular kind of globalized mindset doesn't go very far. Art has to connect with us—and vice versa.

Is there enough high-quality art available at the art fairs to feed this rising demand?

Your question raises the primary reason why we've never done a third fair, despite the success of Art Basel and Art Basel Miami Beach: our galleries face a large enough challenge in bringing great booths to two shows a year. Many of the more clever gallerists have become very strategic: they plan eighteen months ahead of time, keeping back specific artworks for both Art Basel shows and focusing on only a few artists per stand. This makes their presentation more compelling to the fairgoers because they see a more concentrated group of pieces. And it is also more attractive to the artists because they feel like they're really being put in the spotlight.

Does the growing influence of the international auction houses on the market affect the art fairs?

First of all, we don't allow any auction house–owned gallery to be a part of Art Basel. It's been a rule since 1996, because our committee and directors have felt strongly that our platform should promote a certain kind of interaction between the artist, the gallery, and the collector. Our galleries work very closely with the artists, placing them into the collections that they think best support them, where they will be best shown, which will actively loan pieces to museum shows. This is something that auction houses don't do. It's a very, very different model.

When someone buys at an auction, it benefits the auction house and the consignor. When a collector buys at a gallery, it benefits the artist, the gallery, and by extension all the other artists of the gallery,

whose work hasn't found its market so far. Drawing that line is something that is becoming more and more of a priority for us. We're one of the strongest platforms for promoting the paradigm of the art gallery's central position in the art world—and we take that role quite seriously. So Art Basel is a kind of counterweight to the auction houses.

Due to globalization the so-called new markets have become very attractive for the art world. To what extent are you involved in this?
Obviously, many interesting developments are happening in Asia and in the Middle East, which is reflected in our shows: in 2007 we had only one Indian gallery at Art Basel Miami Beach, and in 2008 we had three. We also had the first gallery from the United Arab Emirates. And then there's the number of Iranian artists who have suddenly flourished.
Creating every Art Basel now means traveling a lot, to identify the galleries, curators, magazines, and collectors whom we want to be present at our two shows. We have to go in person to these new emerging markets, to see for ourselves and make our own judgments. In certain regions there are galleries that may be at our standard, but seem somewhat intimidated. So we reach out and encourage them to apply.
The art world has a tendency to move its spotlight around rather quickly. I remember ten years ago the focus was on Brazilian and Mexican art. Then everybody was talking about Eastern Europe and Russia. After that it briefly was Iceland, and then on to Leipzig. Now you hear constantly about China, India, and Iran. As an international art fair, we must follow these new developments. But we're as active now as we were in Latin America ten years ago. For us, the focus is on creating a series of long-lasting relationships. We're not trying to create a show with the hottest artists of this year's hyped region, and then feature another hyped region the next year . . .

How has the globalization of the art market affected the job profile of a gallerist?
If you want to be a serious contemporary-art gallerist now, you have to travel the world. You have to go and see what other people are doing—and what your own artists are doing—worldwide. Once you are able to connect with a broad range of people worldwide, you can find collectors and institutions to support the gallery program. If you look at the trajectory of some of the best young galleries, they've managed to build—artist by artist—a program that is totally international. And that is fantastic.

What do you think about the influence of globalization on art? Do you think it's even more dif-ficult to create authentic artwork in times of globalization, where you have no boundaries and everyone is connected to each other?
There are really interesting artists coming from all over the world right now. In that sense, the glo-balization of the art world can only be seen as a positive influence, because it creates a broader pool

of people creating art, a broader pool of people supporting art, and a broader network through which art can be discovered.

There was a moment when you could consider yourself a well-educated member of the art world if you spent a week in London and a week in New York every year. Those times are over. Thus the art world is truly becoming the art "world"—no longer just the east and west sides of the Atlantic. Today you have these teeming geographic, ethnographic influences that make art thrive.

Concerning the problem of authenticity in a global world . . . In the end, art comes from one person—so its authenticity all depends on this person's authenticity. The artists may now have a broader range of experiences and influences, but this should in no way make them less interesting or less capable of inspiring. Actually, it should make them capable of being even more inspiring!

What is your feeling about the relationship between money and art?

At any given moment there's always a group of artists whose prices are rising very, very quickly, much more quickly than those of other people. And the media focus upon that. But there is a lot of work that is not very expensive, even within Art Basel and Art Basel Miami Beach.

Having sat in the committee meetings when galleries are chosen, I can assure you that they are not selected based upon their annual turnover, but rather upon the cultural strength of their program. In fact, it's dangerous for a gallery to be perceived as more commercially oriented than culturally oriented. And it's also very dangerous for a gallery's booth to be judged too "commercial." Because the gallerists on those committees see our shows as a platform for galleries that want to develop long-term programs, and thus create an art world effect that is far more stable than any short-term fluctuation in price.

Will the international financial crisis have any effects on Art Basel?

That really depends on the depth of the crisis. Obviously, if people have no money to buy bread, they are not going to buy art. But I don't think the effects on the galleries at the top end of the art market will be that radical. Since the early nineties, when a lot of galleries closed, there's been a major expansion. So, even if the art market were to contract, it would never be as small as it was in the early nineties. And Art Basel is not that vulnerable, because when we expanded Art Basel, we didn't just put more galleries in Hall 1, which would have been an easy option. Instead, we put Art Unlimited and Art Statements in Hall 1, to give the younger ones a chance for greater visibility and to create a special platform for ambitious installations.

What is your vision for the art fair?

What makes Art Basel powerful is a phenomenon the Nobel Prize–winner Elias Canetti describes in his book *Crowds and Power,* a distinct moment when a group of individuals turn into an organism, where you somewhat lose your individuality. It can be in the form of a religious ceremony; it can be

in the form of an army going into battle. At our show, there's this moment where a group of collectors start to feed off of each other's energy and passion for art and develop a heightened sensibility and attraction toward art.

So our first job is to get the art world to come here to our shows, and our second job is to create that contagious passion for art, which transforms itself into both buying and curatorial interest. But the biggest step occurs when new people start following closely the program of our galleries—making a trip to go see an opening far away, just for one night, and then spending the next day going around to the other galleries of that city. In a sense, we're trying to create this kind of virtuous cycle that serves our galleries continuously, not just in the two weeks when they have stands in our halls, but fifty-two weeks a year.

CORPORATIONS

JAGDISH BHAGWATI Economist, New York

YVES CARCELLE Louis Vuitton, Paris

ULRICH GUNTRAM & STEFAN HORSTHEMKE AXA Art, Cologne

Jagdish Bhagwati

Born in Mumbai, Jagdish Bhagwati studied first in Mumbai and then at Cambridge, the Massachusetts Institute of Technology, and Oxford. Today he is a university professor at Columbia University and a senior fellow in international economics at the Council on Foreign Relations. He has been economic policy advisor to Arthur Dunkel, who served as director-general of the General Agreement on Tariffs and Trade from 1991 to 1993, special advisor to the United Nations on globalization, and external advisor to the World Trade Organization, where he served on the expert group on the organization's future. He was on the advisory committee to U.N. Secretary-General Kofi Annan for the New Partnership for Africa's Development, and was also

a member of the eminent persons' group under the chairmanship of Presi-
dent Fernando Henrique Cardoso on the future of the U.N. Conference on
Trade and Development. Five volumes of his scientific writings and two of
his public policy essays have been published by MIT Press. He has been the
recipient of six festschrifts, and he has also received several prizes and
honorary degrees, including awards from the governments of India (Padma
Vibhushan) and Japan (the Order of the Rising Sun and the Gold and Silver
Star). His latest book, *In Defense of Globalization* (Oxford University Press,
2004), was published to worldwide acclaim.

"Art certainly plays a role in the economics
of the global world, whether it is music,
literature, or fine art."

**Where do you see the role of art in an increasingly global society? Has art become an economic
tool in the global world?**
Art certainly plays a role in the economics of the global world, whether it is music, literature, or fine
art. For instance, the global-trade issue of U.S. agricultural subsidies has been deeply affected by
music and film. Ironically, Willy Nelson, the folk musician, has sung of the plight of the small farmer,
creating the image that the subsidies are going to beleaguered small farmers when in fact the vast
bulk of them go to rich farmers and hurt the small farmers in the exporting poor countries. Similarly,
the film *The Country* featured Jessica Lange and Sam Shepard portraying a struggling small farming
family. Of course, there is also the "Make Poverty History" campaign, which has been led by bands,
rock groups, and singers such as Bono and Bob Geldof.

**Do you think art could contribute to a better understanding in the context of intercultural ques-
tions or problems?**
I believe it can, though this goes both ways. Good examples of how art can produce intercultural
problems are Salman Rushdie's novel *The Satanic Verses*, which led to the issue of the *fatwa* by Iran
as a reflection of the country's extremist Islamic factions, or the outrageous murder of Theo van
Gogh by a Muslim extremist after his provocative film *Submission*. Again, the Danish cartoons of the

Prophet Muhammad led to street protests in Islamic countries, while the principled Danish Prime Minister Rasmussen courageously refused to exercise state censorship in defense of freedom of expression, which is central to Western culture.

But art can also build bridges between cultures. The joint concerts of Yehudi Menuhin on the violin and Ravi Shankar on the sitar established a bridgehead between the Western and the Indian classical musical systems, which made Indian music more readily acceptable to Western ears. Similarly, Zubin Mehta, from my home town of Mumbai, has built bridges between Israel and India by bringing the Israel Philharmonic, which he conducts, to India. Another example is my nephew Sandeep Bhagwati, who grew up in Germany and is a "German" composer and who wrote an opera on the great Indian mathematician Ramanujan that was performed at the Munich Opera House.

Could art contribute to a better ethic in the context of global economics?

Art flourishes on imagination and empathy. Fine art and literature enables those less endowed with such gifts to put themselves in the shoes of others, to share their joys and sorrows, thereby promoting a better ethical behavior toward others. The two great men of the Scottish Enlightenment, Adam Smith and David Hume, talked of empathy diminishing as the distance between people grew. Today, documentaries—which are a form of art—have destroyed this distance: it is no longer possible to ignore the suffering of others far away, since it now comes through television right into our living rooms. And so we get a better, more ethical world that builds stronger bonds among human beings everywhere, regardless of geographic distance.

What do you think about the relationship of art and money?

Art prices moved up as wealth multiplied in the last quarter of a century. The Japanese wealth during the eighties led to massive purchases of Western art. The Indian wealth since the nineties has meant that Indian paintings like those I had bought for a $100 each in the sixties were now fetching half a million dollars, as the newly rich Indians in India and in the United States competed for modern Indian art and inherited sculpture and miniature paintings. Chinese art also became hugely expensive as the Chinese prospered after their own economic reforms, which allowed them to profit from their integration into the global economy.

How will the current worldwide financial crisis affect the art market?

In the current crisis, the huge wealth and incomes have both crashed, and so have art prices, which are now at a quarter to a half of the peak prices of the last decade. It is doubtful that the huge incomes and therefore the huge art prices will return: there is likely to be some attempt at regulating and taxing huge wealth and also the high incomes that have now become subjects of opprobrium. But the art market will surely rise once the crisis has been fixed, as it will be, in a year or two.

Is art a sustainable investment—like gold—in our present economic situation?

Yes, indeed. Gold itself has been volatile. Art in fact remains a better investment, especially as pros-
perity spreads in the global economy and most people who acquire upper-middle-class or quasi-rich
status today want to own a piece of art, usually from their own culture; this steadily builds up demand
against a supply that is often static, as in the antiques market, or slowly growing, as in the market for
modern paintings and sculpture.

What is the role of the artist in a global world today?

Artists, even though anchored in their own cultures, have always affected others outside their own
culture, whether it is in literature or in fine arts: Tolstoy and Dostoyevsky wrote from the Russian
milieu and in Russian idiom, but their novels raised profound moral issues and have influenced
countless non-Russians. Solzhenitsyn wrote of the Gulag, but he illuminated for millions abroad the
nature of tyranny and man's indomitable spirit. Art is never good when it is not authentic, grounded
in the culture that the author, the painter, or sculptor knows best; but it transcends these confines in
its salience for humanity everywhere.

Is it still possible to create unique art in a global world?

Yes. As I explained above, the artist must reflect the immediacy of his own experience, which, even
in a globalized world, remains for the most part anchored in local culture. Also, as I explained in the
chapter on culture in my book *In Defense of Globalization*, the fear of losing one's culture in a global-
ized world paradoxically leads to an intensification of attention and regard for one's own.

**The artist as commercial popular star, businessperson, or service company in the globalized
society: how did the "open markets" contribute to this development?**

Once the markets expand, so does the size of your enterprise. Artists are not immune from this
"law." This is true of marketing too. Successful artists are no longer confined to attics, spending their
time on canvases and seeking ties to some local gallery that will exhibit their work. They produce
on a larger scale and they also seek markets in many places, requiring entrepreneurial and public
relations skills that make them more like the businessmen who buy their paintings. This is also true
of literature and music, of course.

**The sizes of artworks—paintings, installations, sculptures—are becoming bigger. Does this de-
velopment stand in correlation to the globalized, big world?**

This is an intriguing question. Open-space sculptures are clearly large, reflecting the spaciousness
that open space provides. Perhaps, just as we have had high-rise architecture, we have outsized
sculptures—both reminiscent of tropical rainforests where trees push upward for sunlight. Or is it
that the growth of an American presence in painting and sculpture, challenging the earlier hegemony

of France and Europe, has ushered in "gigantism": unlike Europe, the United States has far more space, and its love for large cars, outsized suburban housing, big canvases, and large sculptures is of a piece.

What do you think about corporate sponsorships in art? Does art advance creativity for employees in corporations?

I believe that this is part of corporate social responsibility. In the old days, we had family firms like the Rothschilds doing this. Today, we have non-family corporations that are moving into doing what the old family firms did. Supporting the orchestras, the art exhibitions, and the myriad ways in which a society's aesthetic life enriches one's being: this is surely an activity that can only be applauded.

Maybe art advances creativity for employees in corporations. But this sounds like overbuilding a good case! I have known countless numbers of people who never notice their environment. Are they outnumbered by people who do?

Where do you see the role of the museums today?

Maybe our children will watch only the Internet, and visiting museums will become obsolete. Yet, museums provide a socializing experience and a shared way—unlike the Internet, where you are glued by yourself in front of a screen—of enjoying an aesthetic experience in the company of your family or friends; that is surely unique. Why do people still go to bookstores instead of buying everything on Amazon.com, for instance?

How do you explain the increasing numbers of exhibitions and biennials worldwide?

To some extent, this reflects the globalization of the art market, of course. But there is also greater interest today—thanks in part to economic globalization—in art, music, and literature from other cultures.

YVES CARCELLE Louis Vuitton, Paris

Yves Carcelle

A graduate of the Ecole Polytechnique in Paris, Yves Carcelle developed an early fascination with the marketing style that was developing in France in the late sixties. After nine years in consumer goods merchandizing and sales, he happened to find himself in textiles and, logically enough, the related creative fields. Spells as managing director of a children's clothing company and CEO of Descamps were followed in 1989 by an invitation from Bernard Arnault to join LVMH just after Arnault had taken control there. Yves Carcelle became Chairman and CEO at Louis Vuitton in 1990 and, in recent years, has intensified the company's involvement in contemporary art through a series of collaborations with international artists.

"Artists need loudspeakers."

What explains the Louis Vuitton passion for contemporary art?

At Louis Vuitton, there's a connection with the art world that goes a long way back. The Vuittons—
Louis and his son and grandson—were very close to the artists of their time, notably the Impres-
sionists, and were collectors and patrons in their own right. The same goes for Bernard Arnault and
contemporary art. In 1997, we recruited Marc Jacobs as artistic director at Louis Vuitton. In addition,
a number of Louis Vuitton executives were fans, too, so it's logical that this traditional bond with art-
ists should be such a strong one.

Patronage as part of the brand image: What do you think of that?

Patronage has always been part of the LVMH Group. Every year we sponsor at least one big exhibi-
tion in Paris. But we also take our patronage further via direct collaboration with the artists. It takes
a number of forms: sometimes, for example, we commission works—permanent installations—to
put in our stores, as we did with James Turrell in Paris, Michael Lin in Taipei, Teresita Fernández
in San Francisco, Zhan Wang at The Landmark in Hong Kong, and Fabrizio Plessi on Canton Road.
The idea is to commission a work that will be in full-time contact with the public. It's interesting,
for instance, the way the James Turrell video on the second floor on the Champs-Elysées offers a
kind of stationary journey: the color changes gradually over a period of fifty minutes, giving you the
impression of traveling without moving. When Zhan Wang came up with his stylized stainless steel
stone, he explained to us that for every Asian garden, whether Japanese, Korean, or Chinese, years
are spent finding the marvelous stone that will be the core element. Sometimes in the West, people
look for a statue for their garden, but there it's a stone. For Zhan, having put this stone in the middle
of the store is like turning the whole place into an Asian garden.

Plus for a long time now we've been commissioning window displays from artists like Bob Wilson,
Ugo Rondinone, and Olafur Eliasson. In the case of Olafur, I've got a revealing story that illustrates
the Louis Vuitton approach and relationship with art. We had asked Olafur Eliasson to do an eleva-
tor for us, and the work he came up with was totally different from what we'd been expecting. We
thought he was going to produce a lightwell, a kind of shaft of light going all the way to the eighth
floor—and what we got was an all-black elevator! No sound, no light, and for seven seconds you
completely lose all notion of reality. It's spectacular and conceptual at the same time.

Our second project together was a window display, and for that he dreamed up the work titled *I See
You*—an eye which looks back at you through the plate glass in which you're also looking at yourself.
There's a powerful interaction between the work, oneself, and the reflection of the city, which means
the thing can be read on several levels. Everybody was absolutely fascinated. We had a meeting in
Paris to discuss presenting the work, and Olafur told us he wanted the windows hung with black

fabric. We did a simulation, and all of a sudden someone said, "Hold on, Olafur, what do we do with the products?" And that's when we got the answer that was perfectly logical from the artist's point of view, but not at all from ours: "Look, if you've commissioned a work of art from me, it wasn't for dumping merchandise next to it!" And that was when the penny dropped: it was the Christmas window we were talking about, and we saw ourselves having to tell three hundred and eighty store managers, "Good news, guys! No merchandise in the windows this Christmas!" That was quite a moment for us in our relationship with art, because ultimately it meant sticking with the artist's approach right to the end and to put our trust in him. What happened was, our visual merchandising manager, who's English and has a great sense of humor, broke the tension by saying, "Guys, don't bother, because the window is the invitation but the store is the party!" And we've never had so much Christmas business as that year when there was no merchandise in the windows. I think that was when the art world grasped that we really were serious.

Would you say that travel is the key theme in what artists do in the Louis Vuitton settings?
Not literally. But travel is what got Louis Vuitton started, and this automatically influences everything on the company's creative side.

You have also had artists, such as Murakami, develop products for the company. What role does the artist actually play for Louis Vuitton? And what are the benefits for the artist and the group?
Obviously the high point of the relationship is when the artist gets involved not with the décor but with the product itself. For this we've worked successively with Stephen Sprouse, Takashi Murakami, and Richard Prince—and each time at the instigation of Marc Jacobs, who chose those particular artists because there was something he wanted to say. "You know," he told me once, "looking back over the company's history, you see that since the beginning we've been putting the initials or the customer's heraldic sign on things. I want to restart that tradition, but in a 'now' style, and one of today's styles is graffiti. So if we invite Stephen, the pope of the graffiti artists, to work with us, that could really be something: in tune with company history, but completely modernized at the same time."

So you modernized a traditional marketing tool.
God knows, I'm a marketing man and marketing holds no fears for me, but I think that was really a creative move: being part of the tradition and reinventing it at the same time. And as it happens, it was an incredible sales success.
When Marc called Takashi Murakami in, the situation was a very special one. It was the spring of 2002, a few months after 9/11, and Marc said, "You know, it seems to me everyone's been very sad since September 11, and me included, because I'm a New Yorker and what's more from Downtown. But I don't think we can go on grieving like this season after season. So for the next collection"—he

Louis Vuitton on the Champs-Elysées with a window design by Olafur Eliasson, Christmas 2006

was talking about spring/summer 2003, which he was already working on—"I want to send out a message full of happiness and naïveté and colors. And I think that if I work with a contemporary artist it would give it more impact. I saw some stuff by Murakami not long ago and I think it would be great to work with him. What about it?" I told him sure and asked him if he knew Murakami. "No, but I'm going to." And a real relationship developed between the three of us, I mean between Marc Jacobs, Murakami, and Louis Vuitton: a truly sincere friendship that gave us the urge to do it again, the way we've just done with Monogramouflage, six years down the track.

It was pretty complicated at the start because Takashi has very definite ideas about what he wants—and so does Marc, and so does Louis Vuitton. Ultimately, Takashi suggested making some changes to the Monogram canvas pattern, which had never been done before, even if we'd reworked it in other fabrics. But to change the canvas, which has been our strongest code since 1896, when Louis Vuitton's son created Monogram, was to change something that ran very deep. And when Takashi came up with thirty-three different colors, it was pretty unrealistic: we spent weeks finding a workshop that could print canvas in thirty-three colors. The easy way out would have been to ask him to simplify—twelve or twenty-four colors at most. But we had so much respect for his work that we went ahead

with thirty-three. We put in the time it called for and took a lot of flak because the imitators beat us to it with a simplified version ahead of our real one. But in the end I think the public recognized it as a great gesture on the part of the artist and the company.

You are thus indirectly widening the audience for contemporary art through your consumer products. Is this a role you'd like to take on, this kind of intellectual patronage?

Yes, I think art is many-sided: someone like Takashi Murakami is an heir to the Andy Warhol Factory tradition, and maybe that's what brought us together. One day, I was talking to a journalist friend about what we were doing with Murakami and she said, "You were made for each other: on one side there's the craftsmanship factory and on the other the art factory." So what we've done together has really, in my opinion, built a historic bridge between the creation of luxury items and artistic creation.

These bags were a stunning success all over the world, and the public, by acknowledging the creativity of the gesture, proved it was ready to adopt a new lifestyle. This gave us, and Murakami, the urge to keep on working together. And here's another characteristic: when we commission an artist, we give him absolute freedom, whatever the consequences—thirty-three colors or a black elevator. But when it's a question of a bag, which has to be a real product, the reality principle won't just go away. It's not a matter of producing a work of art with no practical application. It's a matter of putting art into a product, in this case into a bag that has to remain a bag, retaining its functionality while being enriched by the artist's creativity.

Does Louis Vuitton also take a stand for lesser-known artists?

Absolutely. The Espace Louis Vuitton on the eighth floor on the Champs-Elysées gives unknown artists a chance. Our India exhibition was one of the first in France to highlight Indian contemporary artists, and at the moment there's a show devoted to contemporary art in Korea. These exhibitions, which are free, offer the public whole new worlds. And the emotional reactions triggered by the works in the stores make the public want to feel the same way at home, in the company of a painting, a photograph, or a sculpture. Art is not exclusively for museums, even if museums are vital.

What prompted Bernard Arnault to set up the Louis Vuitton Foundation?

It's something he had been wanting to do for a very long time. He had been talking about the idea practically ever since I started working with him. A year ago I had a really nice surprise when he rang me and said, "I've been thinking. Calling it the LVMH Foundation is going to sound a tad forced; what do you think about Louis Vuitton Foundation?" And I said, "I'm very honored and flattered by the suggestion, and I think that, given all the discussions we've had, if there's a member of the group that deserves it, it's Louis Vuitton." This choice emphasizes the creativity that's been going on here for generations, from the Vuittons themselves up to the present time, and gives it the status it merits.

Takashi Murakami and Yves Carcelle in front of *Flower Ball*, Guggenheim Museum, Bilbao, 2009

What will the museum's mission be?

Bernard Arnault didn't choose the easiest row to hoe when he picked architect Frank Gehry, but when the museum is built it's going to be something really extraordinary in Paris. What he's created is going to harmonize brilliantly with the Jardin d'Acclimatation context: there's going to be a section made of amazing curved windows reflecting the sky and the trees and changing color the whole time. So the work of art is going to highlight the natural setting like a statue in the middle of a garden; for me that makes nature even more beautiful.

As in any museum, there will be a permanent collection, and at present the acquisition strategy is in the hands of artistic director Susanne Pagé and Bernard Arnault himself. The works and the artists will really reflect the international spectrum. There will also be temporary exhibitions organized on a loan and exchange basis. In addition, there will be a contact and work space for artists and young people, with appropriate documentation. It's important to help the younger generation develop a taste for art and creativity, and this is why the foundation will have its educational side as well.

What makes Louis Vuitton different from other major brands in the art field?

I think our approach is characterized by real sincerity. First of all, we like the relationship with the artists to become closer over time and to produce different results: Murakami from Multico to Mono-gramouflage; Olafur from the elevator to the window display; and Ugo Rondinone from the Christmas tree window to his involvement in the *Icons* exhibition. But there are also the roots, traditions, and codes that mean we're not afraid to enrich our in-house creativity with the creativity of artists, even if it can be unpredictable or disconcerting.

You are a collector yourself. Were you influenced by the artists the company has shown?

I'm only a modest collector. My wife and I like to be surrounded by works that are part of our lives, but we've never bought in order to resell or speculate.

Who has the most important role in your opinion: the gallery, the auction house, or the museum?

The artists, no question. The artists are the source of everything, but they need loudspeakers. They can't create and do their own marketing at the same time. In the art world everyone has their part to play: patrons, galleries, auction houses, the media—and books.

Do you think art is increasingly becoming a global player? You're not the only group to use art: there are others, like Hugo Boss and Agnès B, for example.

There are several factors at work here. Given today's means of communication, artists, whether working with us or not, can achieve global visibility. Contemporary art is a fast-spreading phenom-enon, and every year, all over the world, including the emerging countries, people are discovering a passion for it. The most affluent sometimes opt directly for established artists, but very quickly accept

the idea of taking risks for less well-known works that please them. And then people from all sorts of backgrounds want the pleasure of having creative work in their homes and are buying lithographs, photos, and works by very young artists. Not to mention the way contemporary art is breaking through in lots of countries—not just China, but India, Korea, the Middle East, and elsewhere—and opening up new possibilities. And that's great.

ULRICH GUNTRAM &
STEFAN HORSTHEMKE AXA Art, Cologne

Ulrich Guntram

Stefan Horsthemke

AXA Art is one of the world's leading insurers of art. The company sponsors such internationally important fairs as Art Basel and Art Basel Miami Beach and is the principal sponsor of TEFAF Maastricht. It has an international presence and its clients include private collectors, museums, art dealers, and galleries. Dr. Ulrich Guntram has been chief executive of the AXA Art Group since 2001. He studied economics, information technology, and mathematics, and in the past has worked as a partner for the consultancy firm McKinsey. Dr. Stefan Horsthemke has been managing director of AXA Art Deutschland since 2005. He has a doctorate in art history, is an expert on the development of the art market, and holds a number of visiting lectureships in this field.

"Everyone benefits from globalization."

Why are businesses increasingly investing in art?

Ulrich Guntram: On the one hand, companies are using art as a means of identifying themselves and securing the loyalty of their employees. Thus art is becoming a vital part of corporate culture. At AXA, for example, employees are allowed to choose works of art for their offices, and there are budgets for buying art. On the other hand, companies use art to convey a certain public image, to present themselves as being creative or socially engaged. For the same reason, interviews with prominent politicians are often conducted in front of works of art.

How important is art today—I mean in both the industrialized nations and in the new markets?

Stefan Horsthemke: If you look at what has happened in the art market over the last twenty years, then it is clear that art has become a much more powerful economic and cultural factor. Today the art market is quite deliberately being used as a means of developing cities or certain districts within cities. The best example of this at the moment is the district of Berlin Mitte. In the early nineties, a large number of artists moved there because of the incredibly cheap rents. After the artists, the first galleries arrived, which in turn attracted other galleries. An affluent public followed them, and in the end the galleries are being replaced by expensive designer shops; the entire district has undergone an upturn, has become "in," and the rents have gone up. The same process has happened and is happening in many different cities—especially New York, with the rise of SoHo in the eighties, or now with the opening of the New Museum on the Bowery.

Many of your clients are collectors. To what extent has the globalization of the art market changed your client base here?

UG: In recent years the demand for contemporary art has risen sharply. Formerly the collectors' market was more or less limited to Europe and the United States; today it is a global market. This has meant that, as an insurer, our clientele has also considerably changed. There are still the traditional collectors who collect for the love of it and are deeply involved in art, and who will often search for years to fill a particular gap in their collection. The care with which these clients treat art constitutes the best kind of "reinsurance" for us and fits in with our own approach of trying to avoid losses to begin with. They are very different from the investors who are merely interested in art for its financial value, and for whom art is purely an investment. This client group has a different risk profile. The so-called "prestige buyers," who acquire art in order to decorate their extravagant lifestyle, are also becoming increasingly important. This kind of collector existed earlier, but not to the same extent as you find today. As specialist insurers, they represent an opportunity for us, but they also pose a great

challenge. We still know far too little about this kind of collector. What kind of people are they? What is their attitude to art? What do they require of us as risk managers?

What do you make of the present art boom?

SH: At present more art is being produced than ever before, above all in the countries of the Far East, which are benefiting from rising standards of living. Art has also become an important part of corporate policy. But there have been art booms before, albeit in smaller, exclusively European contexts; for example, during the so-called Golden Age of the Dutch Netherlands. At that time, between about 1600 and 1645, being a painter was a highly sought-after profession among young men. The fact was that this small country generated an enormous demand for art, and interestingly enough, artists at the time were already able to do very, very well for themselves—Peter Paul Rubens is a well-known example.

How do you explain the enormous interest in contemporary art?

SH: The turn to contemporary art definitely has something to do with a generational shift. The subjects that preoccupied the nineteenth century are no longer so relevant to our own time. Back then there was an enormous preoccupation with the past, and it was on this basis that, for example, history painting developed. At the end of the nineteenth century an entirely new kind of art suddenly emerged, with the explosion of the Expressionists onto the scene. From then on, artists started turning to more contemporary subjects. And today art has gone even beyond this—it is examining the future. Of course, this has made understanding art properly all the more difficult, since contemporary art requires intensive engagement with its subjects and artists. On the other hand, only the real collectors are able to do this. All the others, even though they of course deny it, buy art for other reasons: to decorate their homes, as a status symbol, as an investment, or because the work in question has attracted media attention. The fact is that there are more and more wealthy people in the world who can afford to buy what they want. However, there are few other goods like art that are capable of providing them with intrinsic values, beyond those of pure consumption. Art answers questions, poses questions, and moves one to question things.

Given that artists are using so many new materials, how do you as insurers approach the problem of preserving works of art?

SH: The durability of art materials is of course an important issue for us as an insurer, since we cannot guarantee against long-term physical changes in them. However, the phenomenon of artworks changing over time is a very old and familiar one. Among sixteenth-century Venetian painters, for example, Titian used in his pictures a particular kind of green, based on a special pigment, which over the course of time has turned black. In contemporary art, the use of new materials has led to a considerable acceleration in the process of change. For this reason we've initiated various different

projects that are specifically concerned with conserving the modern cultural heritage; for example, with preserving acrylic paintings or works made out of plastic and latex. The biggest problem is photography. Though there are some very good restorers these days, photographic works can easily be lost completely. You can use digital photography to preserve them; but that is in itself an enormous challenge for the market because the rules concerning it are not clear. For this reason, we not only advise collectors on how to treat artworks made out of such sensitive materials, but also offer advice in advance, when they're just thinking of buying one. In these instances it is very important both to document the works meticulously and to have a clear understanding of how to handle them. This is especially true of installations and groups of works where a great deal of technical equipment will need to be replaced over the course of time, such as fluorescent tubes or DVDs. In such cases the question unavoidably arises of whether the overall effect of the work will be changed if its original parts are no longer there. For this reason, artists need to take their part of the responsibility by giving very clear instructions on how they want the work to be treated.

There has never before been such a huge international tide of exhibitions. How has this affected the art insurance market?

UG: Economic development has also caused the art market to shift farther East. Accordingly, the amount of art being lent between East and West has greatly increased as cultural exchange usually accompanies commercial trade. This offers us the opportunity to enter future art markets in the Far and Middle East, in Eastern Europe and also occasionally in Central and South America. Before, though, we start operating in a new market, two conditions need to be met: first of all, there needs to be sufficient market potential. Secondly, the countries in question need to have an adequate infrastructure for the art business—ranging from restorers, storage, and transport to a reliable legal system.

In these new markets, exhibitions are a good way for us to gain entry as an insurer and become familiar with the local market conditions. But we also export experience and security to these developing markets. To this end, we've developed the "Global Risk Assessment Platform" (GRASP), which aims at using our wide experience with art storage spaces and museums to implement local risk analyses for new exhibition spaces. We also benefit organizationally from the infrastructure of various AXA sister companies around the world. In this way we can open up countries like Russia, mainland China, Mexico, or the United Arab Emirates. The next step is to insure the local museums and big collectors. In this way we have developed several new marketplaces and have become a global service provider. A few years ago we had a presence in only eight countries; today we have our own experts serving clients—many of them "global players" themselves—in more than two dozen countries.

Public museums, with their small budgets, are suffering a great deal from high insurance premiums. Do you think they can survive at all in the long term?

UG: Absolutely. Part of the problem is that museums need to learn what they're capable of taking on. Not every museum needs a blockbuster exhibition. It is often also the museums themselves who try to charge excessively high lending fees from each other by coming up with exaggerated valuations. This has pushed up insurance premiums, despite the fact that our prices for exhibitions have been falling every year by between five and fifteen percent. In this complex situation, we offer the museums risk management services and public-private partnerships in order to share the risks and the costs. For example, we are prepared to offer a discount when the museum can offer a high degree of security. Or we divide the risk with the public sector: either we bear the disaster-level risks for large-scale losses, and the public partner undertakes the risks for smaller losses—or the other way round.

SH: Whatever happens, the public museums will survive as the custodians of art and culture. Besides, museums are increasingly looking for new ways of funding themselves, and are suddenly setting aside mere conservation and deliberately engaging with, and exhibiting, young art. About ten

years ago this kind of thing was still regarded with skepticism, since in Germany alternative exhibition spaces or arts societies *(Kunstvereine)* are really the places for these artists to get seen by a wider public. For museums short of finances, exhibitions of this kind involving young artists also serve very pragmatic purposes: they are, quite simply, very cheap and can also help the institution survive economically.

What have been the effects of globalization on the art market?

SH: There has always been a cultural exchange in the art market, through trade and opportunities to travel. Today, thanks to modern transport, distances are becoming increasingly shorter and easier to travel. Everyone benefits from globalization: first of all the artists, some of whom today—at least the top rank of about two hundred properly established artists—have a genuinely international reputation. Then the collectors: they have spread globally and are now in a position to pursue their art interests both locally and in other parts of the world. The museums also benefit; they are now able to position themselves not only through international exhibitions, but also through affiliates across the world— one thinks, for example, of the Guggenheim Museum. And finally the galleries benefit, by being able to build up an international network. An entirely new dynamic has emerged from globalization.

Acknowledgments

AXA Art

Elliott Anderson
The Broad Art Foundation
Emmanuelle Dybich
Milton Esterow
Sabine Gludowacz
Ingvild Goetz
Julia Guelman
Ulrich Guntram
Fiona He
Robert Hobbs
Stefan Horsthemke
Dakis Joannou
Janina Joffe
Tarane Ali Khan
Elizabeth Kujawski
Annette Kulenkampff
Hubertus Langen
Lufthansa
Lissa McClure
Flavio del Monte
Lara Nicholls
PaceWildenstein
Laurence Perrillat
Marlene Poley
Irina Polin
Inge Rodenstock
Karin Seiz
Mari Spirito
Stefan Stocker
Robert Storr
Renos Xippas
Wang Qian

Photo Credits

Name Index

Page numbers in bold indicate an image.